THE ART OF
THE DINOSAUR

Illustrations by the Top Paleoartists in the World | Edited by Kazuo Terakado

The Art of the Dinosaur

Illustrations by the Top Paleoartists in the World

First edition: October 2017

Editor: Kazuo Terakado
Design: Daisuke Matsumura
Project Management: Rie Sekita

Cover art: Luis V. Rey

Art work copyright © 2017 by the individual artist:
Luis V. Rey, Zhao Chuang, James Kuether, Davide Bonadonna,
Sergey Krasovskiy, Rodolfo Nogueira, Masato Hattori, Emily Willoughby, Raúl Martín

PIE International Inc.
2-32-4 Minami-Otsuka, Toshima-ku, Tokyo 170-0005 JAPAN
international@pie.co.jp
http://pie.co.jp/english/

ISBN978-4-7562-4922-7 (outside Japan)
Printed in Japan

Acknowledgement by Kazuo Terakado

I would like to express my gratitude to Rie Sekita, Megumi Shimada and Daisuke Matsumura of
PIE International for making the publication of this book a reality. I know it called for great effort to bring my bold scheme to fruition.
I thank Dr. Martin Janal (formerly American Museum of Natural History, USA) who gave me valuable advice about the text of my conversation with
Dr. Makoto Manabe of National Museum of Science and Nature, Japan.
I am also grateful for the cooperation of my good friends, Mr. and Mrs. Hunter; Lawrie helped me with the English editing and Kyoko with translation.
Without their help, this publication would not have been possible.

Contents

A Persistent Sense of Wonder

Is it science or art?
Time travel through dinosaur art appreciation

The dinosaurs reconstructed in the images in this book are depicted vividly as they lived in their habitat on earth. The images are so realistic it is as if we had gone back to the Jurassic or Cretaceous Period in a time machine and taken photographs. I am sure that the greater the artistic skill, the more people will wonder how much of the images is sciencentific and how much is artful imagination. The art component of earlier dinosaur reconstruction images was very large. Recently, however, it can be said that the scientific side is catching up with art.

It used to be said that we would never know what color dinosaurs were. However, in 2010 researchers found a way to identify the colors and/or patterns of the surfaces of well preserved feathered animal fossils. Now we know that the feathers of *Microraptor* were basically black, but looking at the sequence of eumelanosomes, there is a strong possibility that *Microraptor* had what we call structural color. Depending on the angle of the light, they might have appeared to be of various colors. We also know from the reconstruction of brain shapes from the study of the skull bones enclosing the brain, that the dominant sense of *Microraptor* shifted from olfactory to visual during the its evolution to birds from dinosaurs closely related to birds.

It was also discovered that the feathers of the cheek and cap of *Anchiornis* were red. In the case of modern birds' caps, if they're red it means the bird is a mature male. We don not know if this applies to dinosaurs, but if it does, it is likely that dinosaurs developed systems for rapid collection of information and communication.

Furthermore, it was determined that the dorsal side of the trunk of *Psittacosaurus* was blackish and the ventral side was whitish. The boundary line between the two colors was not clear and located closer to the ventral side and rather removed from the back. In the forest, the rays of the sun shine through plants and the light diffuses in all directions, while in open spaces the rays shine straight down from the above. It is known that the color boundary line of animals that live in the forest is located lower on the trunk and is quite indistinct. Therefore, we can imagine that the main habitat of *Psittacosaurus* was probably forest, rather than open grass fields.

Time travel is not a reality yet. However, with this book, the people who have been wondering how much of dinosaur art is science may have gotten one step closer to venturing back in time.

Makoto Manabe, PhD
Director, Center for Collections & Center for
Molecular Biodiversity Research
National Museum of Nature & Science, Japan

Luis V. Rey

Luis Rey is a Spanish-Mexican artist. He has a master's degree in visual arts from Academy of San Carlos, National Autonomous University of Mexico in 1977. He began his career as a symbolist, hyperrealist and surrealist painter and sculptor. A dinosaur fan from the age of three, he rediscovered dinosaurs after the dinosaur renaissance in the late 1980s. He then began to study paleontology in depth to prepare for his updated and revised reconstructions for publication in popular books. His work took him around the world for research and for meetings with top paleontologists. He has co-published with several of these experts. He is currently working with Stone Company and Gondwana Studios creating murals for exhibitions.

My fascination with dinosaurs started when I was a kid. Their spectacular size, their power, the mystery and iconography associated with them in the late fifties and early sixties, and all the detective scientific work invested in the reconstruction of fossil skeletons—all were powerful sources of attraction.

In my early years living in Mexico and Spain, dinosaurs were seen as a thing of the past, as something obsolete and extinct. With the dinosaur renaissance in the seventies and eighties my interest was rekindled, this time seeing dinosaurs not just as icons in natural history museums, but as real animals in their natural environments millions of years ago. I found people taking a different, more appealing approach to dinosaurs when I arrived in London and later in meetings at the Society of Vertebrate Paleontology in the US (of which I became a member), an approach that has spread worldwide, especially to Japan and China.

The possibility that dinosaurs were related to birds was the greatest motivation for me to become involved in palaeontology. My first professional dinosaur illustration (1988) depicted a pack of feathered *Deinonychus*. I was inspired by the likes of John Ostrom, Robert Bakker and other maverick illustrators to depict dinosaurs in a way that few people would dare at that time. In the end, my dreams came true through a longstanding collaboration in popular books with some of my personal heroes, including Drs. Bob Bakker and Thom Holtz!

In less than two decades, dinosaurs were no longer dusty bones in museums. They changed their posture and became active, agile animals, far from the cumbersome reptiles of old. The new, corrected anatomical studies opened the minds of many, including myself. The simple comparison between *Deinonychus* and *Archaeopteryx* (considered the "first bird" in those ages) led us to firmly believe that birds were dinosaurs—so dinosaurs were not completely extinct. Defending these ideas got me into a lot of trouble years ago. Many academics were not keen on the concept of the dinosaur-bird link.

But ours were not simply whimsical ideas. Three decades after the dinosaur renaissance started, we were finally vindicated with the hard evidence we had been so eager to find. We only needed those now legendary Chinese fossil deposits, which preserved the external appearance of the dinosaurs, to have a triumph, a veritable revolution. I'm proud of having been part of that revolution.

That was not going to be the end of all the problems of course. It is very difficult to change the prejudiced image of dinosaurs that has been cultivated by the media over so many years. Even with *Jurassic Park* and *Walking with Dinosaurs*, in which I was a consultant, we could do little to change the appearance of the "monsters" demanded by the public. I longed to create something more accurate, more real—even today who would dare to represent *Tyrannosaurus rex* as feathered? Today we have worldwide evidence that most, if not all, dinosaurs had some sort of feathery or protofeathery coverage!

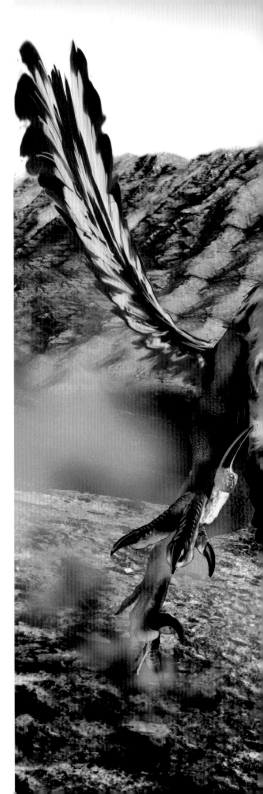

Velociraptor and *Avimimus*
A background mural for a 3D cast of fighting skeletons of these dinosaurs in the exhibition DINOSAUR rEVOLUTION
(Gondwana Studios, Luis V. Rey)
Lifesize digital mixed media

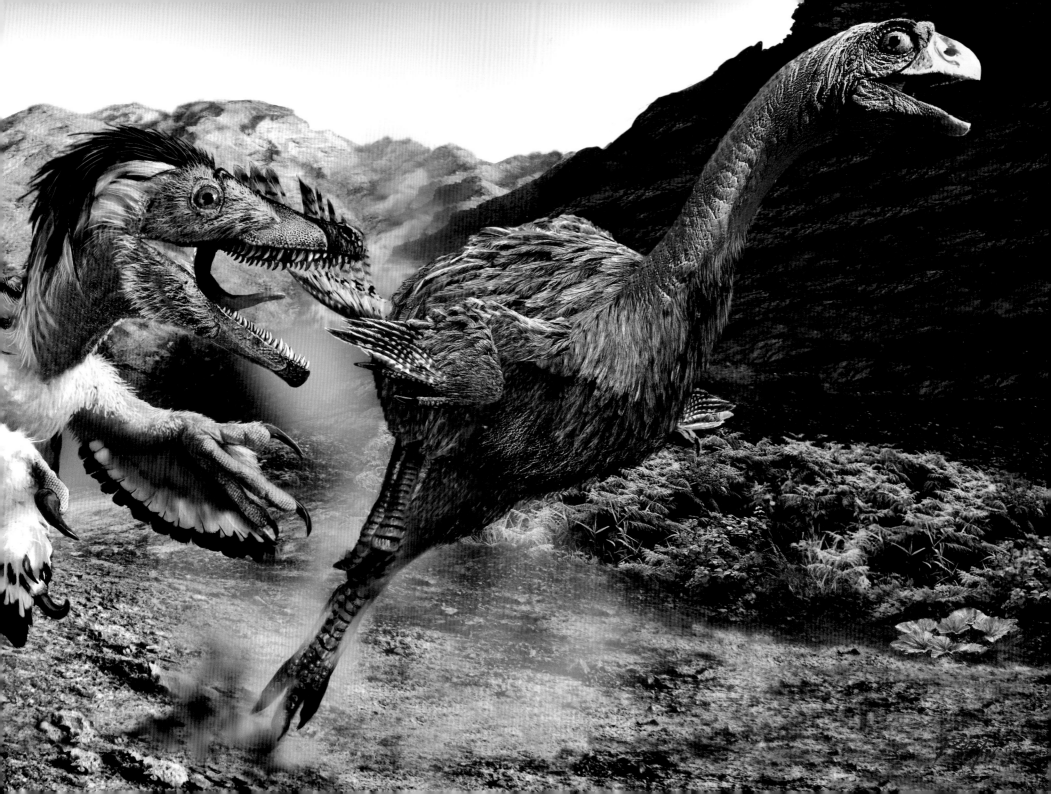

My use of colours was also different. Sometimes I was even influenced by my own cultural background, but I never strayed far from what is possible in nature. I was responsible for the first really "colourful" dinosaurs—no more reduction to greys, browns and greens; rather, wild patterns, sometimes with colourful highlights added, just like cassowaries and many other birds! I studied contemporary animals in their environments and found many possibilities: dinosaurs probably had colour vision like birds and reptiles—so why wouldn't they use patterns of colour to blend with their environment, camouflage themselves, fend off adversaries or attract mates?

Audiences ended up accepting the new colourful approach. The proof of that is the success of books like "Extreme Dinosaurs!" (Rey); "A Field Guide of Dinosaurs" (Gee/Rey); "Dinosaurs: The Most Complete, Up-To-Date Encyclopedia" (Holtz/Rey); and "The Big Golden Book of Dinosaurs" (Bakker/ Rey). My quest has always been to update the image of dinosaurs for popular audiences. I am not afraid of creating controversy or shocking change, but I do hate dinosaurs that look like clowns—as long as the anatomy is correct and we do our homework, we artists have an open field to expand our minds and develop our creative powers at the service of science. Palaeontologists call us their eyes to the imagination; our only limitation is the evidence.

For many years my medium was inks and acrylics on cardboard, but for the last 15 years, I have turned mostly to digital media. I find that digital tools allow me much more freedom and realism.

I can paint in extreme detail with real scales, hair and skin, and play with the light at will! I call it my "orchestra." But I still basically start with a pencil drawing, and the digital software I use is the simplest, most primitive application of Photoshop imaginable. I need to be part of the medium and manually control what I do. I never allow the tool (the computer) to take over, not even when I use photographs. The style should always be stronger than the machine, and should direct the computer to where I want it to go, otherwise the personality and the artwork suffer. I think anybody can recognise my artwork instantly, even if they don't always like it. The computer also allows me to create images as big as real dinosaurs.

At this moment in time there are so many paleoartists that the competition is fierce—though I don't feel I'm competing with anyone but myself. I love diversity and I am very serious about keeping abreast of what's happening in the paleoart world, and about always trying to do something different from what others are doing. Sometimes I spend more time thinking about original ideas that will challenge lay viewers and palaeontologists alike, than about the technicalities of the artwork itself. I am on a quest for two goals: accuracy, and surprise for the audience. You haven't succeeded if you don't get your message across.

Tarbosaurus and Talarurus
Background for 3D casts of the two dinosaurs fighting as the culmination of the exhibition DINOSAUR rEVOLUTION. The reconstruction of *Tarbosaurus* is based on a study of the *Tyrannosaurus rex* skeleton at the Denver Museum of Natural History, under the supervision of Dr. Robert Bakker.
Digital mixed media and life size mural

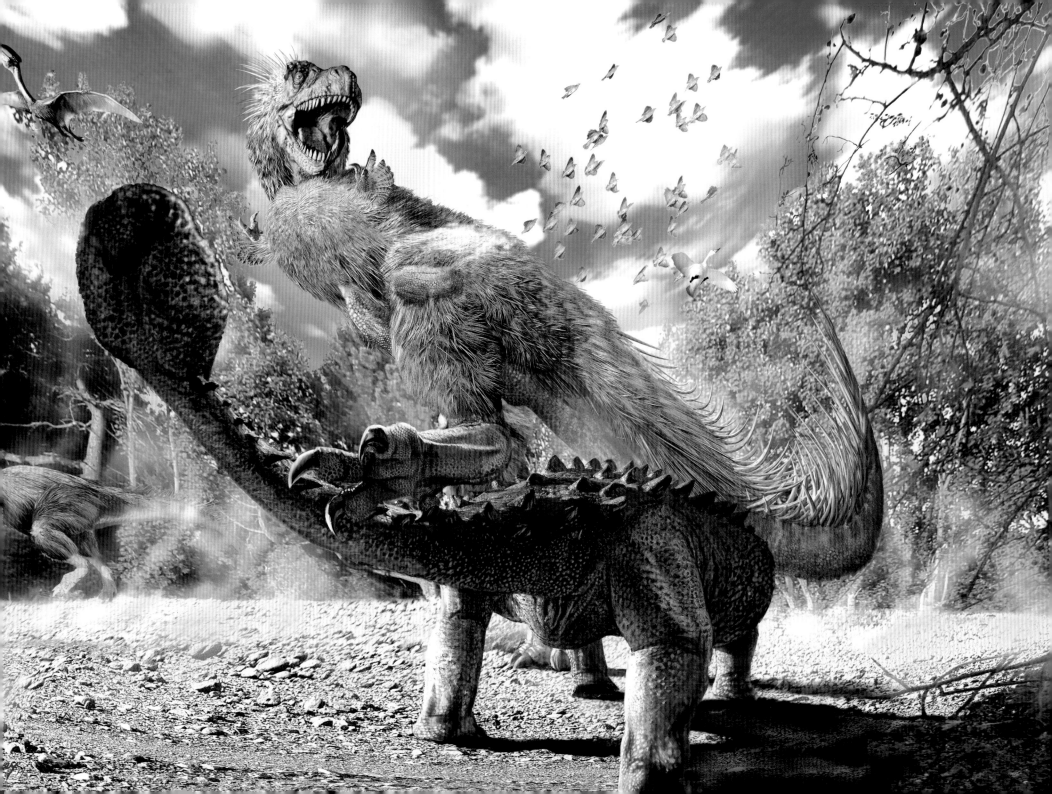

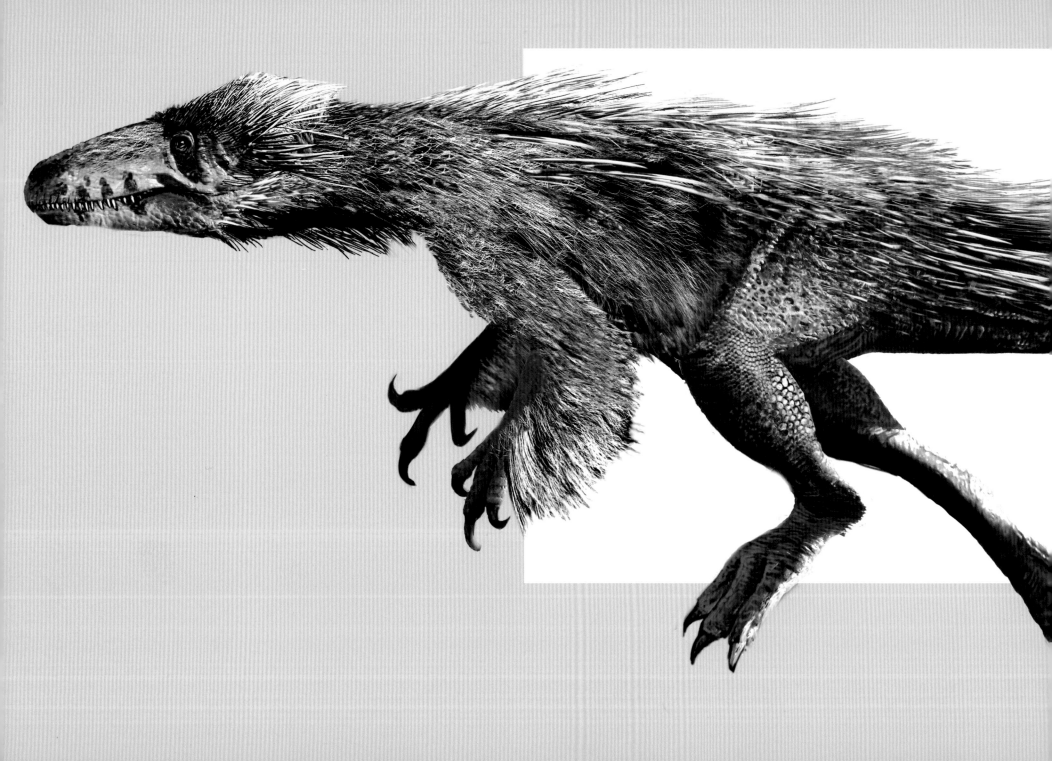

Tanycalogreous
A detail of the *Mexican Dinosaurs* exhibit mural,
"*Huehuecanauhtlus* Attacked by *Tanycalogreous*-like Theropods."
Different branches of the evolution of theropods are now accepted as having been feathered or protofeathered.
This is a member of a hunting pack bringing down the much bigger primitive hadrosaur *Huehuecanauhtlus*.
Digital mixed media

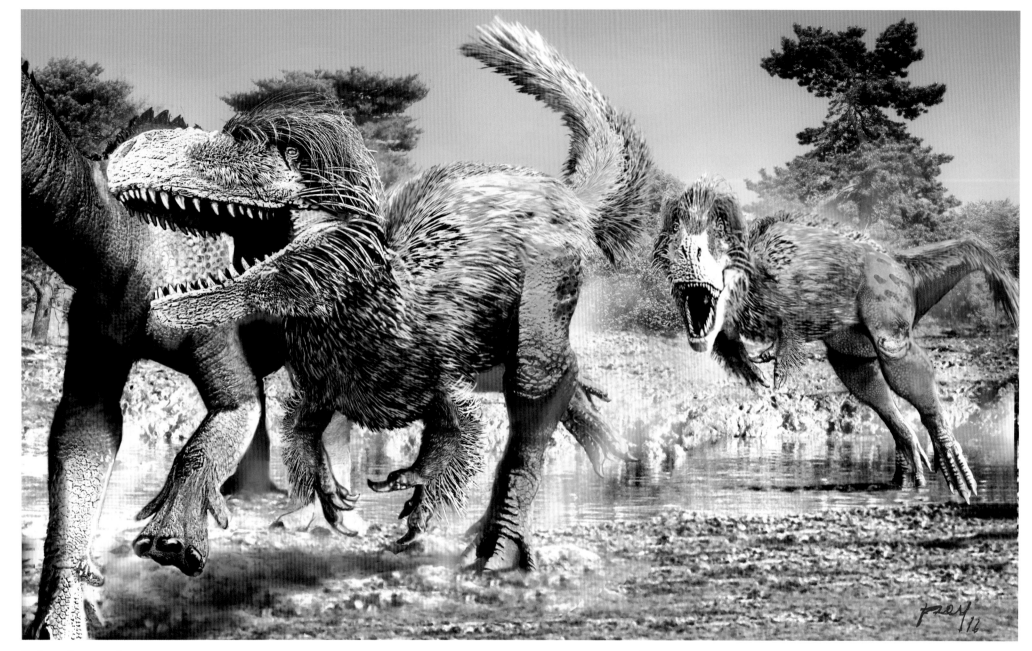

Labocania anomala

A fragmentary primitive Mexican tyrannosaur inspired by the more complete three-fingered, feathered *Yutyrannus*.
Part of a series for the *Mexican Dinosaurs* exhibition. My interest in Mexican dinosaurs was rekindled by
the work of palaeontologists René Hernández and Angel Ramírez. It is known that this was a predator of the primitive
hadrosaurs, but the details are very sketchy, hence the no-show of the head of the hadrosaur.
Digital mixed media

p.15

Magnapaulia and Albertosaurus

A massive lambeosaur from Mexico being attacked by a flock of tyrannosaur *Albertosaurus*.
Part of the series for the *Mexican Dinosaurs* exhibition.
Mexican hadrosaurs had long-spined tails.
Digital mixed media

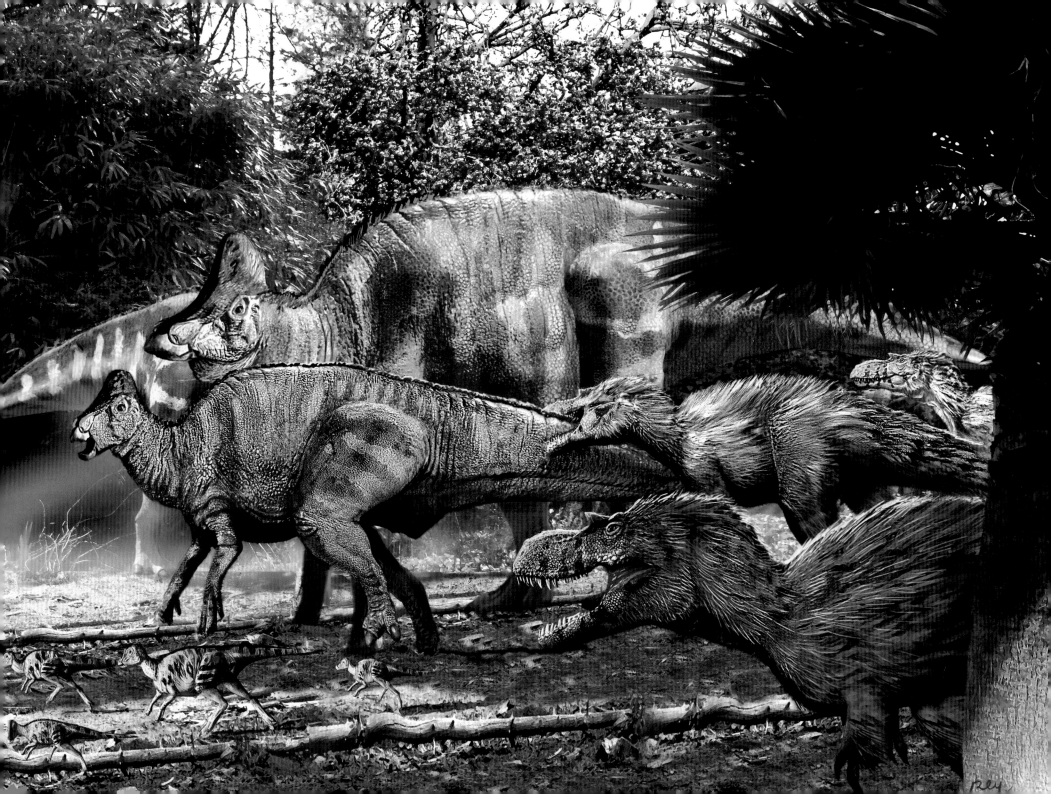

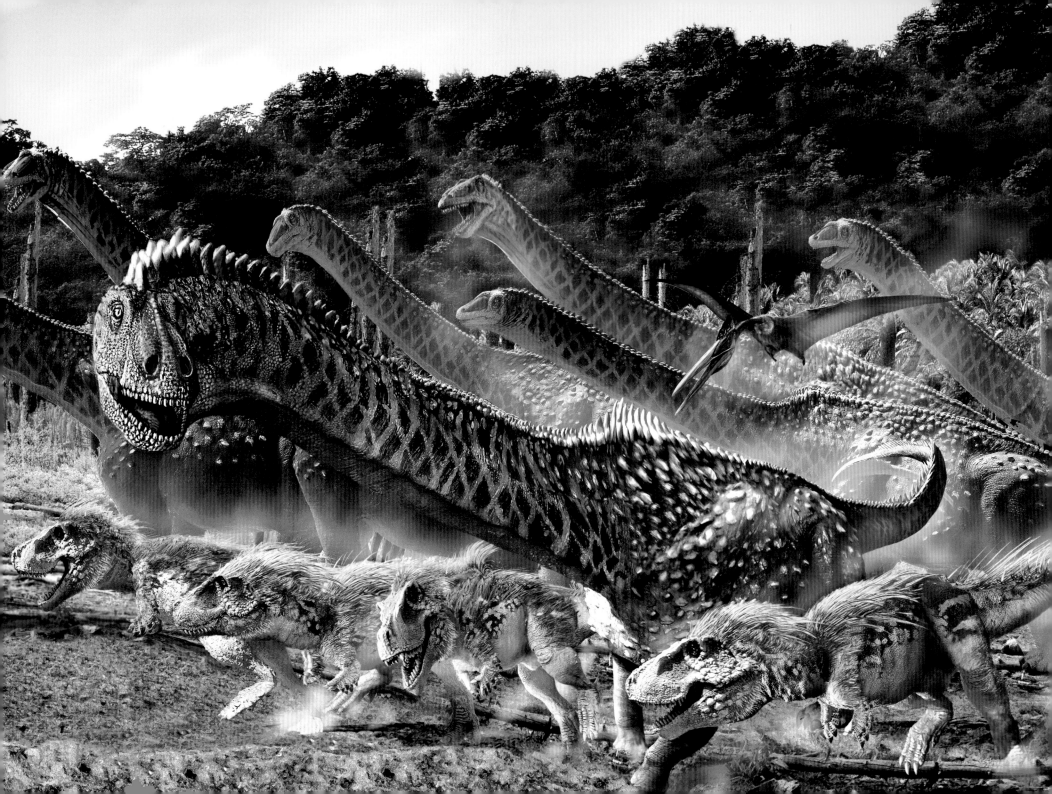

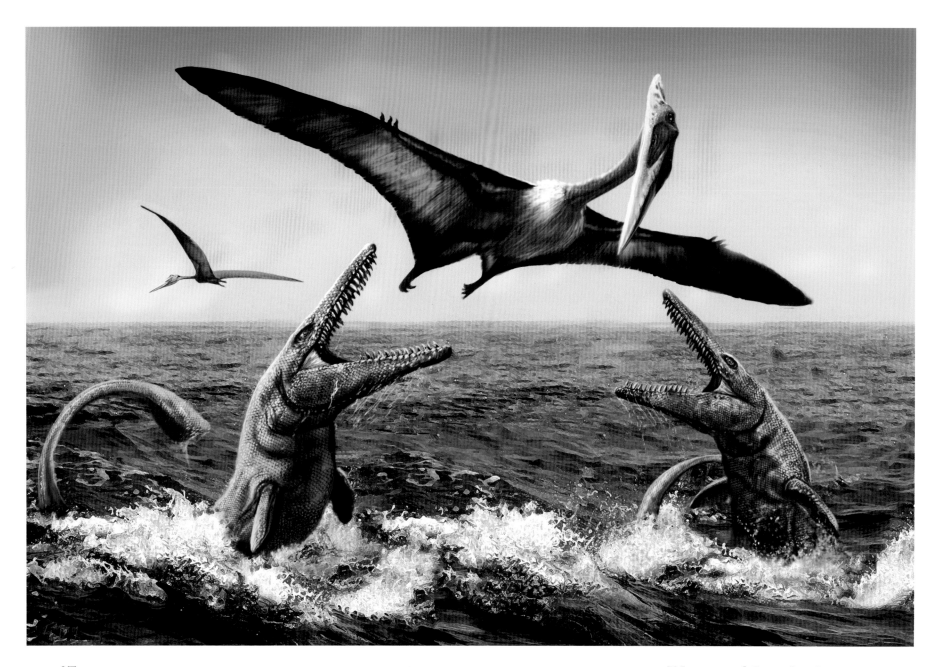

p16

Alamosaurus* and *Tyrannosaurus

I based this digital recreation on pictures of the mounted skeletons in an exhibition at the Perot Museum in Dallas.
The massive titanosaur *Alamosaurus* was one of the last sauropods to roam North America at the end of the Cretaceous.
Tyrannosaurus were relative puny, but they could have hunted the sauropod herds in packs.
Taken from the book, "Super Predator. The world of T. Rex" by Mike Kelly.
Digital mixed media

Tylosaurus* and *Quetzalcoatlus

A modified version of the cover for the Random House children's book,
"Monsters" by Dr. Bob Bakker and Luis V. Rey.
This digital painting technique is completely different from the one
used in previous illustrations.
Digital mixed media

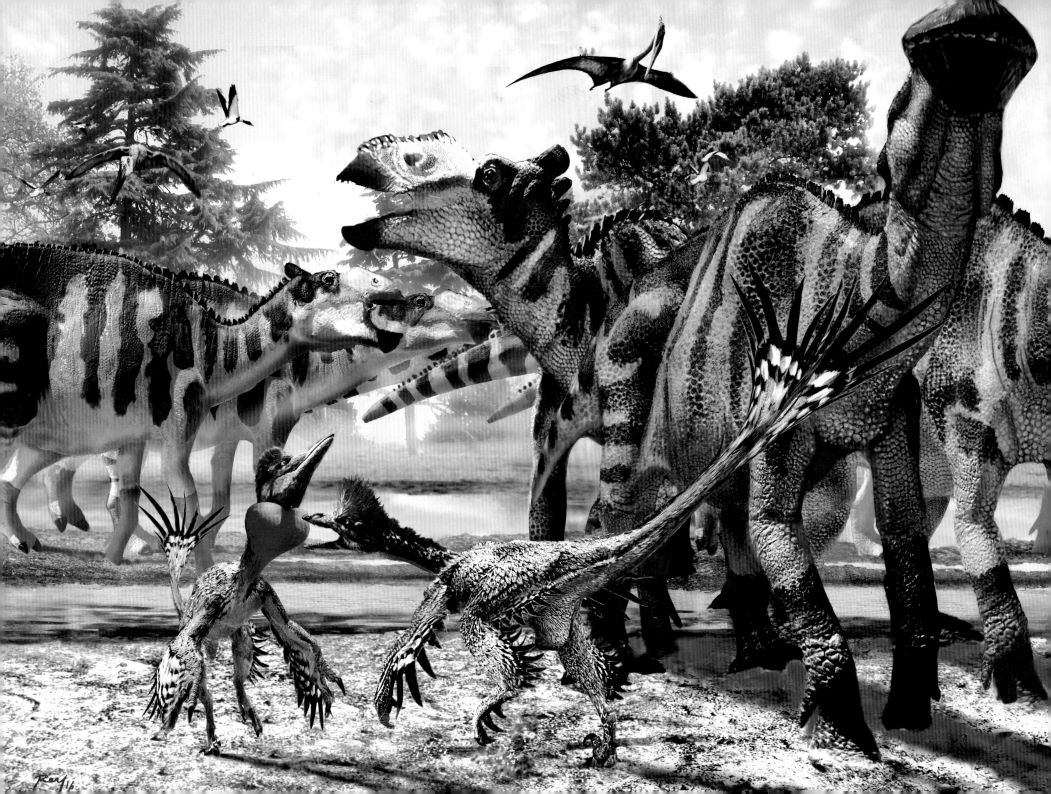

Rey '16

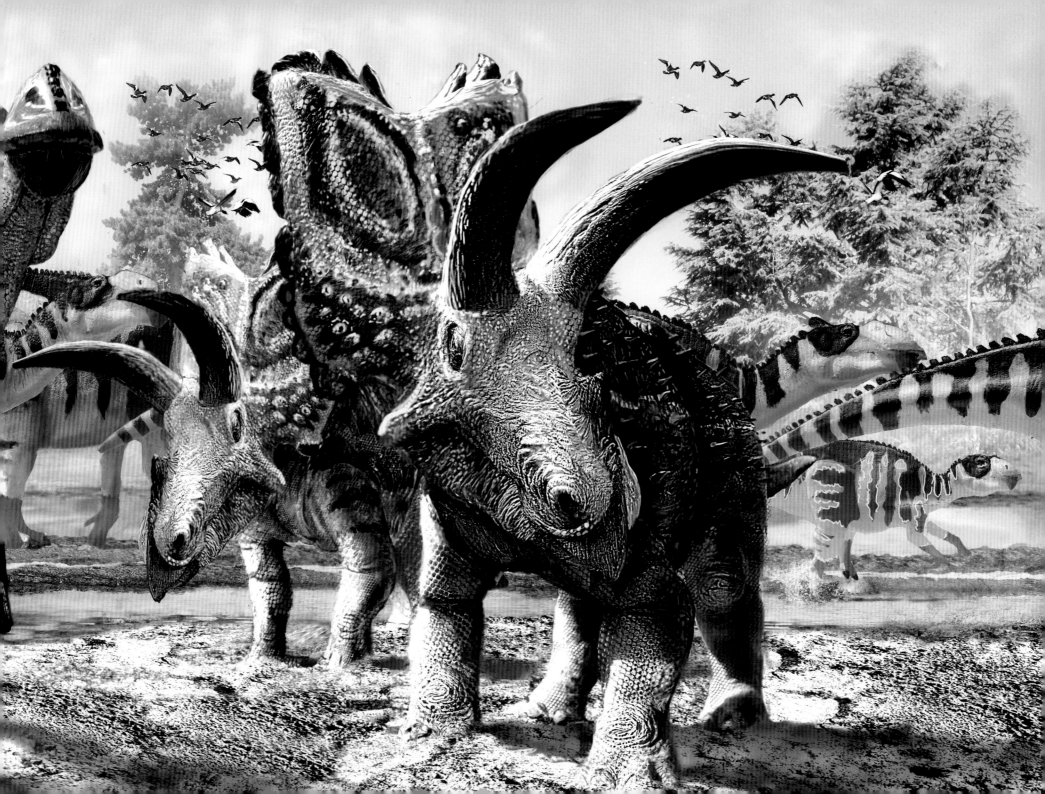

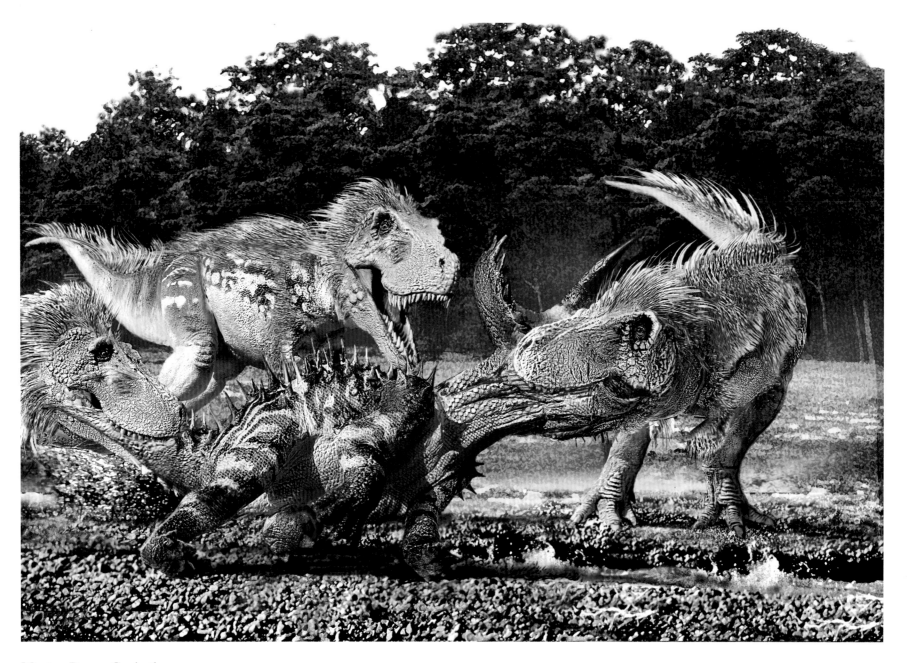

p.18-19

Cretaceous Mexico: Parras, Coahuila

The main protagonists of this landscape are the well known *Coahuilaceratops*, a ceratopsian with enormous horns, and the hadrosaur *Latirhinus (Isauria)*. There are remains that give evidence of *Tröodonts* displaying to each other, like in the picture, but unfortunately they are very fragmentary. *Adzharchids* and birds are flying in the background. Mural for the *Mexican Dinosaurs* exhibition.
Digital mixed media

A Feast. *Tyrannosaurus Rex* and *Triceratops*

This picture is based on the evidence of a fossilised lower jaw of *Triceratops* with marks clearly indicating that a *Tyrannosaurus* tried to pull the head off the carcass.
Digital mixed media

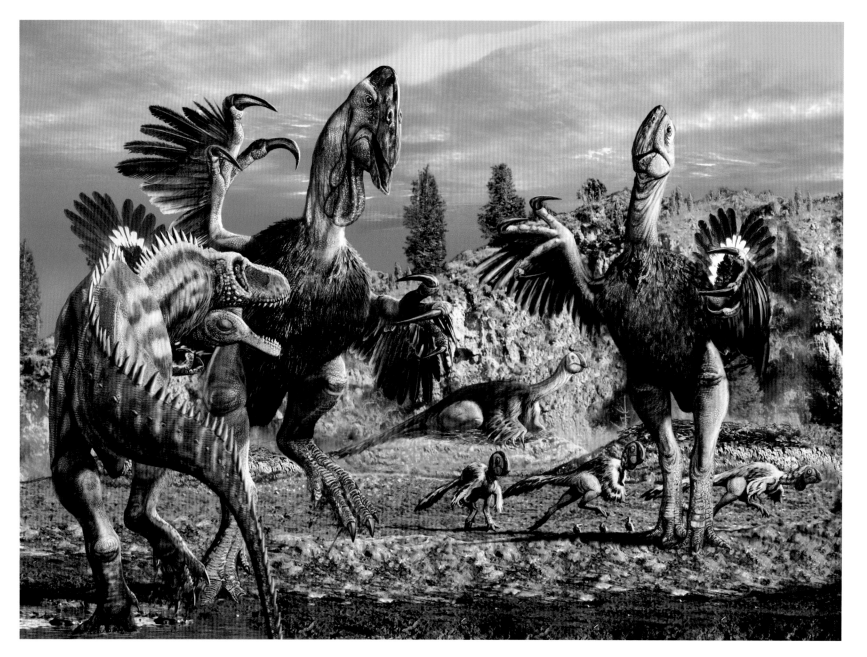

Gigantoraptor and *Alectrosaurus*

I wanted to show interaction between a tyrannosaur and *Gigantoraptor*, a giant oviraptorid, defending its nesting grounds. The only contemporary tyrannosaur was the mid-sized *Alectrosaurus*. *Gigantoraptor* was approximately the size of a *Tyrannosaurua rex*. The picture is in need of refurbishment, since according to contemporary evidence, I would need to feather the *Alectrosaurus* too! On display at all the Stone Co and Gondwana Studios *Hatching the Past* exhibitions worldwide. Winner of the Society of Vertebrate Paleontology Lanzendorf Award 2008.
Digital mixed media

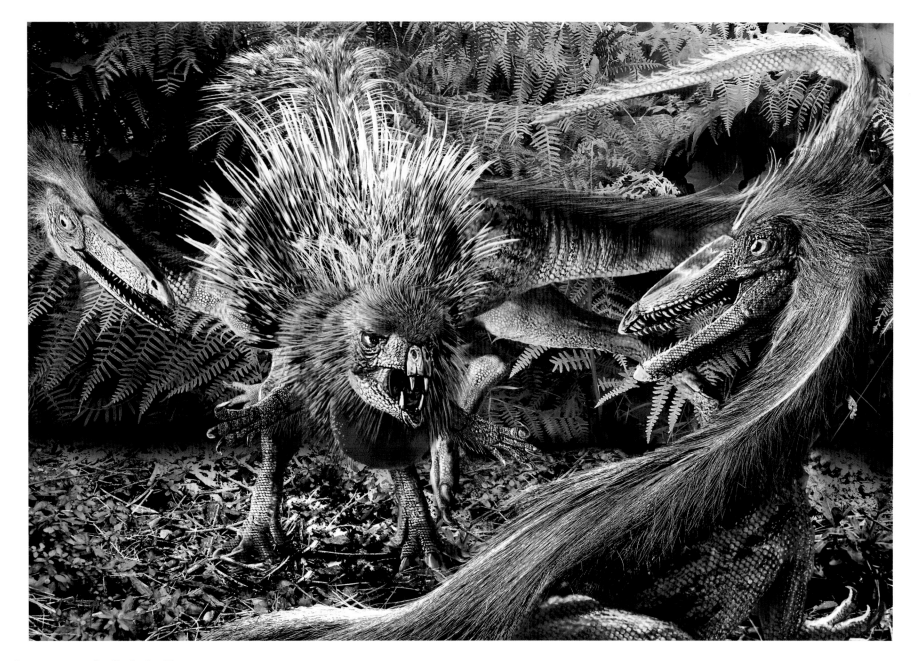

A Heterodontosaurus* and a *Coelophysid
The fossil material in Mexico is very fragmentary but it's indicative of varied fauna. *Heterodontosaurus* and *Coelophysis* lived in the early Jurassic in Mexico.
I have incorporated all the new information we have about primitive ornithischians like *Tianyulong* and *Heterodontosaurus*,
which according to more complete material from China and South Africa were covered with quills like a porcupine.
Here a tiny *Heterodontosaurus* is displaying and defending itself against a couple of primitive coelophysid theropods. From the *Mexican Dinosaurs* exhibition.
Digital mixed media

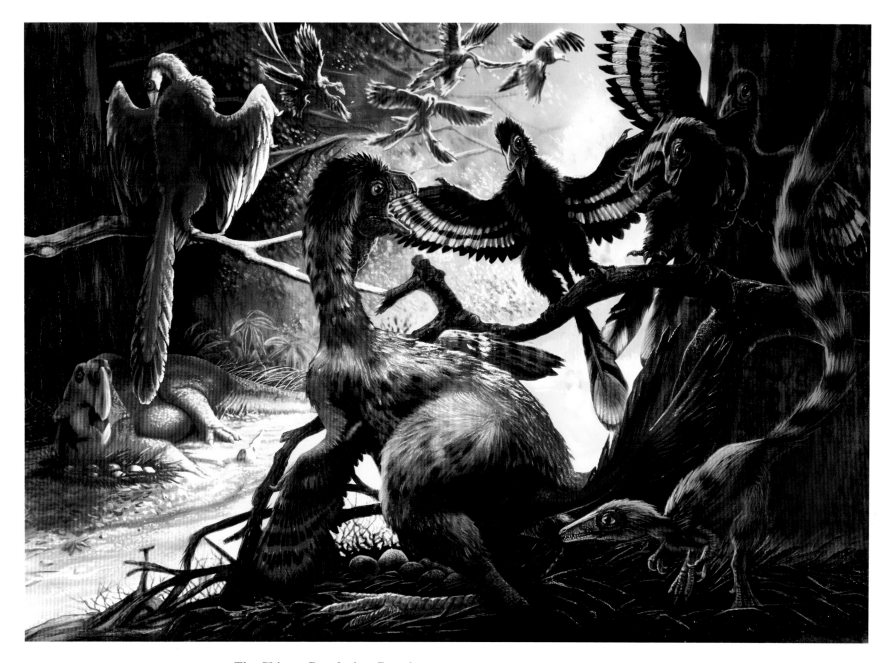

The Chinese Revolution, Part 4

This image illustrates just a few of the enormous variety of animal remains found in China. These finds have shined a light on much of what dinosaurs really looked like. In the foreground on the right, a nesting *Caudipteryx* is being stalked by a *Sinosauropteryx* and harassed by a band of *Jixiangornis*. In the near background on the left a *Psittacosaurus* is resting, and a *Jeholornis* is perching on a branch above. Several Microraptors are gliding in the distance. This is a true mosaic of bird evolution, with an onithischian quilled twist. The color of the *Sinosauropteryx* has been digitally modified from the original to match new evidence.

Acrylics and inks on cardboard

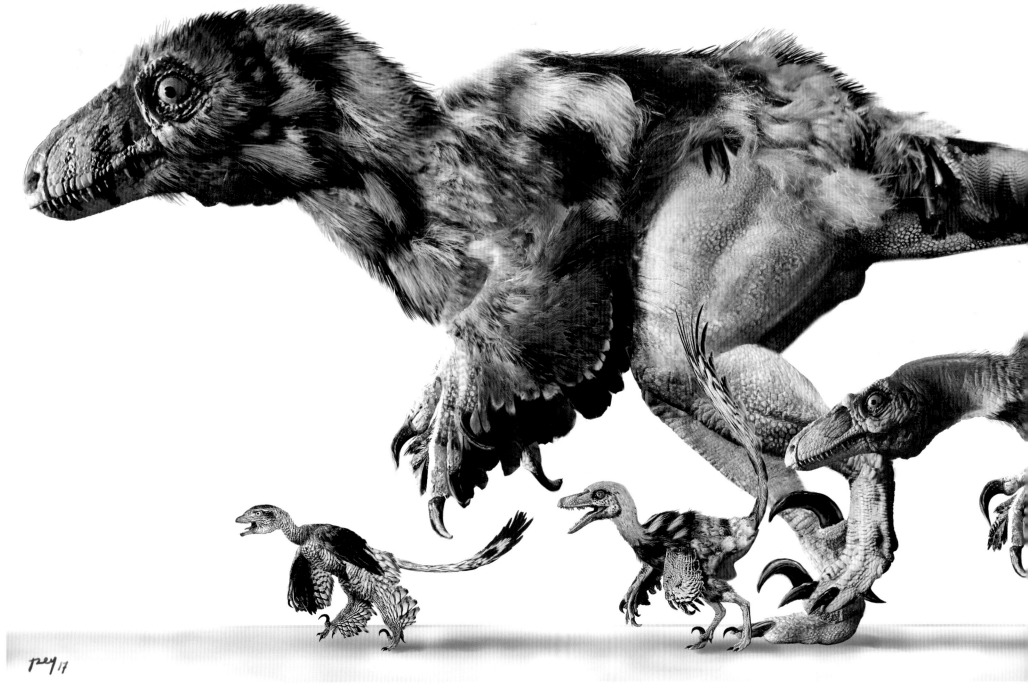

The Maniraptora
Lifesize mural for the *Dinosaurs Take Flight* itinerant exhibition by Silver Plume Exhibitions. I wanted to reflect the multiple sizes and
astounding variety of *Archaeopteryx* maniraptoran relatives. Seen here are *Archaeopteryx* itself and *Confuciusornis, Cathayornis, Ichthyornis, Anchiornis, Tröodon, Velociraptor,*
Deinonychus, Microraptor, Bambiraptor, "Dave" the *Sinornithosaurus* and a seven meter *Utahraptor.*
Digital mixed media

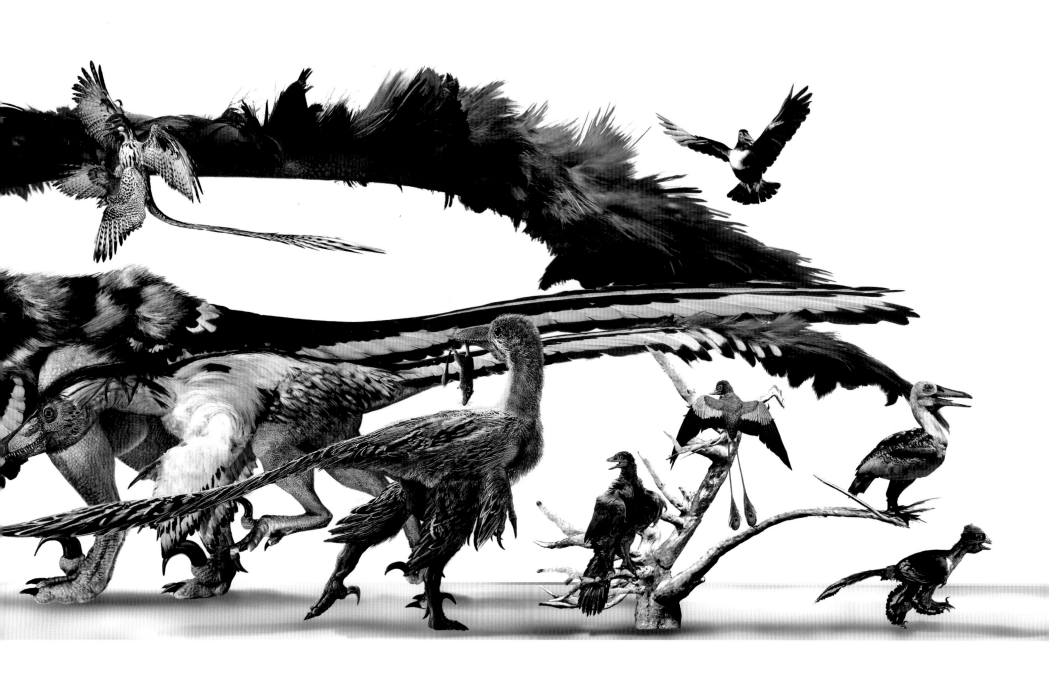

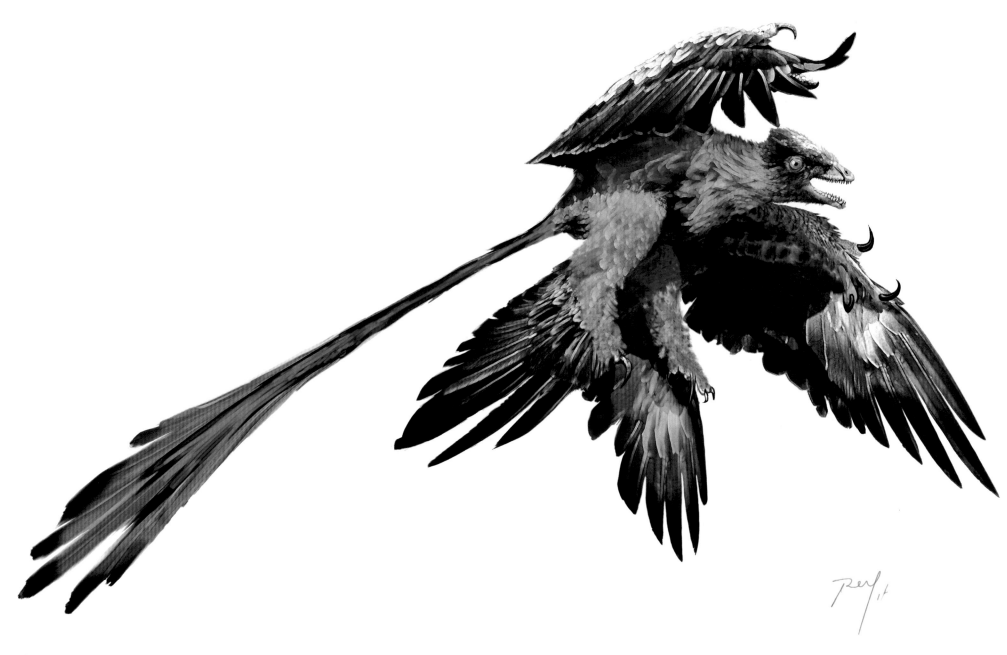

Microraptor
Originally commissioned by my palaeontologist friend Scott Foss as a wedding present,
this digital painting ended up as a tattoo on the shoulder of the bride!
It has the colours preferred by the commissioning party.
I have a new version of this four winged theropod that is iridescent black to match new evidence.
Digital mixed Media

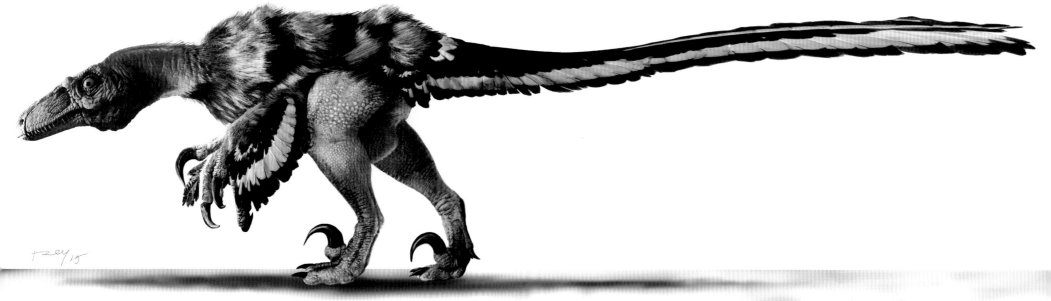

Deinonychus

A detail of the mural *Dinosaurs Take Flight*.
This is a digital recreation of an old painting where I originally depicted *Deinonychus* in unusual, bald vulture regalia.
I tend to use the same external appearance in my dinosaur species to keep them recognisable.
Digital mixed media

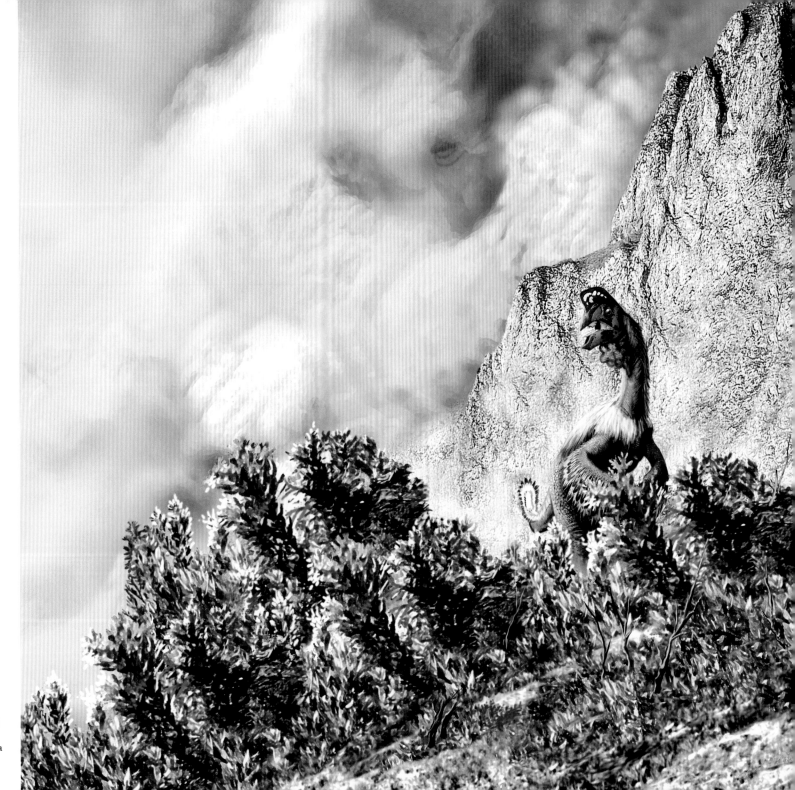

Citipati Nesting Ggrounds
A composite of two original cardboard paintings
of *Citipati* contemplating a sandstorm, for a mural
that would overlook a children's play area in the
American version of Stone Co's *Hatching the Past*
exhibition. They created matching custom made
Citipati disguises to be worn by the chidren at play,
simulating oviraptorids nesting.
Acrylics and inks on cardboard/digital mixed media

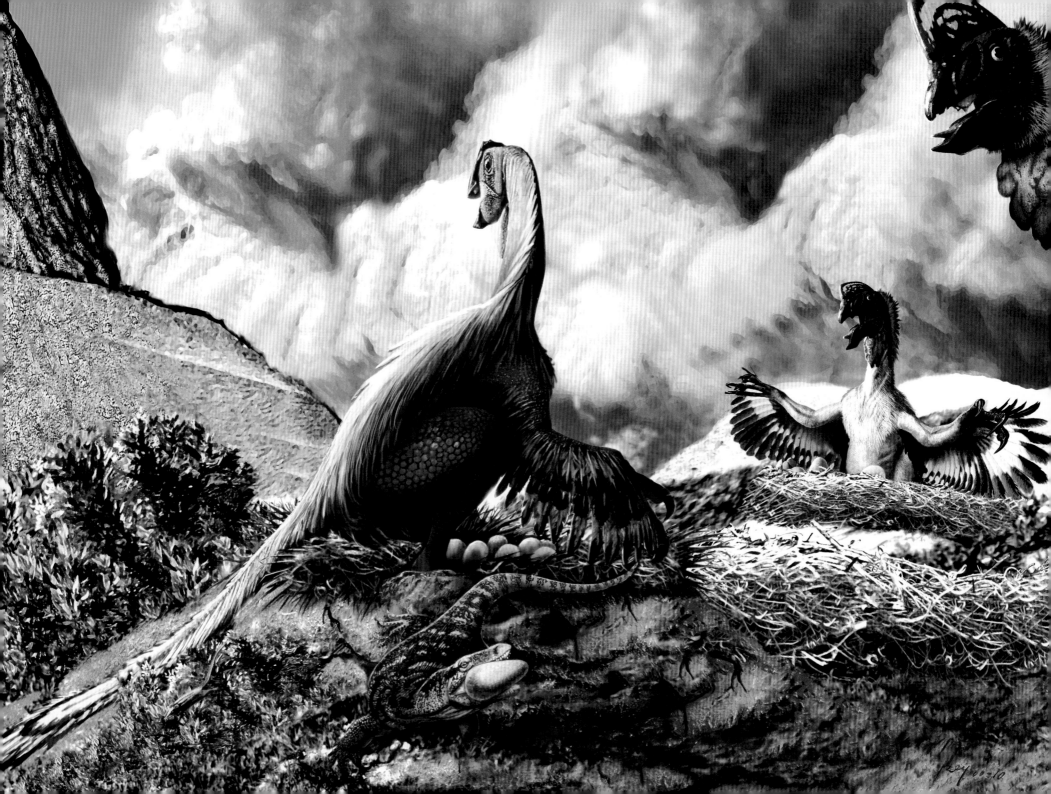

Zhao Chuang

Zhao Chuang is a Chinese science artist and co-founder of PNSO, a world-class scientific art research institution. Since 2006, Zhao Chuang's artworks have been published in prominent academic publications such as *Nature*, *Science* and *Cell*. He collaborates with dozens of leading scientists from research institutions including the American Museum of Natural History, the University of Chicago, the Chinese Academy of Sciences, the Chinese Academy of Geological Sciences and Beijing Natural History Museum, working in their paleontology research projects and providing artistic support for their fossil restoration works.

I remember when I was a child I was fascinated by the wild animals in TV nature documentaries. My initial exposure to dinosaurs, at about the same age, was through a variety of television programs such as *Dinosaur Express Kesai*, a Japanese drama that was a big hit in China. Those shows gave me a very superficial concept of dinosaurs, and as a child I was somewhat frightened. I imagined that the dinosaurs in film and television were fictional monsters. Then when I started reading popular science books I realized that dinosaurs actually existed, and that they were not monsters. The first dinosaur I heard of was *Tyrannosaurus*; then I learned about *Triceratops*, *Stegosaurus*, *Pachycephalosaurus* and *Psittacosaurus*. I came to realize that there were a great many different kinds of things in the prehistoric world, and that their appearance was beyond our imagination.

I was still quite young when I began painting marine animals, especially huge cetaceans. Then I drew all the marine animals I knew of on one long scroll. Not long after that, I began paleontology drawing. I didn't have much access to dinosaur books, so I got the idea of collecting information about dinosaurs, drawing them, and making a picture book. This became my hobby for the rest of my childhood. When I was in high school my dinosaur obsession gradually faded, but I never lost that interest completely. From time to time I use to draw dinosaurs for fun. Later, when I was in college, I came into contact with the Internet and I was able to gather a lot of information about dinosaurs;

that rekindled my enthusiasm about those ancient creatures, and I began to create a lot of paleontology works based on that new information.

Things changed dramatically when I was a sophomore: I had a chance to meet some paleontologists in Beijing. They invited me to draw some specimens of the ancient animal *Volaticotherium antiquus*. Eventually my work began to appear on the covers of *nature* magazines. That gave me great confidence and when soon after that I got the opportunity to work with other scholars, I decided to dedicate my life to paleontological restoration. Dinosaurs are the world's most gorgeous group of creatures, a super-species whose appearance is beyond our imagination. We never know what the next dinosaur discovery will look like. Different dinosaurs attract me from different angles. Some species have a very exaggerated appearance, a rather artistic effect. For example, the angles of the various features of Ceratopsia look like a line of Chinese calligraphy, reminiscent of running water.

I like to try to depict the animal's inner thoughts and spiritual qualities. Some large stocky carnivorous dinosaurs such as *Tyrannosaurus* or *Yangchuanosaurus* look dynamic, with the temperament of boxers. Some small dinosaurs such as *Velociraptor*, *Microraptor* and *Zhenyuanlong* look clever. Their behavior might be more complex, as if they were interested in things around them, or they might have a sneaky aspect, like a cat who is hiding from a child. Some might

fight like puppies, very lively and noisy, and others might be more like serious students, sitting very quietly, thinking deeply. The large sauropod dinosaurs are undoubtedly the most spectacular animals that ever lived on earth. They are the seniors of the prehistoric era, and their huge bodies give them great confidence. They were relaxed and walked across the the plains without thinking anything much at all. They had a hundred times the volume of an elephant, and a hundred times more regal aspect.

Paleontological restoration is different from writing academic papers. Academic papers report precisely, on the basis of clear evidence, but restoration calls for complete detail, including things that fossil material cannot tell us, such as eye color, pupil shape, and whether the teeth were hidden or exposed when the mouth was closed. As a result I have to collect as much relevant literature as possible, and then try to make accurate judgments. The most noticeable points of animal bodies are color and pattern, but for most dinosaurs we have no direct evidence about color and pattern. I need to speculate on the basis of what we know about the animals who live in a similar environment today. For example, to imagine small dinosaurs we need to observe existing birds and reptiles, particularly their rich colors and skin patterns. But dinosaurs were completely different animals, so we can't just draw them like contemporary animals. It is important to keep a delicate balance between free imagination and the established features of animals.

Zhenyuanlong
The climate has changed dramatically, the trees grow exuberantly, everywhere is green, and it seems as if even the sky far above is a green reflection. A 2-meter-long *Zhenyuanlong* runs through the forest in the dazzling sunshine. It has long tails, short arms covered with soft feathers, and large wings. It looks as if it's about to fly away, although it can't.
Digital painting

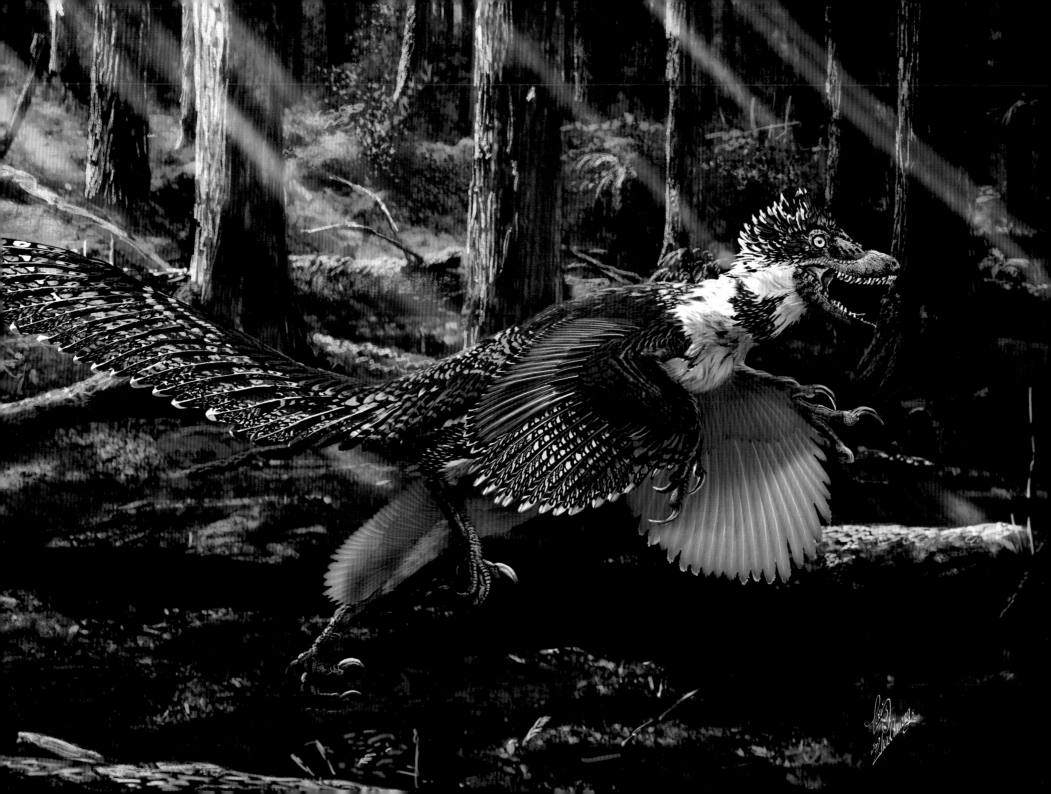

I think of the Mesozoic era as the period when the forces of nature and the forces of life were wrestling in an unyielding frenzy. In the late Triassic and Jurassic, vegetation was exuberant and uncontrolled, and forests covered more of the earth's surface than today. It was a chaotic scene: at the edge of the forest, large trees fell and piled up for millions of years, and the giant dinosaurs ate the small plants that were nourished by the decaying fallen trees. The colors of the landscape included various soil colors and the green of vegetation. Perhaps most of the dinosaurs in that period had some green coloration. In the Cretaceous Period, after the emergence of flowering plants, the forest color scheme was suddenly much richer, and the dinosaurs of this period were probably the most beautiful creatures of all time, since they had better vision and more color perception than today's mammals.

Drawings for academic papers are mostly digital paintings, since the digital medium is much more efficient and accurate, and it's easy to adjust images during discussion with the scholars. Paleontological restoration generally requires the most accurate representation possible of the fossil bone structure and proportions of the body, so I usually start by drawing from a skeleton. In that process I photograph or scan the fossil specimens, and then I use image processing software to move the bones around to create a standing posture. To compensate for missing fossil parts, I try to find the bones of a close relative of the dinosaur so that I can make approximations. I work from my completed sketch of the skeleton to create a sense of action and to decide the composition of the image. Then I add muscle and skin as effectively as possible.

For other works such as postage stamps and museum murals, I like traditional forms such as oil painting and watercolor, which require calm expression, since the animal's shape has already been determined.

Sinosauropteryx

140 million years ago, in what today is Liaoning, China, two male *Sinosauropteryx* are in dispute over a female. They have been standing there for a long time, and their beautiful feathers are misted by the early morning fog. Although the scene appears tranquil, the atmosphere is murderous. Both males are trying to keep calm. Each takes on a carefree expression to confuse his opponent, but regardless of the expression, the body speaks. The legs are stiffened, the head is raised, the red skin below the arms is on display. The tail is held high to display its bright white rings. The body feathers are raised for an impression of unhesitating aggressiveness.
Sketch and digital coloring

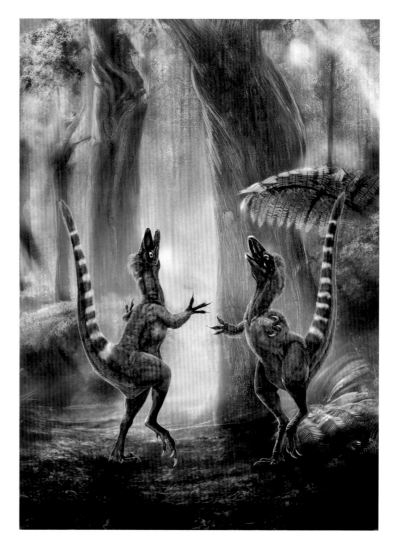

Sinocalliopteryx

124 million years ago, in what has become Liaoning, China, a *Sinocalliopteryx* is standing quietly at the water's edge. One foot is raised as if he wants to step towards the water. The water must look pleasant to him, flowing smoothly like silk. It is difficult not to be attracted by the elegance of *Sinocalliopteryx*. Those who see him rushing towards them must think that they have met a beautiful princess. That is what he wants his prey to think. *Sinocalliopteryx* is the largest member of the small *Compsognathus* family but he is not as well-tempered as the others: he's hungry and on the lookout for prey.
Digital painting

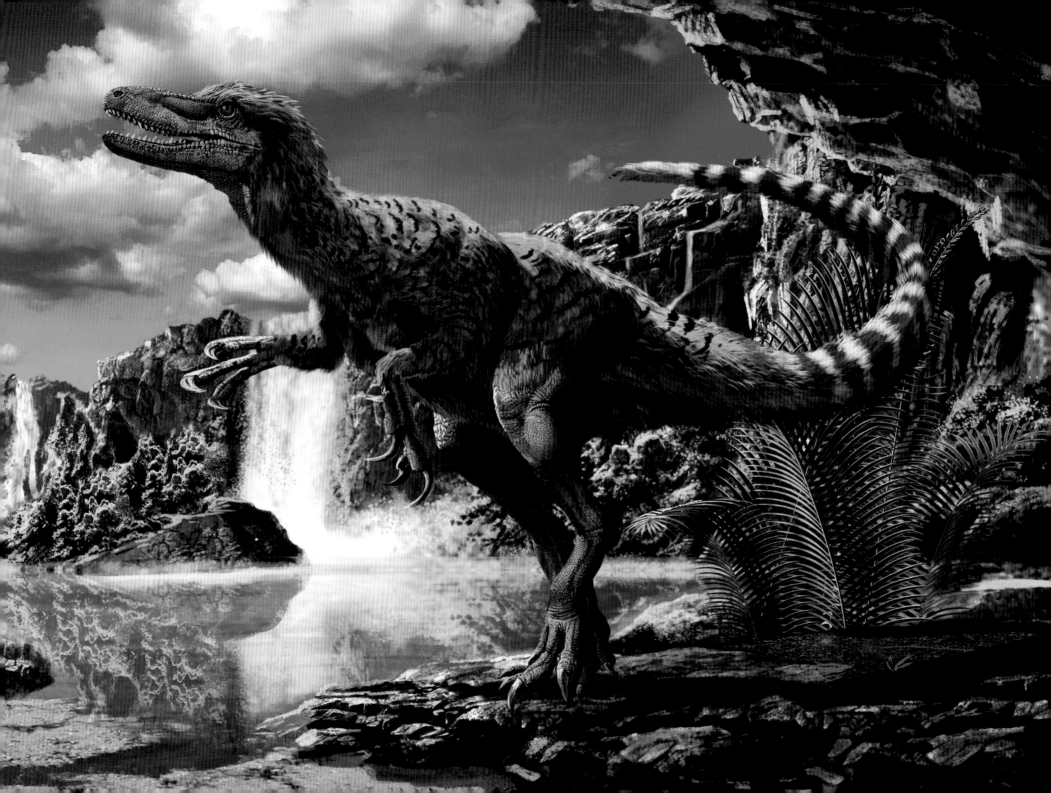

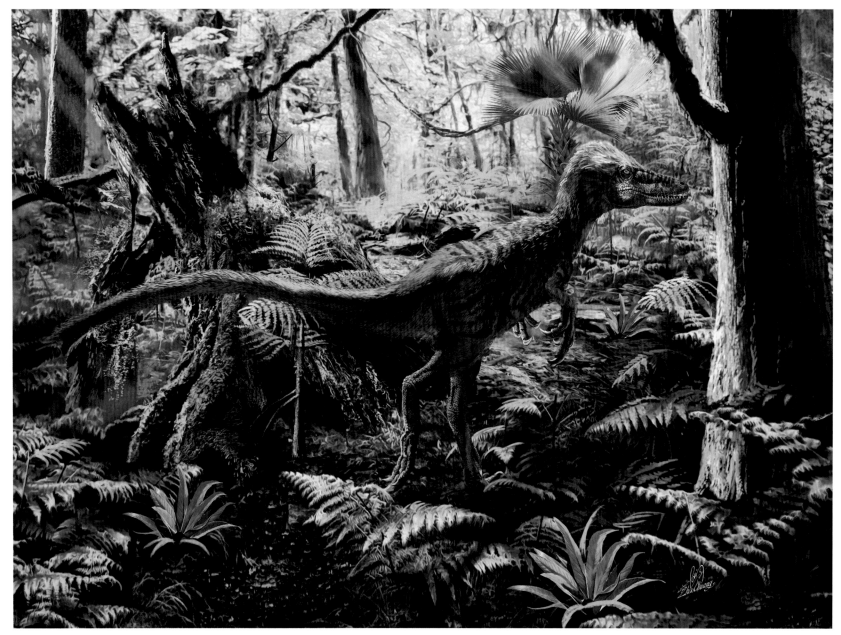

Huaxiagnathus

122 million years ago, in what today is Liaoning, China, a *Huaxiagnathus* is walking along a narrow path in the mountains. His feet, cut by the rocks, look very painful. He is not walking in the mountains to enjoy the scenery. Rather, he's looking around for suitable prey. If you think it looks impossible to find prey in such barren hills, you are quite wrong! Most predators think like you, and they never come to the mountains, so this is a sanctuary for herbivorous dinosaurs. The clever *Huaxiagnathus* discovered this secret place and comes here regularly to seek his prey.

Digital painting

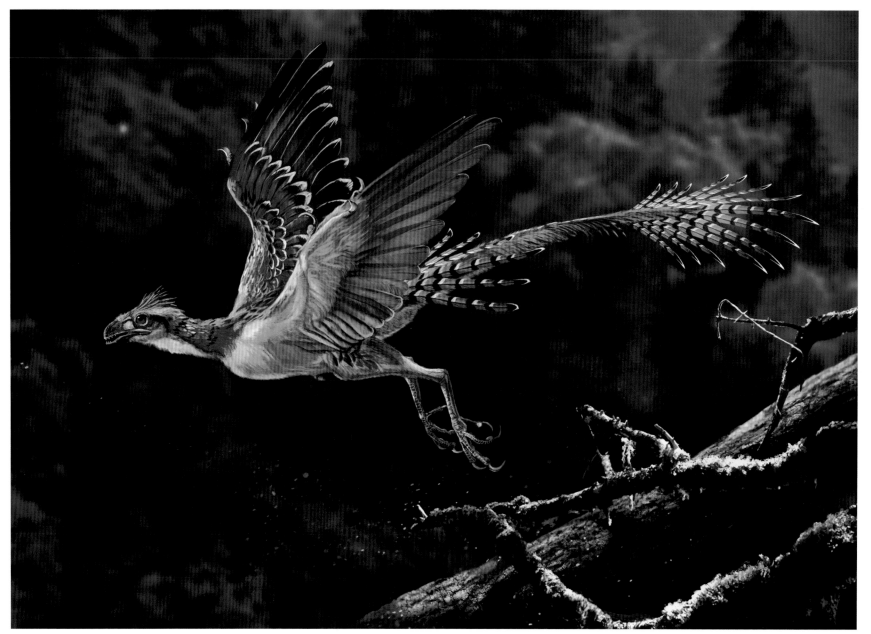

Jeholornis

125 million years ago, in is now China's Hebei Province, *Jeholornis* is glowing in the brilliant sunlight as he takes off from a tree trunk, displaying his beautiful wings and long tail. How lovely: every feather is moving as if a gentle wind were blowing. Although *Jeholornis* looks like a dinosaur, it can fly. And although it's primitive, it's a member of the world of birds, and it longs to fly high in the sky. *Jeholornis* is not a hunter: early in the morning it eats seeds and drinks dewdrops to fill its stomach. It does not want to waste the good weather so it flies off to practice flying and learn more about the sky.
Digital painting

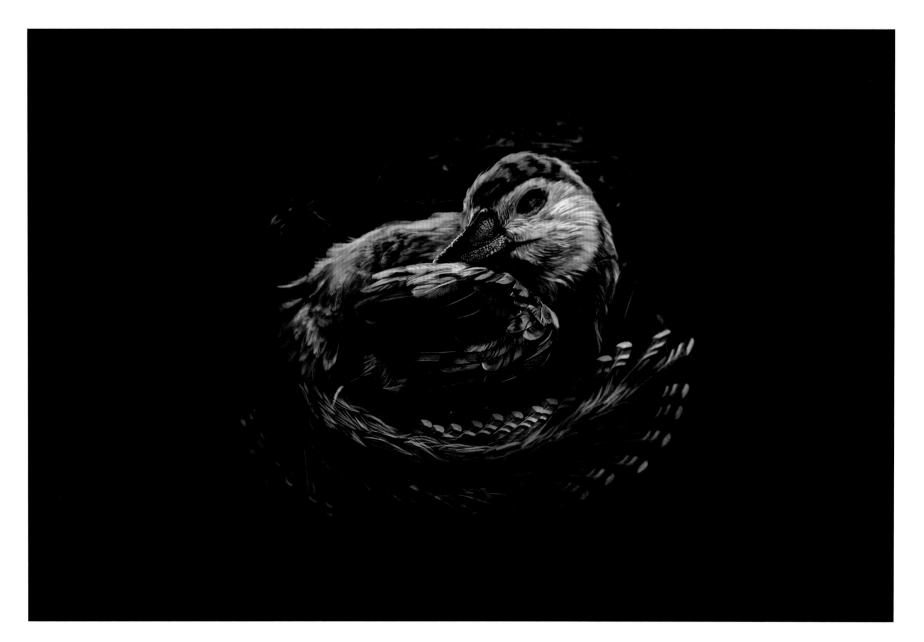

Mei

140 million years ago, in what was to become China's Liaoning Province. Noble, elegant *Mei* is quietly asleep in the dark of night. Its breathing flutters the tree leaves. Its sleeping position is exquisitely attractive, even to the moon. *Mei* is bathed in moonlight, and the feathers of its delicate body glow golden, lighting up the dark night!

Digital painting

p.39

Yi

Living 160 million years ago, *Yi* was a most unusual member of the dinosaur family. It had a completely different flying structure from that of all the other dinosaurs who dreamt of flying. It had wing membranes much like those of modern bats and flying squirrels. It seems that the dinosaurs who were trying to fly were more diverse and more ambitious than we imagined. Perhaps *Yi* had the courage to succeed. Now let's watch this pair of sweet *Yi* gliding in the forest!

Digital painting

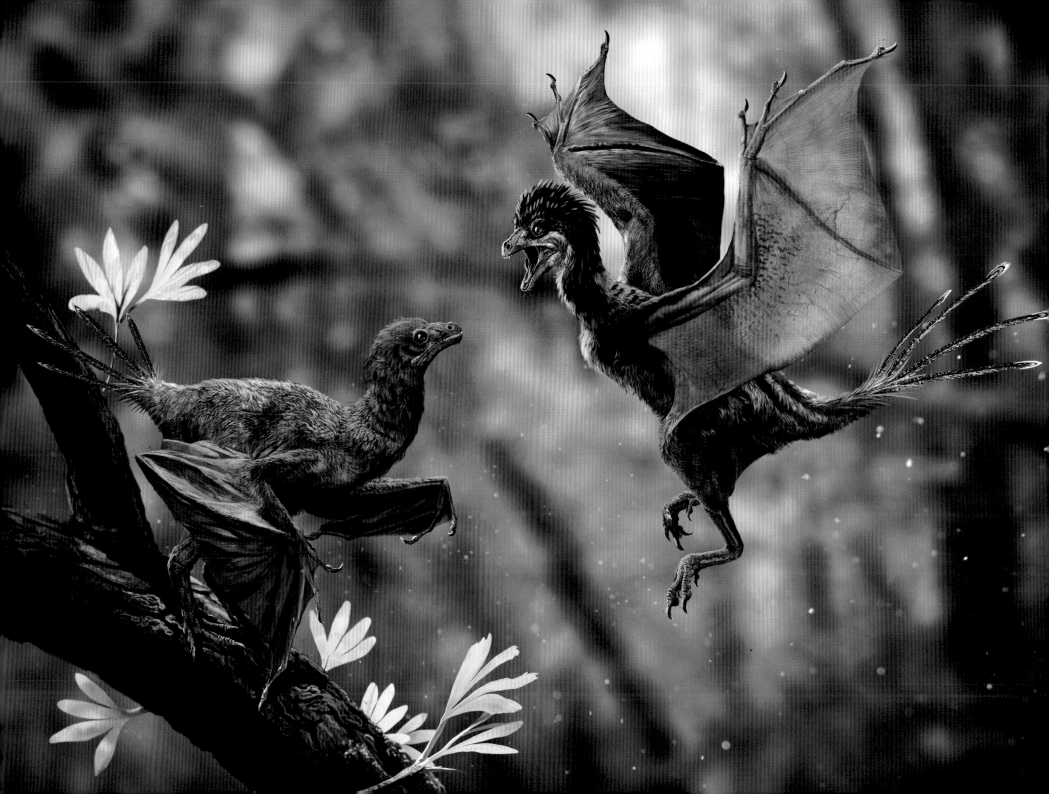

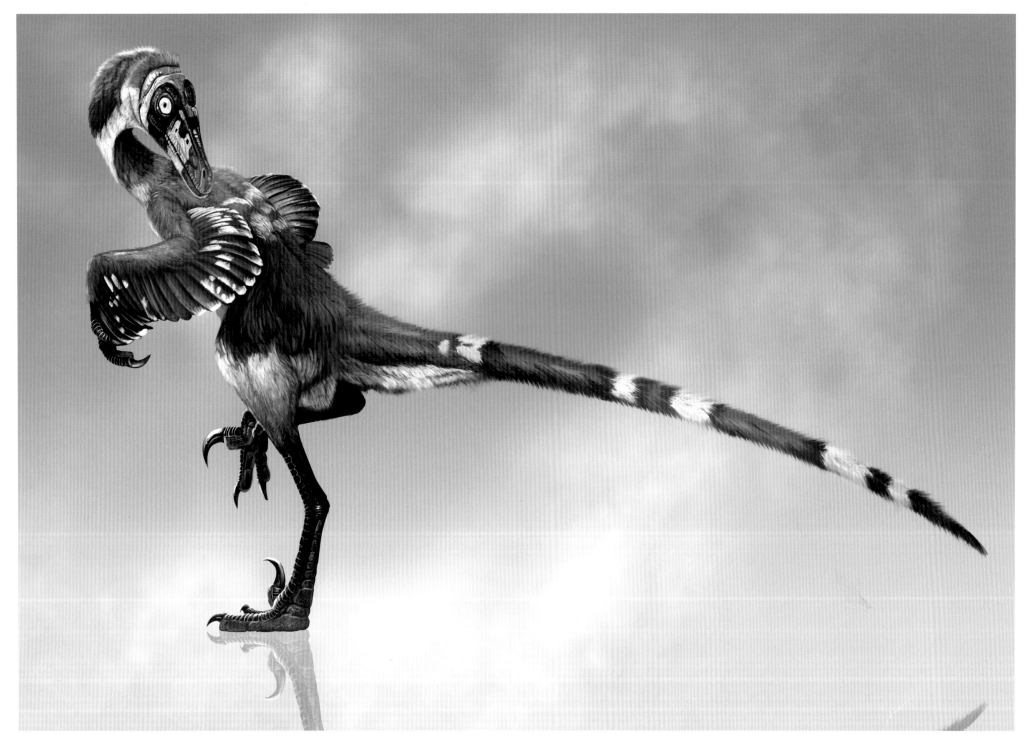

p.40
Unenlagia

90 million years ago, in what today is South America. The weather is extremely hot. The steamy humid air rolls over the lake and strikes the *Unenlagia*. With beautiful feathers covering its slim body, *Unenlagia* is quite uncomfortable. It is worried that this despicable weather will affect its beauty. *Unenlagia* shakes itself angrily, reaches back with its beak and scratches its body. It really hopes that a burst of cool breeze will blow away the heat.

Digital painting

Pursuit

125 million years ago, in what will become China's Liaoning Province. The weak morning sun shines straight into the cave. *Psittacosaurus* awakes, stretches, and leaves the cave to hunt for food. *Psittacosaurus* soon finds something to eat and is so intent on eating it that it does not notice the *Sinornithosaurus* swooping down from the sky. The moment *Sinornithosaurus'* claws pierce its back, *Psittacosaurus* feels unbearable pain. *Psittacosaurus* wants to fight back, but the attack is relentless. *Sinornithosaurus* jumps again and again, striking *Psittacosaurus* repeatedly in the abdomen with its sharp claws. *Psittacosaurus* screams but it is too late to resist.

Digital painting

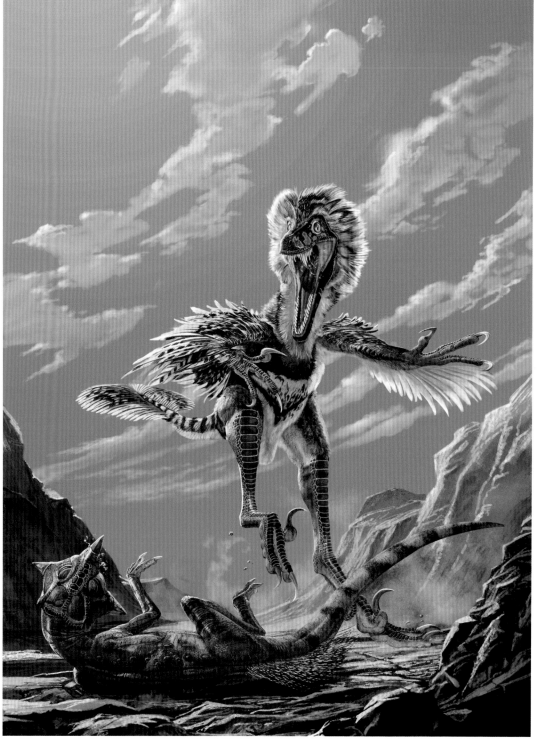

10 厘米

Microraptor

The earth is shrouded in mist. Something blackish blue is moving in the dense forest. Most of the animals are deep asleep, surrounded by silence. An early rising little lizard is lying on a tree branch. Its big eyes keep turning but they see nothing but green trees, nothing else at all. Suddenly a *Microraptor* stretches his four wings and glides silently down from the high canopy, like a falling leaf. He strikes, and shatters the early morning tranquility.

Sketch and digital coloring

p.44

Fighting Dinosaurs

Hot weather, the sun strikes from overhead, every animal is lazy. But there: a *Protoceratops* is looking for food. Its short limbs do not give it the speed it would like, but it does not seem to care. It is looking around in the blazing sunshine, hoping to find some fresh plants to eat. Then things take a different turn. *Protoceratops* is spotted by a hard-working *Velociraptor*. Sometimes life is so cruel. There are always strong animals who spare no effort to capture their prey. The battle is soon over: *Velociraptor* kills *Protoceratops* with its sharp teeth. The dust stirred up and floating in the air is the only evidence of *Velociraptor*'s unparalleled combat capability.

Digital painting

Velociraptor

When night comes, the world falls silent. *Velociraptor* stands alone on a rock by the shore. His loneliness is vast and endless. Living 83 million years ago, in what today is Mongolia, this *Velociraptor* has never seen his father and mother. When he opened his eyes for the first time, he was alone. He does not know why his parents abandoned him, but now he does not think about such things. For many years he tried to find his parents, hoping for their warm embrace. He talked to the moon and the sea about his heartfelt dream, about his wish that the next day when the sun rose he would hear his mother's gentle call.

Sketch and digital coloring

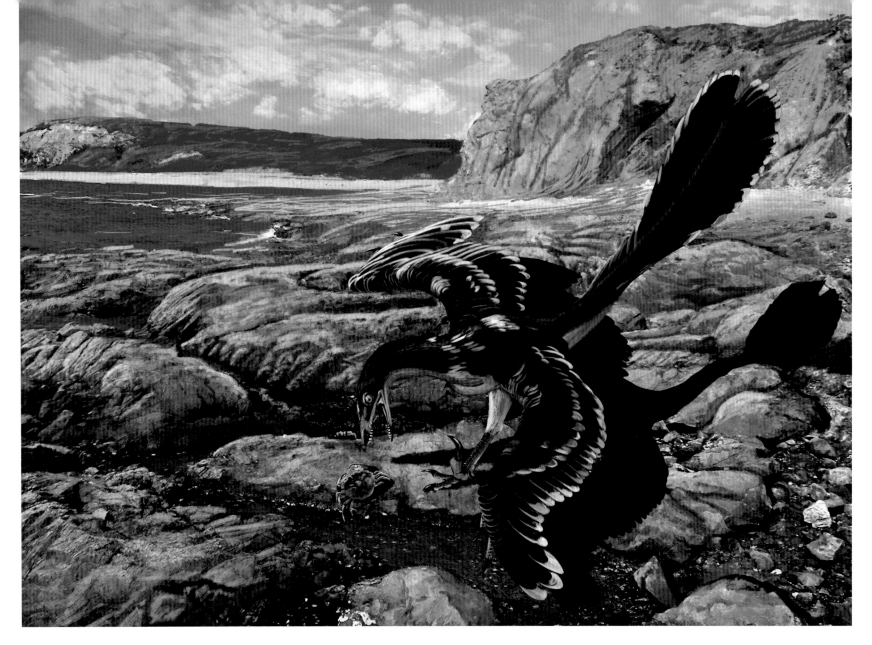

Rahonavis

The huge waves pound on the rocks along the shore, breaking the quiet of the night. At dawn the sun shines on the sea and the whole world is bathed in golden light. A pair of dark brown wings slash the golden sky. These are the feathered wings of *Rahonavis*, a flying dinosaur. Perhaps it is too early to be out; the whole world is so quiet. *Rahonavis* flies a few loops in the lonely sky and then gently descends to the beach in what will become northwest Madagascar.

Digital painting

p.47

660 Million Years Ago in the Forest of Jiangxi

Qianzhousaurus lives in the forest, hiding from his prey in the dense foliage. However, even if there were no greenery, *Qianzhousaurus* would not be easily spotted by his prey. Unlike *Zhuchengtyrannus*, with their short wide faces, *Qianzhousaurus* have narrow heads and agile bodies, making it easy to hide themselves. Imagine the scene: a *Nankangia*, from the oviraptorosaurus family of dinosaurs, is separated from his companions. Fear seizes him, and he wants to find his companions as soon as possible and get away from this dangerous place. But suddenly the danger is real and immediate: *Qianzhousaurus* has appeared right in front of him. By the time he notices, there is no chance of escape.

Digital painting

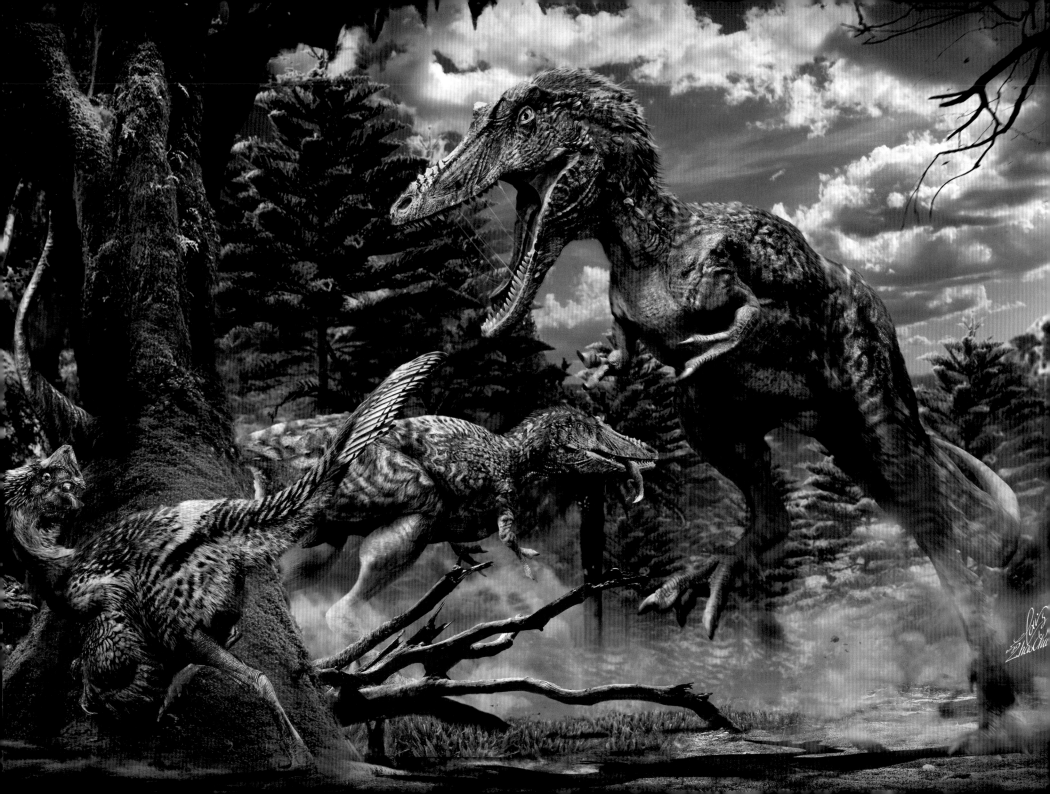

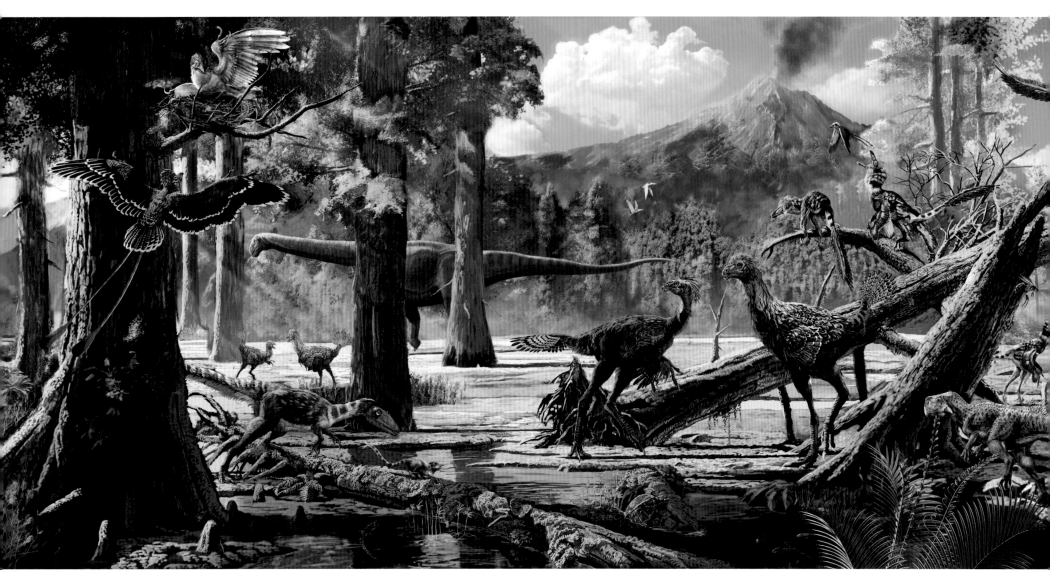

Jehol Biota

125 million years ago, in what will become Liaoning, China. The forest is lush, thick with cedar and bald cypress towering into the clouds. In western Liaoning, the first flowers on earth, *Archaefructus liaoningensis* and *Archaefructus sinensis*, are quietly blooming. In the treetops we can see the magnificent *Confuciusornis* and *Liaoningornithidae* nesting. Beside a small bush, a *Sinosauropteryx* is stalking a *Zhangheotherium*, a mouse-like mammal. A feathered *Caudipteryx* is courting a female on the open ground by the lake shore, shaking his beautiful feathers. We can see a *Sinornithosaurus* running in the distance, waving his forelimb and

seemingly about to leap up and grab a *Confuciusornis*. A *Jinzhousaurus* is quietly watching a *Yutyrannus* busy in the jungle. *Lycoptera* and *Peipiaosteus* are swimming lazily around the lake, enjoying a free life. An *Aeschnidium* sits quietly on a dead branch, watching a clumsy *Manchurochelys* climb out of the water. A *Callobatrachus* is sitting on a mossy rock, waiting for prey to come along. At the edge of the forest, a huge *Dongbeititan* walks alone, heading for home. This is the early Cretaceous, when the dinosaur family entered its golden age.

Digital painting

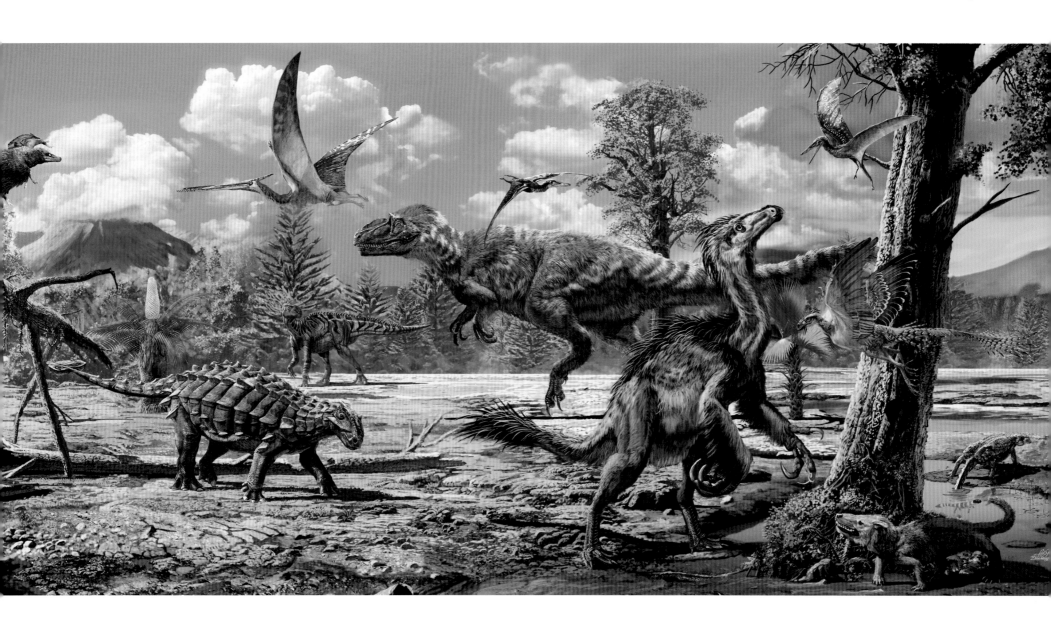

James Kuether

James Kuether is an author, editor and illustrator. He is an award-winning artist whose paintings and photographs hang in galleries and private collections around the globe. He is an amateur fossil hunter and a life-long dinosaur enthusiast. His natural history art has appeared in numerous publications and accompanies museum displays in the United States and Europe. His first book, *The Amazing World of Dinosaurs,* features more than 160 original illustrations, and was published by Adventure/Keen in October 2016.

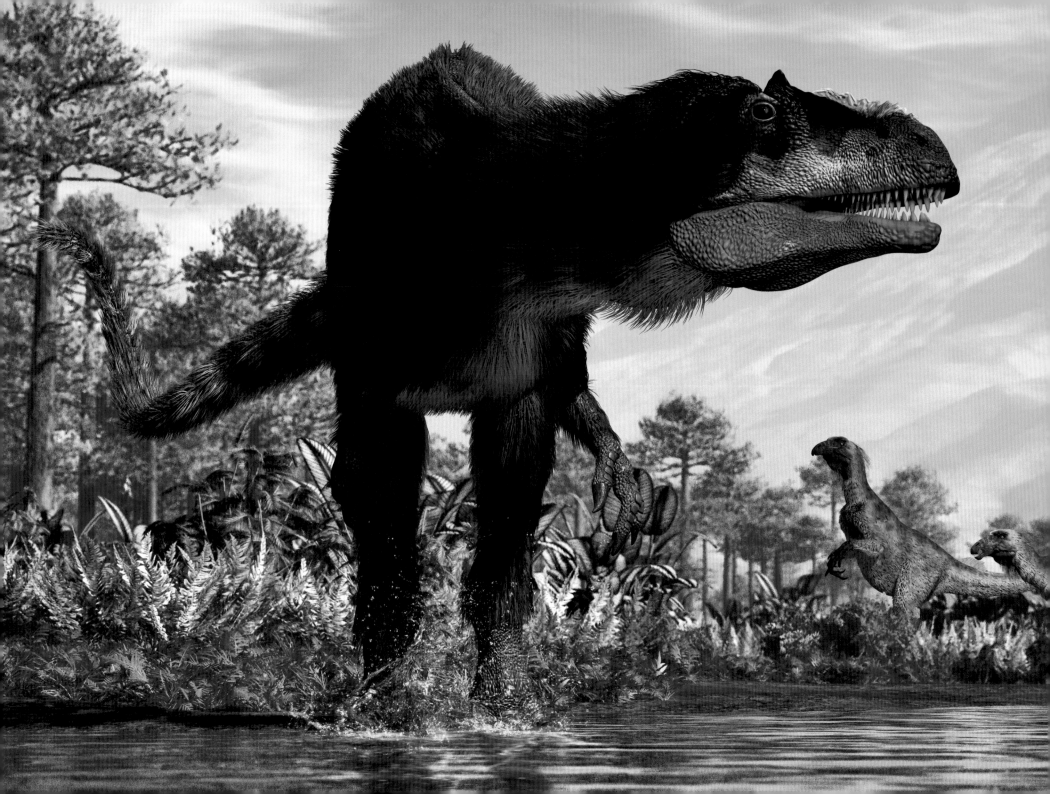

Like most people, I became fascinated with dinosaurs as a child. By the time I was old enough to hold a crayon I was drawing them, and that early inspiration set me off on a life-long pursuit of exploring the world through art. As an adult, I found success painting traditional subject matter. But in the back of my mind there was always this itch to go back to the beginning and find new ways to explore the lives of dinosaurs.

In 2005 I introduced myself to the world of 3D computer graphics. While the tools and technology had been around for decades, their sophistication was beyond the capability of most home computer systems, and the learning curve and price tag were too steep for the casual dabbler. But with the advent of increased home computing power, affordability, and more user-friendly software, the accessibility of the medium increased and I soon found myself hooked.

My preferred medium is 3D computer graphics. This consists of virtual models (called meshes) sculpted in the computer, where they can be manipulated and posed. All the elements in my images consist of these meshes. I do not use any photographic elements in my compositions as I find I get greater control over the landscapes by creating them myself. The animals are created, posed, and then placed in a virtual landscape. A digital atmosphere creates the real-world effect of sunlight, clouds, fog and wind. Terrains are sculpted and textured. Virtual water, rocks and plants are positioned and the final, integrated scene is rendered to create a digital image (a process that can take days of computer time).

Some people consider digital artwork – especially 3D digital work – "cheating," that is to say, they feel that the computer does all the real work. Coming from a traditional art background, I can attest that it does streamline some processes – especially regarding issues of perspective and scale. But simply placing models in a scene and adding digital sunlight does not make for good art. The same principles that apply to traditional artwork – form, composition, color, value – are just as critical to the success of digital art forms, and can be just as challenging to achieve.

Another challenge in the creation of natural history images is the relative sameness of the environments. Mesozoic flora in particular is limited – ferns, cycads, tree ferns, pine and gingko trees. It was not until the late Cretaceous environments that deciduous trees (trees with leaves), flowering plants and grasses evolved. And even then they weren't terribly common. The landscape palette is limited – greens and browns dominate. And the environments in which most dinosaur fossils are found are similar as well. Flood plains and desert environments are the most common fossil-bearing sites – places where the dead remains of animals fossilize more easily. This too limits the variability of landscapes and presents a challenge to come up with new and interesting ways in which to depict them.

Luckily, we've had lots of inspiration over the years. All of us, regardless of our endeavor, stand on the shoulders of those who came before us, and the world of paleoart is no different. Ever since the first mysterious bones were pulled from the Earth, scientists have worked with artists to reconstruct these "terrible lizards." One of the earliest attempts came in the form of sculptor Benjamin Waterhouse Hawkins' life-size reconstructions for the 1854 Great Exhibition in London. Today, those marvelous creations still stand in Bromley's Crystal Palace Park, south of London. By today's standards, these reconstructions seem brutish and clumsy. But at the time, they sparked the same level of awe and wonder that modern audiences experience with *Jurassic Park* and its sequels. Since then, impassioned artists have taken dinosaur reconstructions to ever more refined levels. From the hugely influential Charles R. Knight and Rudolph Zallinger at the beginning of the 20th century, to modern masters like James Gurche, Douglas Henderson, Raul Martin and Fabio Pastori (artists who have greatly influenced my own work), the act of scientific reconstruction has merged with the world of art and imagination, giving us incredibly realistic and breathtaking glimpses into the world that once was.

My personal style and approach to reconstructions has evolved over time. Unlike many paleoartists whose work is done primarily to accompany scientific papers and to illustrate new discoveries (an intensive process that has a discipline and rigor unequaled in any other art form), my images are done to entertain, to inform and, hopefully, to inspire. That's not to say that I throw accuracy out the window. The landscapes I create are informed by scientific knowledge, and the animals in each scene accurately reflect what is known of their physiology and what species co-existed in time and place. But unencumbered by the rigors of peer-reviewed publication I'm more free to use my imagination. My goal is to give someone, be they young or old, that same spark of wonder I felt as a child, to make them want to know more and to seek out their own way of expressing that excitement.

The Yixian Formation
Yutyrannus huali is the largest dinosaur definitely known to have had feathers.
A primitive tyrannosaur, it reached lengths of nearly 9 meters. *Beipiaosaurus* was an early therizinosaurus that was around two meters in length.
The Yixian Formation in China dates to around 125–121 million years ago.
3D digital

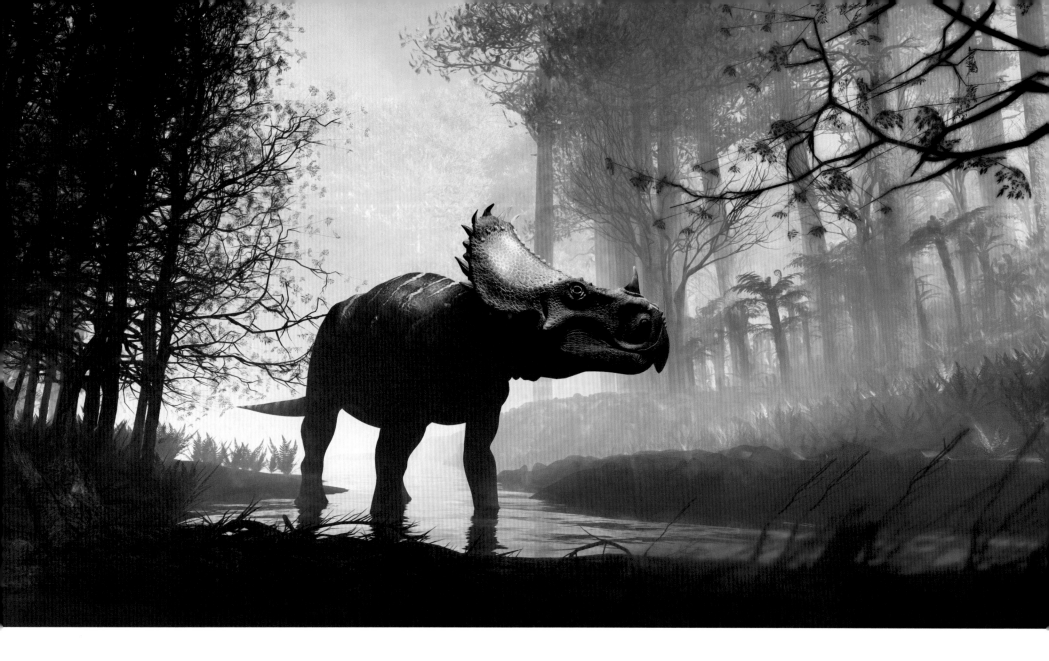

Sinoceratops

Sinoceratops zhuchengensis belongs to the group of advanced ceratopsians known as centrosaurines, which include *Centrosaurus* and *Pachyrhinosaurus* from North America. *Sinoceratops* was around five meters in length,
and is the only known ceratopsid from Asia. *Sinoceratops* lived in China around 72–66 million years ago.
3D digital

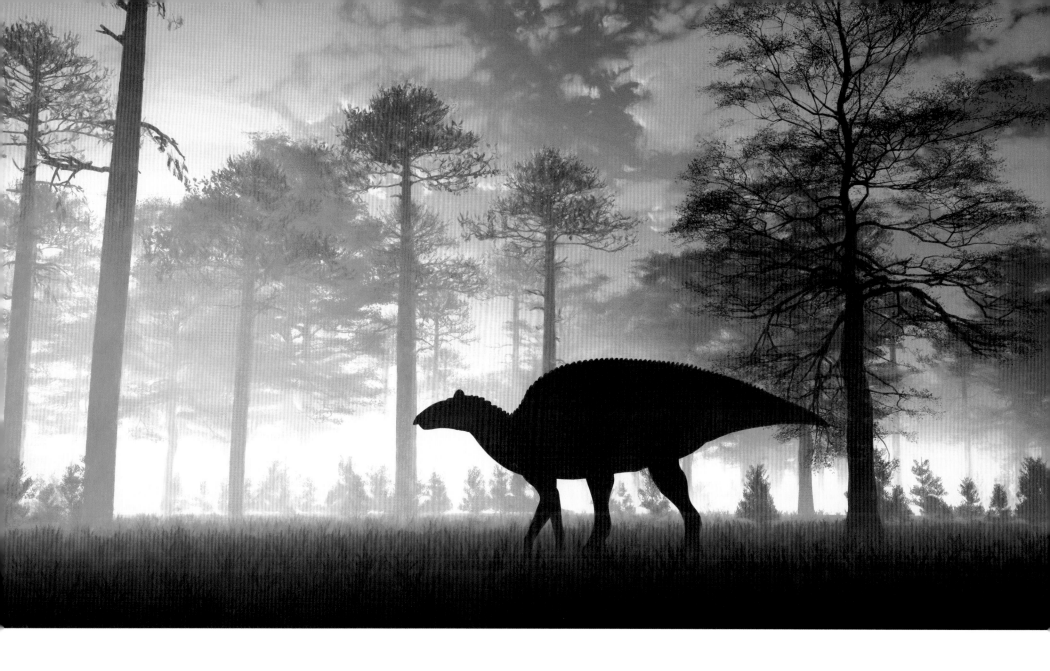

Cretaceous Sunrise

Edmontosaurus regatis was one of the most common hadrosaurs in the late Cretaceous of North America.
Bonebeds indicating herds of thousands of animals have been found.
This nine-meter-long herbivore had a small, soft-tissue crest on the top of its head, somewhat like a rooster's comb.

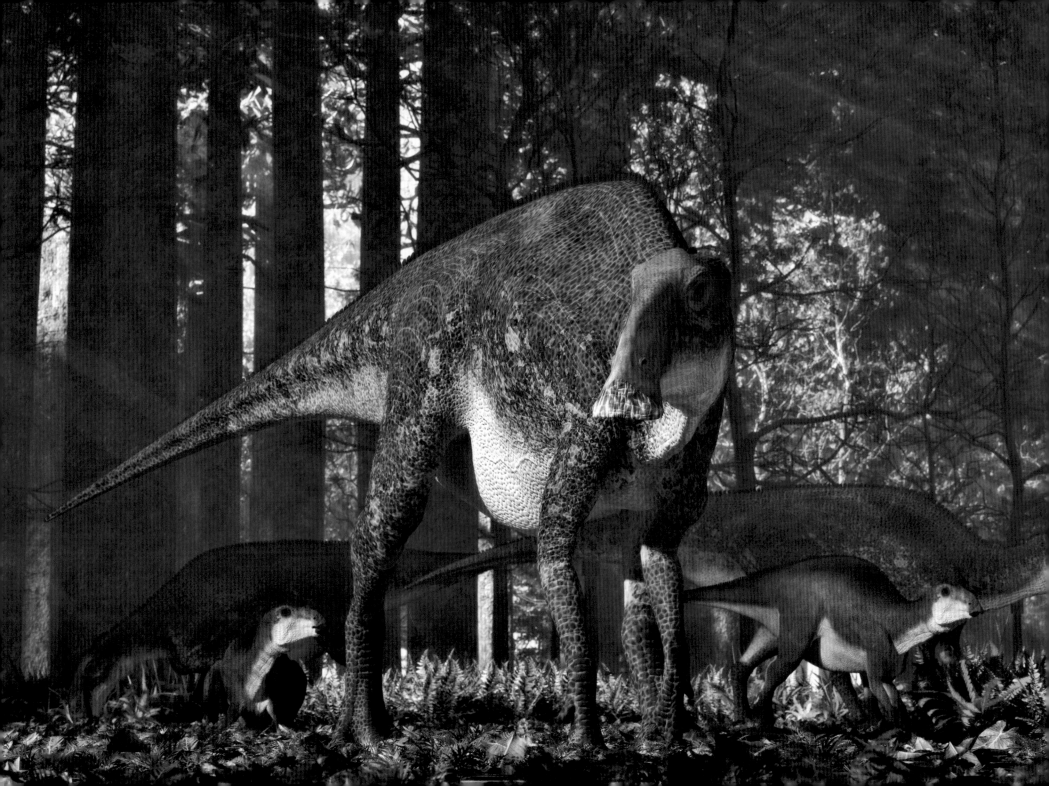

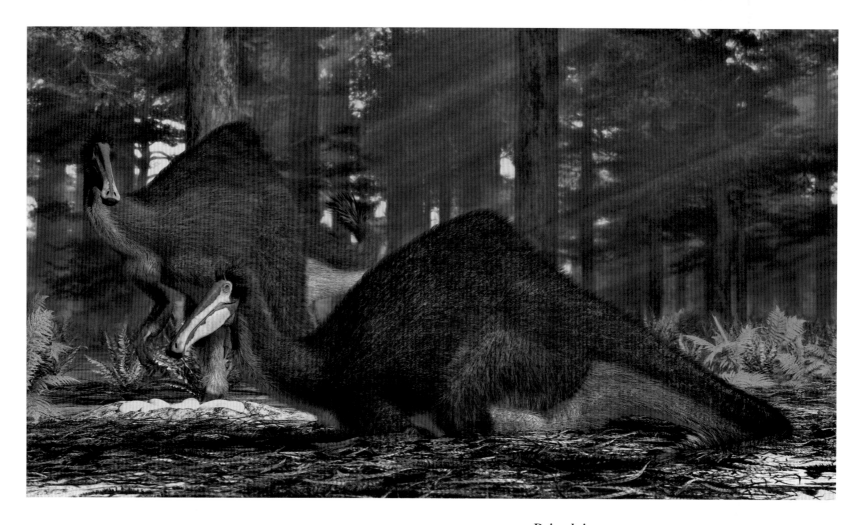

Deinocheirus

Deinocheirus mirificus may be the oddest dinosaur yet discovered.
A member of the ornithomimid (ostrich mimic) group,
it sported a tall hump or sail, and a long, spoonbill-shaped skull.
At nearly 11.5 meters long, it was also the largest member of the group.
3D digital

Brachylophosaurus

Brachylophosaurus canadensis is one of the best known dinosaurs thanks to the discovery of several mummified remains
that included impressions of skin, muscles and even fossilized stomach contents.
Brachylophosaurus lived during the Campanian stage of the Cretaceous (77 million years ago),
and was around 11 meters long.
3D digital

Leshansaurus

Leshanaurus guianweiensis is a little known megalosaurid theropod
from the Dashanpu Formation of China, dating to the mid-Jurassic period.
At six to seven meters long, it was one of the largest theropods in its ecosystem.
3D digital

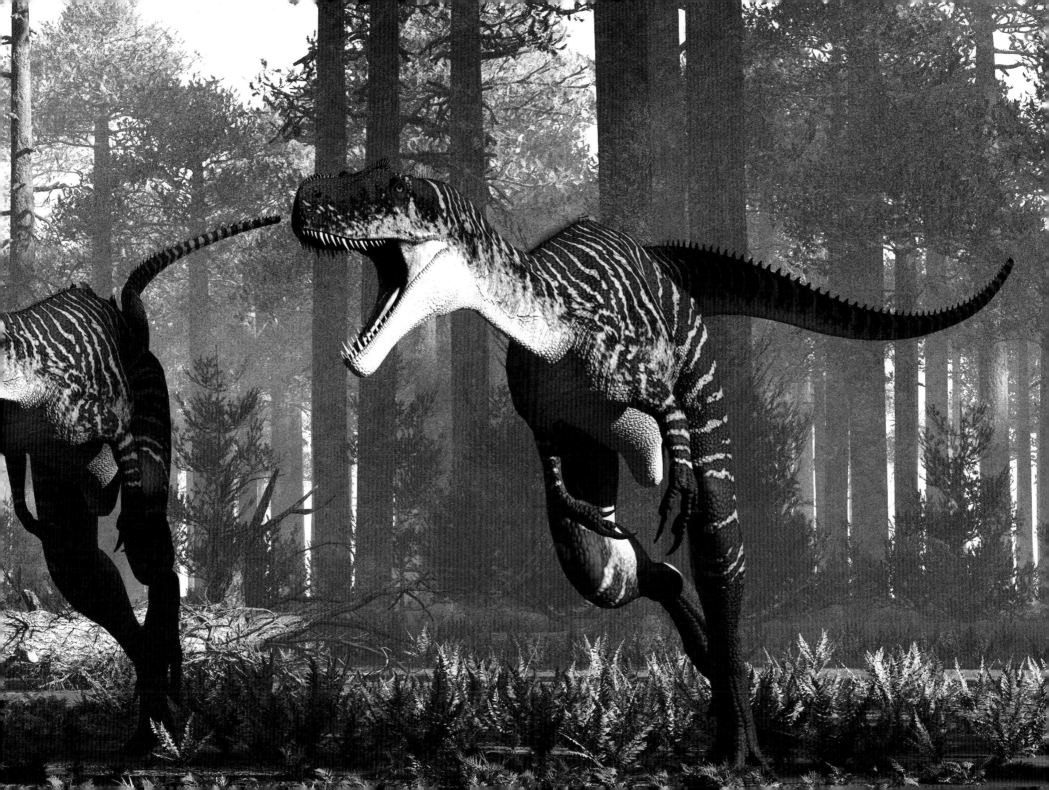

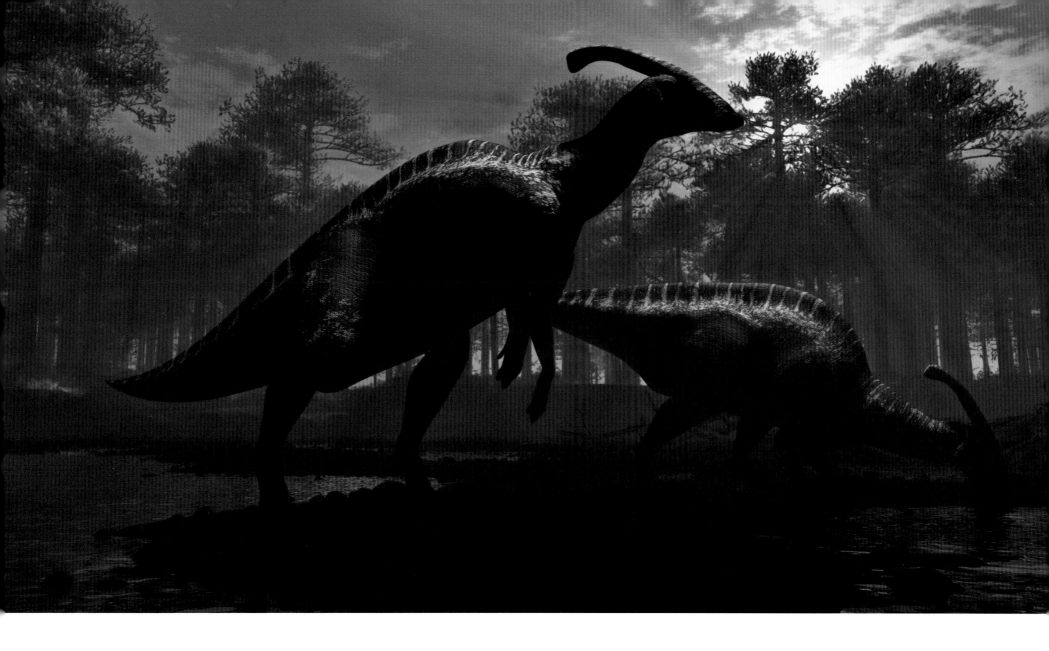

Parasaurolophus

There are several species of *Parasaurolophus*, differentiated by the size and shape of their tubular head crests.
Parasaurolophus walkeri is one of the most familiar.
It was 7.5 meters long and lived in what is now Canada during the Campanian and Maastrichtian stages of the late Cretaceous.
3D digital

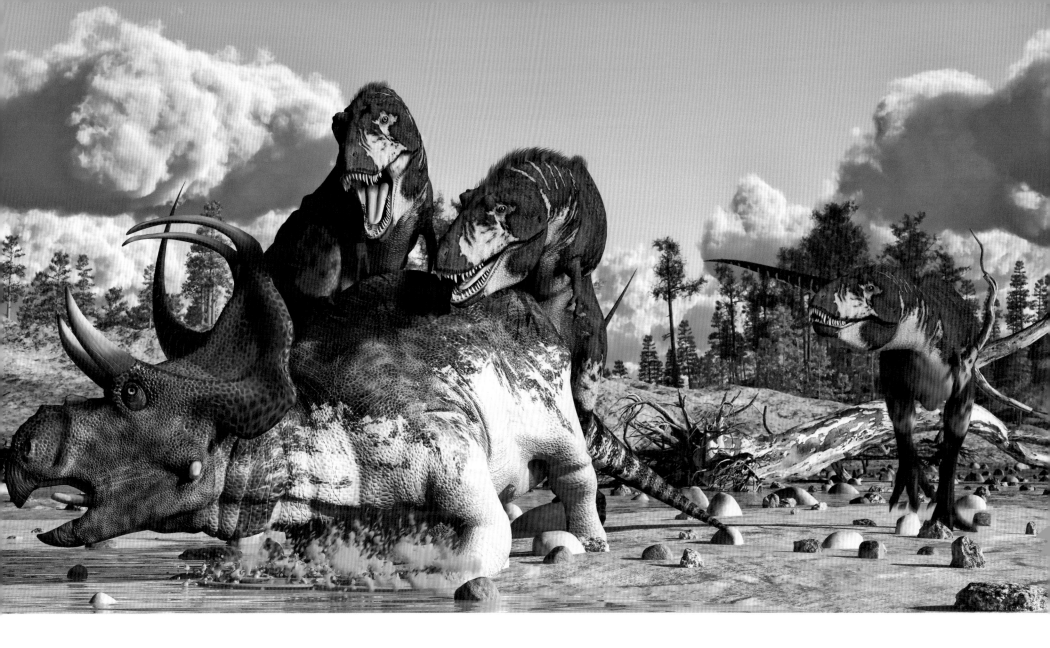

Mud Flats of Utah

Lythronax argestes was a primitive six meter-long tyrannosaurid and the earliest known tyrannosaurid from North America.

It lived alongside the six to eight meter long ceratopsian *Machairoceratops cronusi*.

Both animals were found in Utah in the United States.

3D digital

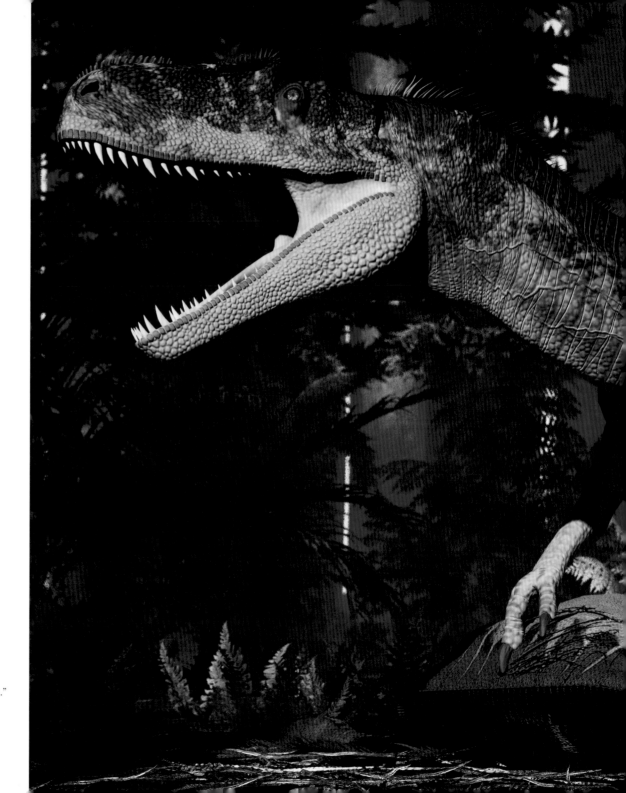

Wiehenvenator

When it was announced in 2016, *Wiehenvenator albati* was dubbed "the Monster of Minden."
While originally thought to be up to 12 meters in length,
Wiehenvenator turned out to be a bit smaller, seven to eight meters long.
Its remains were found near Minden, Germany.
3D digital

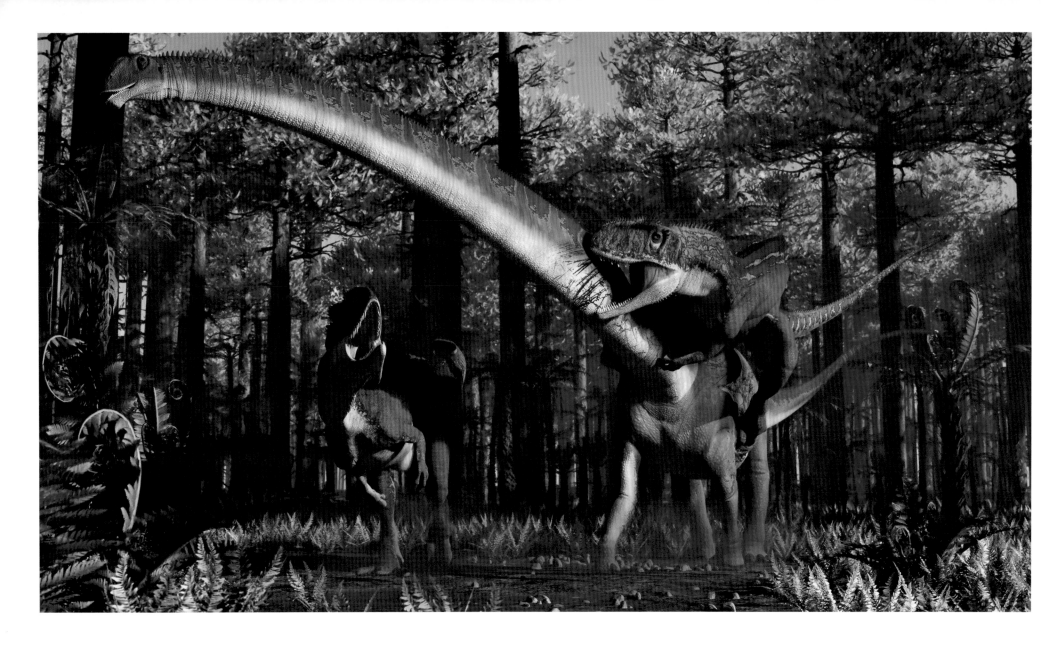

The Dashanpu Formation, China

Yangchuanosaurus shangyouensis was an apex predator that reached 11 meters in length.
Mamenchisaurus youngi was one of the longest sauropods known, with one species measuring upwards of 35 meters in length.
Both animals come from the Dashanpu Formation of China, and date to the mid to late Jurassic period.
3D digital

p.65
The Kaiparowits Formation

The Kairparowits Formation of southern Utah in the United States has been one of the most prolific sites for dinosaur discoveries in recent years.
Nasutoceratops titusi was an early centrosaurine around five meters long, while *Gryposaurus monumentensis*, a hadrosaur, reached lengths of eight meters.
3D digital

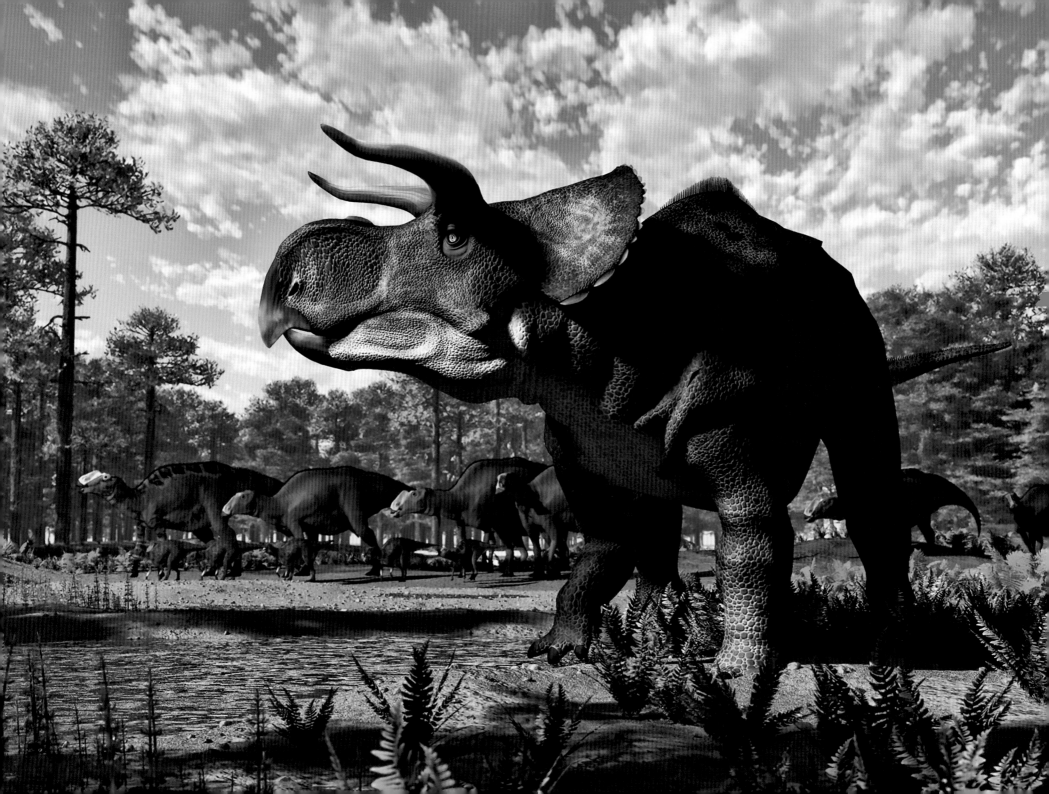

Juvenile *Tyrannosaurus*
Juvenile tyrannosaurs were built much more lightly than tyrannosaur adults. Their skulls were lower, narrower and more lightly constructed, and their relatively long legs gave them great speed and maneuverability.
3D digital

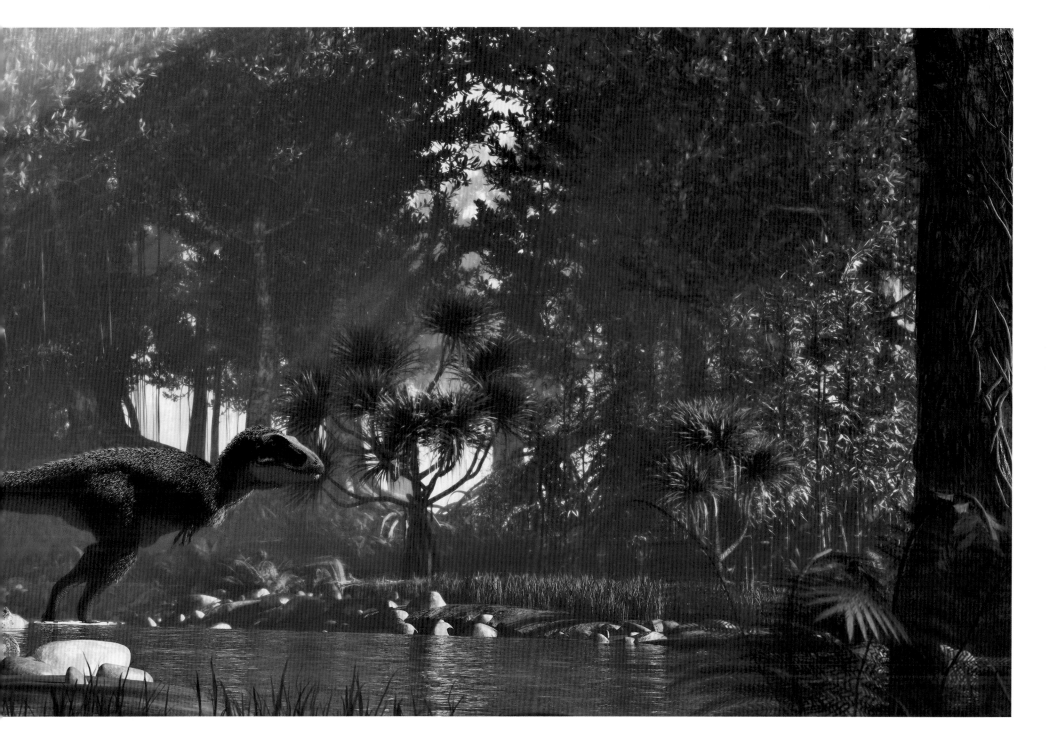

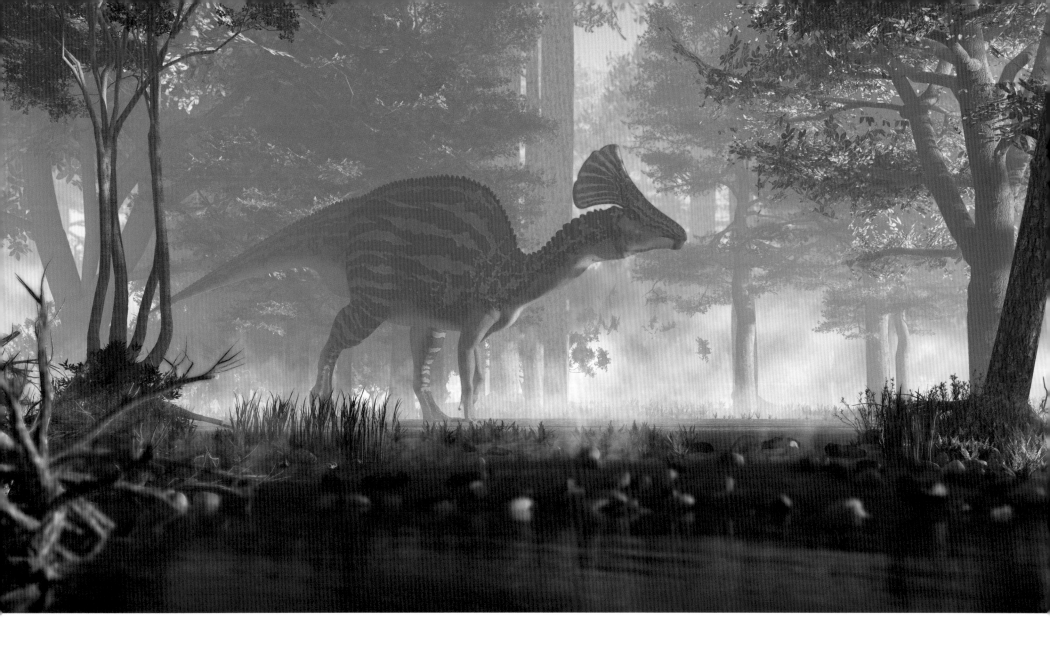

Olorotitan
Olorotitan arharensisi was an eight-meter-long hadrosaur that lived in Eastern Siberia
at the end of the Cretaceous period.
3D digital

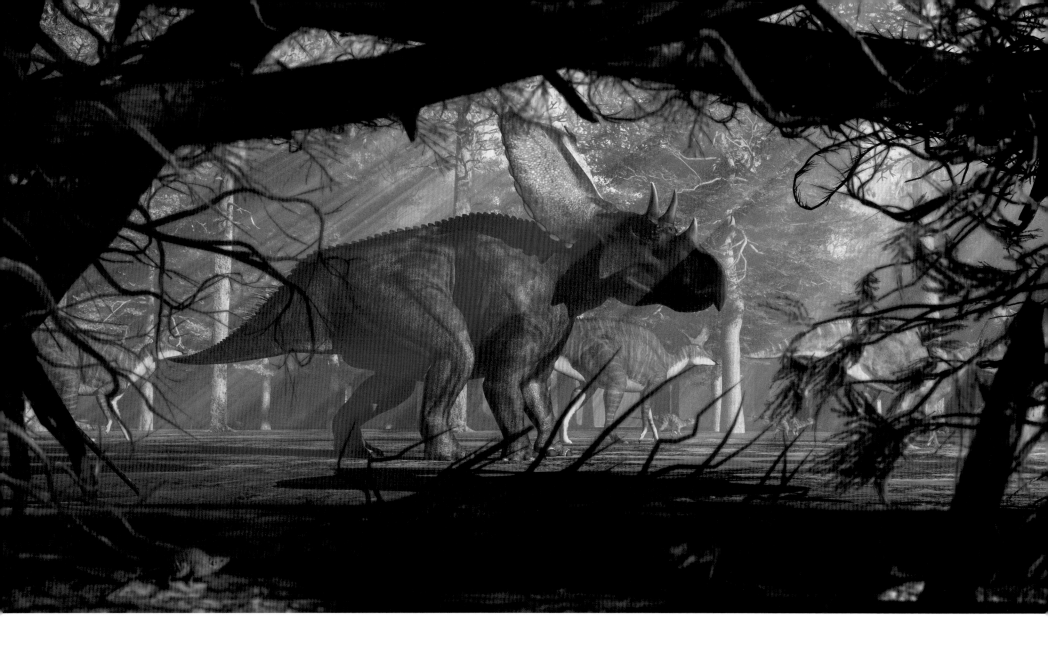

Chasmosaurus

Chasmosaurus russelli was a ceratopsian that lived in what is now Alberta, Canada during the Campanian stage of the Late Cretaceous.
It reached lengths of four to five meters.
3D digital

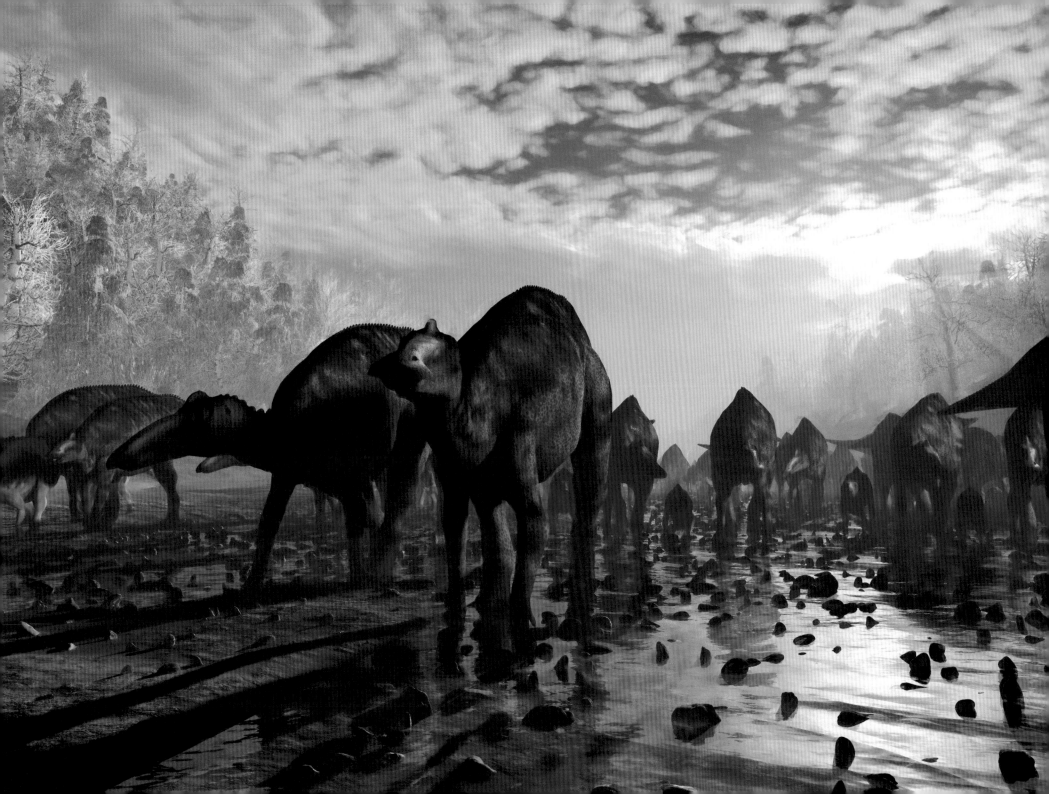

Northern Migration

Known at various times as *Trachodon*, *Anatosaurus* and *Anatotitan*, the animal now known as *Edmonotosaurus annectens* lived a bit later than *Edmontosaurus regalis*. It had a longer, lower skull than *E. regalis* and had the "duckiest" shaped head of all the duckbill dinosaurs.
3D digital

Davide Bonadonna

Davide Bonadonna has been working as a medical and scientific illustrator for more than 15 years, combining scientific research and visual communication. In 2007 he became a full-time paleontology illustrator and digital sculptor, and he has won prestigious international awards including the Lanzendorf PaleoArt Prize. Cooperating with paleontologists worldwide on prehistoric model reconstructions and settings, he has displayed his work in museums, exhibits and theme parks, and has published them in scientific and educational magazines, including *National Geographic*. His illustrations are featured in the traveling exhibition "Dinosaurs in the Flesh."

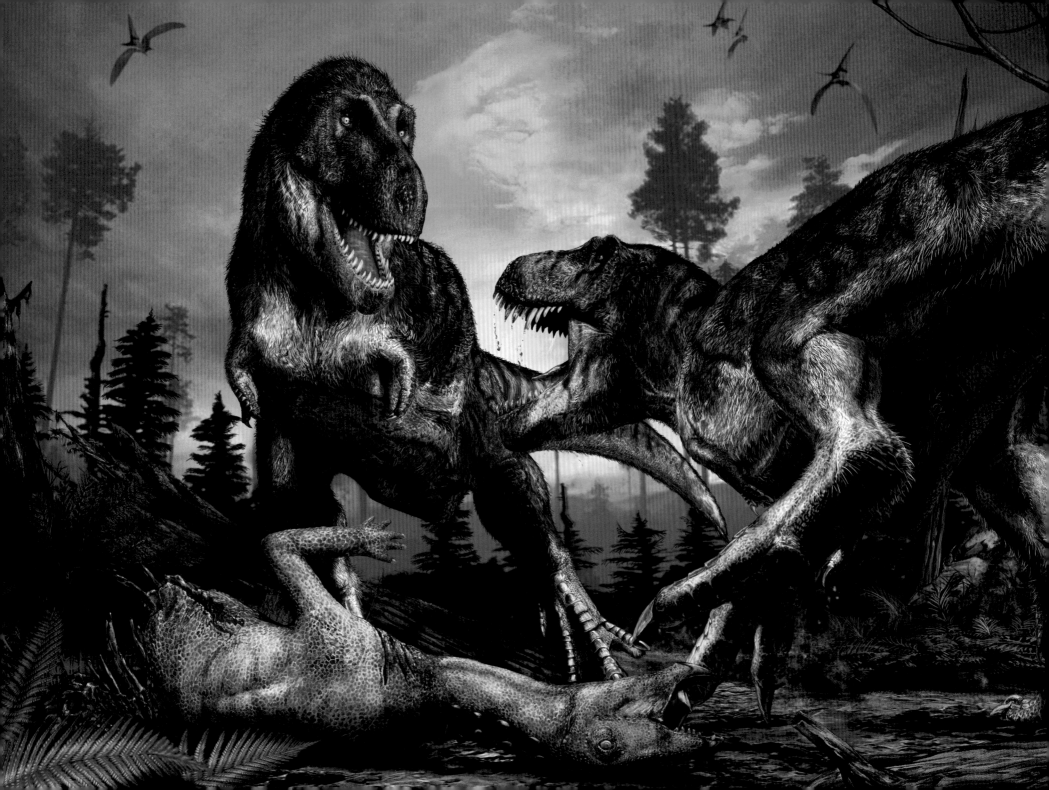

For me paleoart is the convergence of my artistic skills and my attraction towards the natural and scientific worlds. I've always enjoyed drawing animals, and dinosaurs were, as for many children, my very first love. It's a primal passion. Paleoart lets my artistic side fly free. Of course I can't forget the scientific aspect: without a paleontologist as a supervisor I'd be lost. Paleoart lets me satisfy my interest in science and nature while keeping my inner child alive.

My taste is genetic, I think: both my father and my grandfather, a doctor and a zoologist, were famous scientists. The natural world has always been my passion. I grew up dreaming of becoming a sort of a second Attenborough, so I studied to be a biologist. I wasn't a brilliant student, though, so I turned to illustration. After working as a medical illustrator for a long time, I finally got my chance when I met Simone Maganuco, a young paleontologist. Simone and my young colleague Fabio Manucci, a 3D modeler, introduced me to the world of paleontological reconstructions, and showed me the right scientific approach.

Dinosaurs were animals, just like the ones we see today. I don't think they had any superior abilities, but they were not the slow and stupid creatures that were portrayed until a few decades ago. I'd like to be more daring in my reconstructions, and show how dinosaurs might have behaved in everyday life instead of showing them in the typical predatory scenes we see today. I tend to overdo the speculation, so I used to be quite conservative.

My attention always goes first to specimen and skeletal reconstructions. That leads me to my personal attempt to recreate the in-the-flesh version. Once I used to look for references and consult other artists' reconstructions from the Internet or from books I'd bought, but actually I prefer to check those sources only after I have sketched my ideas. That way I can avoid being overly influenced by other people's work.

I don't have any particular view of the Mesozoic Era. What I learned from my work with paleontologists is that there are very precise clues and specimens for work in biology and geology, enough to provide a very detailed sense of the environment for every creature I draw. In that sense it's a pleasure for me to discover new animals and new worlds every time I work on a well supervised project.

My method is always pretty much the same. First the paleontologist gives me all the material (skeletons, specimen pictures, notes) so I can start to compose the scene and find the best positions for the subjects. In the beginning, my illustration technique was a mix of traditional tempera and watercolor painting. After I learned to use Photoshop I started to adjust my paintings digitally, and now I only use digital. Sometimes I like to work on black and white projects in pencil. I like sketching very much, but unfortunately the tight deadlines of many jobs don't allow me to spend too much time on pencil work.

Hell's Chickens

Two *Tyrannosaurus rex* fighting over a *Thescelosaurus neglectus* carcass.
North America, Upper Cretaceous (Maastrichtian)
Scientific supervisor: Simone Maganuco (MSNM)
Tempera and digital

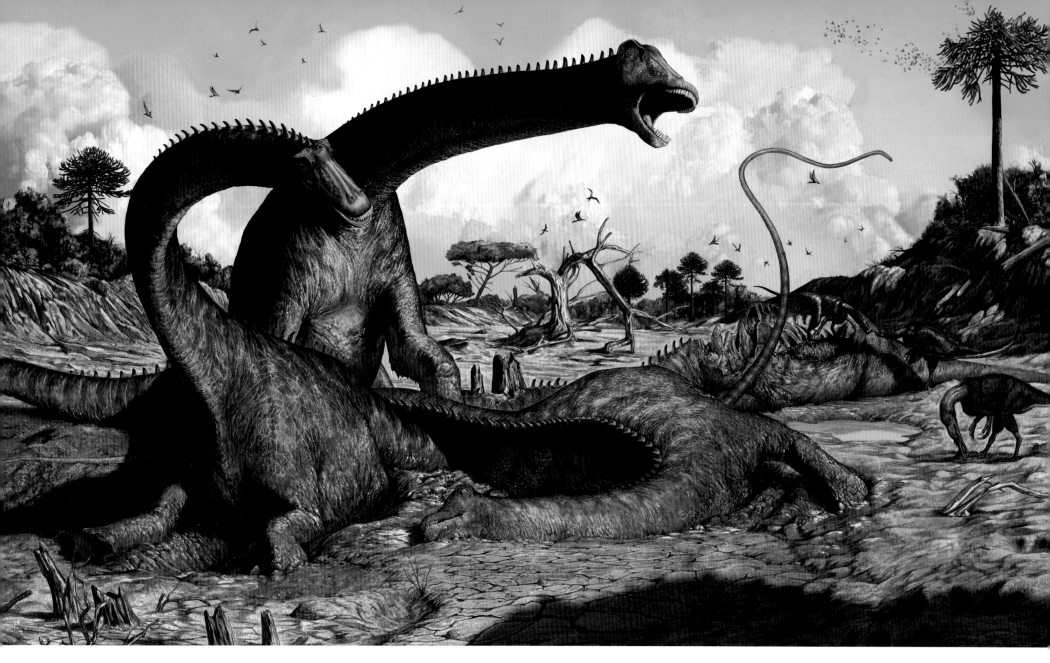

Life and Death at Howe Quarry

This new life (and death) reconstruction of the Howe Quarry reflects the latest research on material from that site.

Here *Kaatedocus siberi* individuals have gotten stuck in the mud, and are struggling to get out before they get eaten by *Allosaurus* or *Ornitholestes*. But it's too late.

Shell, Wyoming (USA) - Morrison Formation, Late Jurassic (Kimmeridgian)

Scientific advisor: Emanuel Tschopp (American Museum of Natural History)

Client: Sauriermuseum Aathal (Switzerland)

Tempera and digital

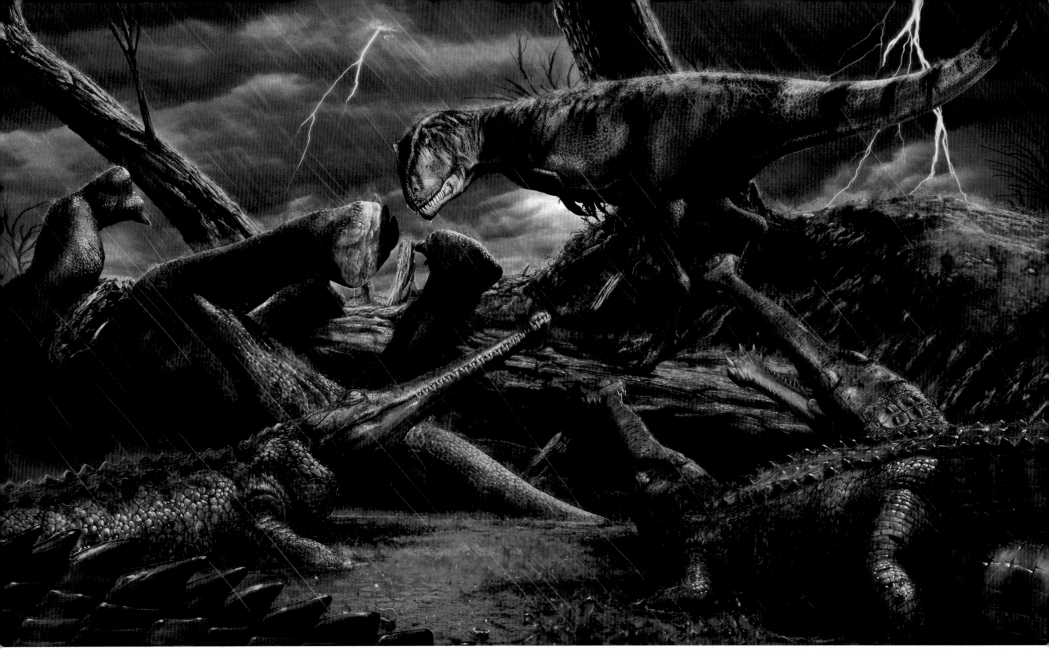

Predator's Paradise

A sauropod carcass attracts a flock of large *Elosuchus* and one young *Carcharodontosaurus*. The Kem Kem vertebrate assemblage contains abundant remains of predatory forms, including giant theropods and crocodyliforms, but few herbivorous ones.

Kem Kem region of Morocco - Cretaceous
Scientific supervisor: Nizar Ibrahim (University of Chicago)
Client: National Geographic traveling exposition *Bigger Than T. Rex*

Digital

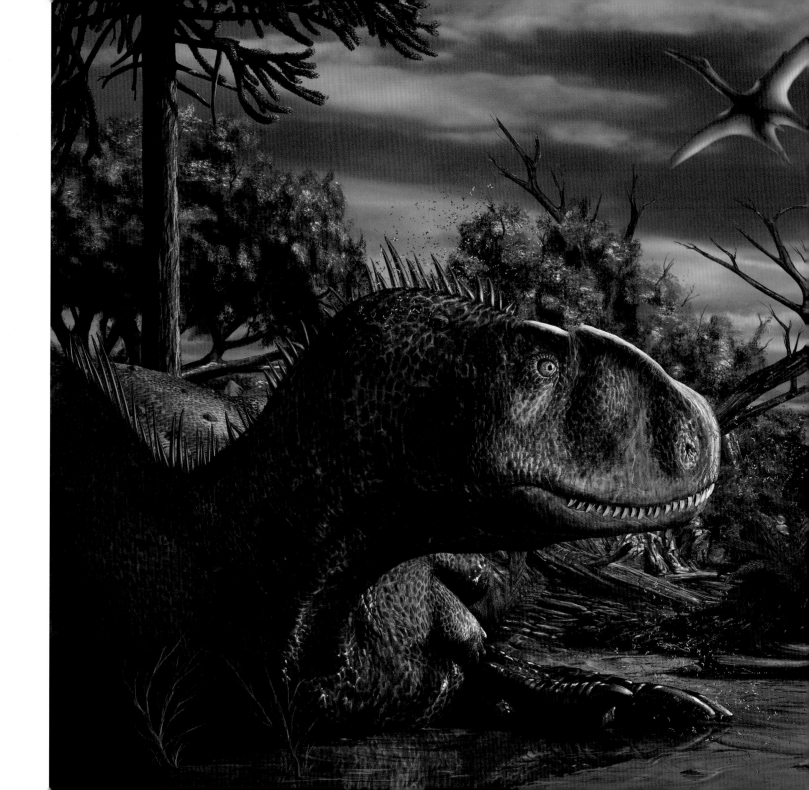

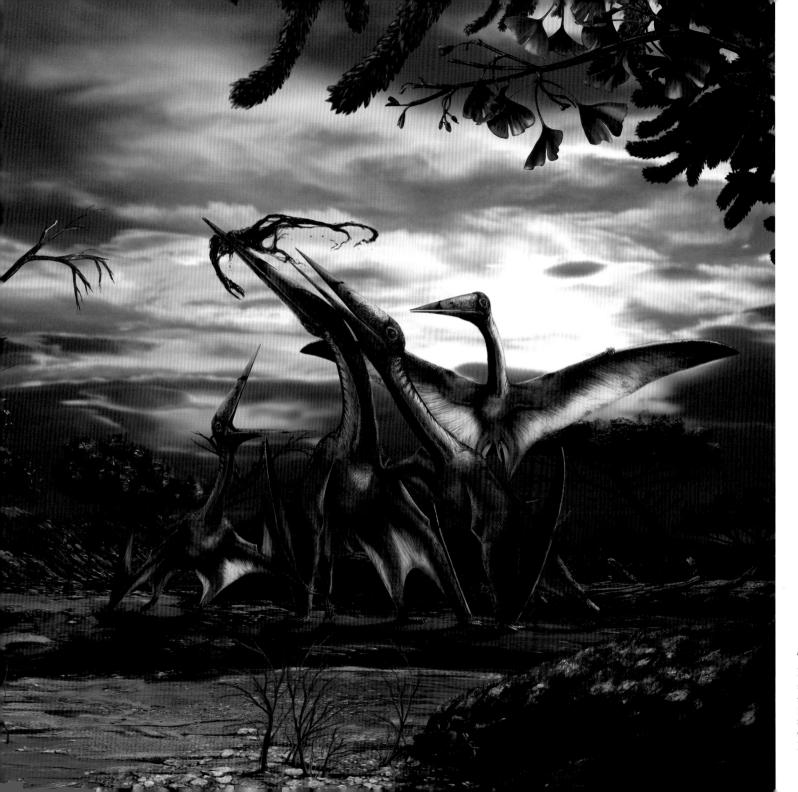

The Quarrel
It's dawn in Kem Kem and a bunch of *Alanqa*
are fighting for the best bite
while a *Rugops* cooling off in a puddle looks on.
Kem Kem region of Morocco - Cretaceous
Scientific supervisor: Nizar Ibrahim (University of Chicago)
Client: National Geographic traveling exposition *Bigger Than T. Rex*
Digital

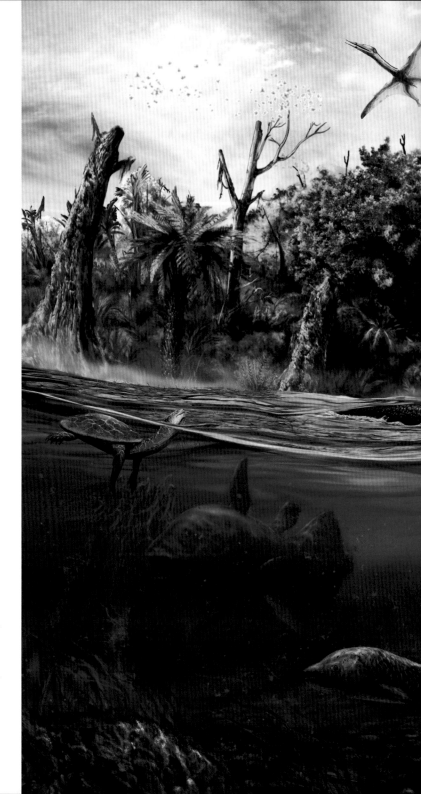

River of Giants

Two *Spinosaurs* patrol the Kem Kem river in search of prey.
Abundant lungfish, turtles and coelacanths (*Mawsonia*) make it a perfect hunting ground.
A large *Alanqa* spreads its wings in the distance.
Kem Kem region of Morocco - Cretaceous
Scientific supervisors: Simone Maganuco (Museo di Storia Naturale di Milano), Nizar Ibrahim (University of Chicago)
Client: National Geographic Magazine (USA), June 2014
©Davide Bonadonna, National Geographic Creative
Digital

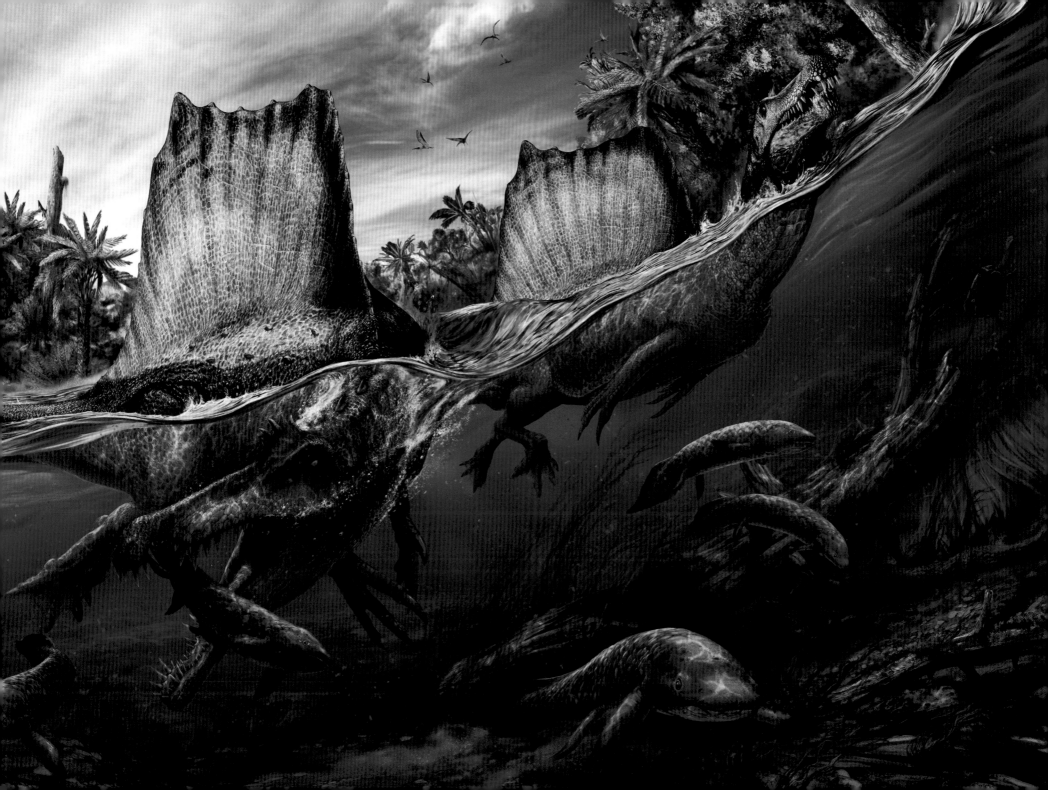

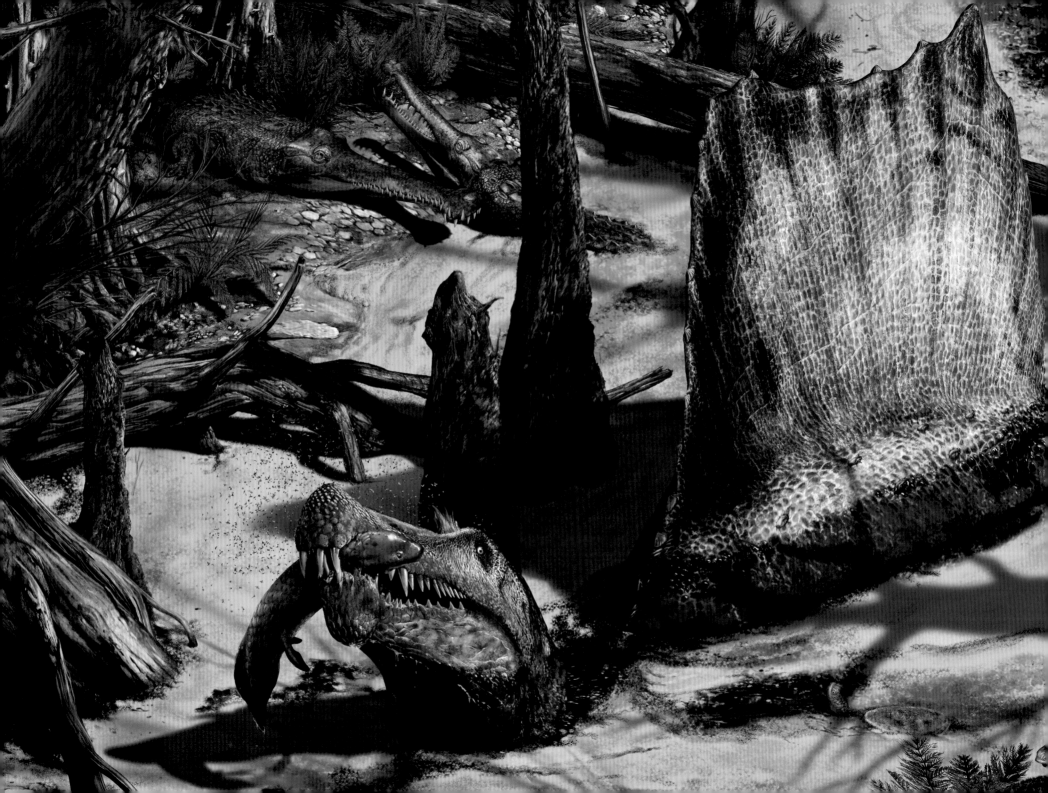

Spinosaurus Pond
After catching a big *Ceratodus*, a *Spinosaurus* swims slowly in a small pond
where big *Elosuchus* crocodiles and *Pelomedusa* turtles are resting.
Kem Kem region of Morocco - Cretaceous
Client: Focus Magazine (Italy)
Digital

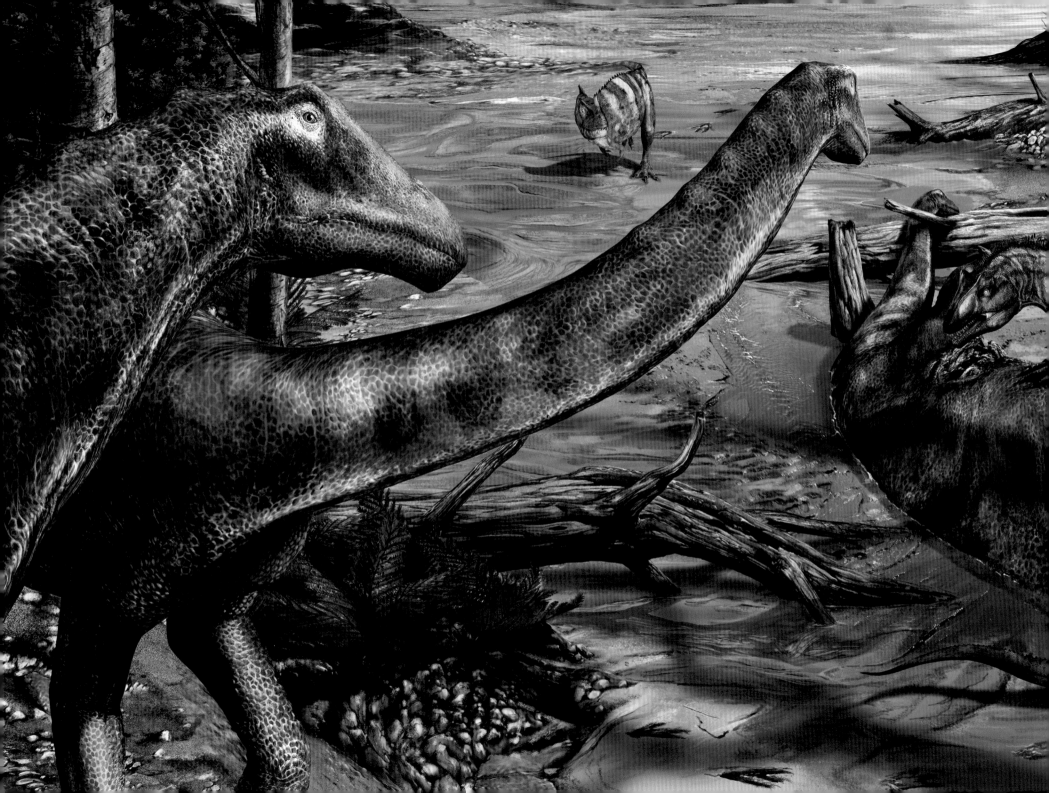

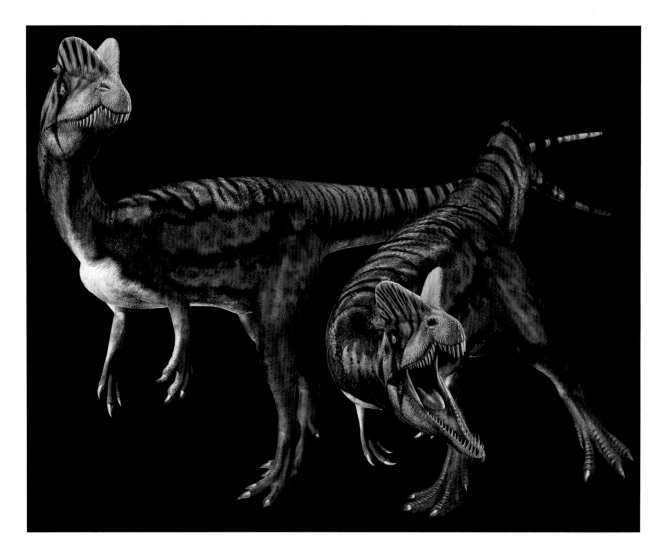

Dilophosaurus
Dilophosaurus wertellii
Scientific supervisor: Massimo Bernardi, Museo delle Scienze - MUSE
Client: Museo delle Scienze - MUSE (Trento, Italy)
Digital

The River Wild
A pair of *Galeamopus* searching for water pass by a cruel scene as they arrive at an almost dry river:
a couple of *Ceratosaurus* wait for an *Allosaurus* to finish dining on a dead *Galeamopus*.
Wyoming, USA, Morrison Formation – Upper Jurassic (Kimmeridgian-Tithonian)
Scientific supervisor: Emanuel Tschopp (Dipartimento di Scienze della Terra, Università di Torino, Italy)
Client: Sauriermuseum Aathal (Aathal, Switzerland)
Tempera and digital

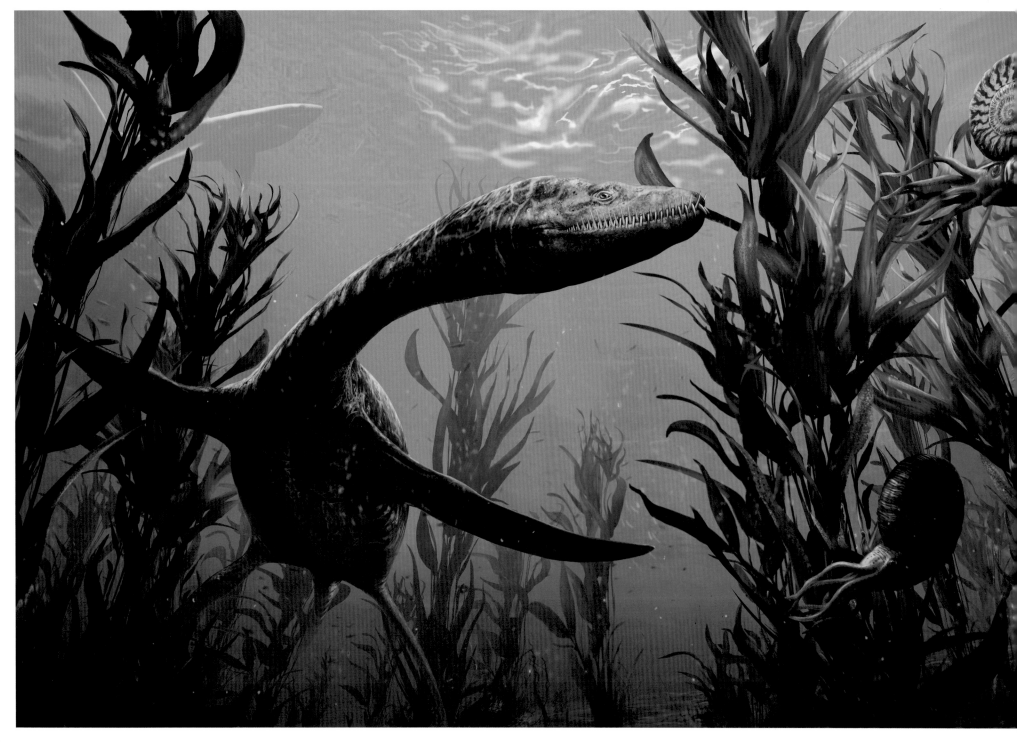

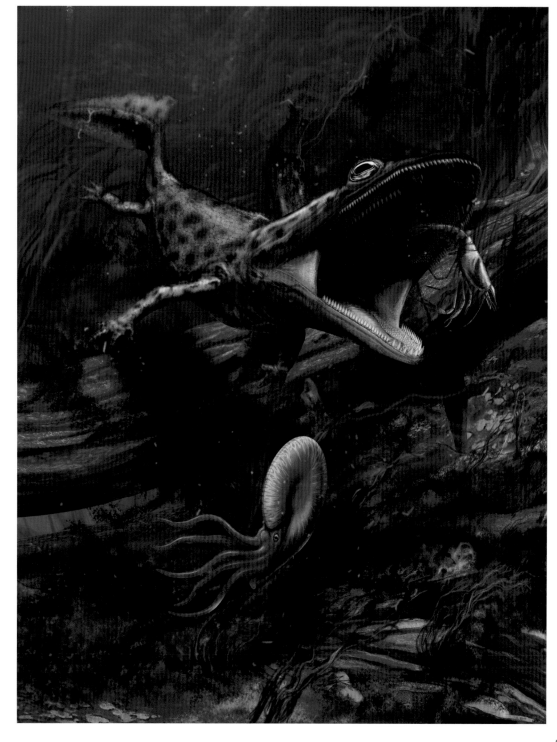

p.86

The Seas of Kansas

80 million years ago a large *Elasmosaurus* searching for ammonites
swims majestically through kelp in what is now Kansas and Colorado.

Colorado, USA – Upper Cretaceous

Client: Garden of the Gods Visitor & Nature Center (Colorado Springs, Colorado, USA)

Tempera and digital

Mahavisaurus

The temnospondil amphibian *Mahavisaurus dentatus* is about to eat a *Placenticeras*,
its natural prey. It will crush the *Placenticeras'* exoskeleton easily with
its impressive teeth.

Madagascar - Lower Triassic (Induano)

Scientific supervisor: Simone Maganuco (Museo di Storia Naturale di Milano)

Tempera and digital

Fantasia 2015

In the Sea of Kansas a *Mosasaurus* is trying to steal a flying *Pteranodon*'s prey, but it may be after something bigger. Surprisingly there is good evidence of this scenario thanks to the pterosaur bones found in a *Mosasaurus*' stomach.

Colorado, USA – Upper Cretaceous

Client: Garden of the Gods Visitor & Nature Center (Colorado Springs, Colorado, USA)

Tempera and digital

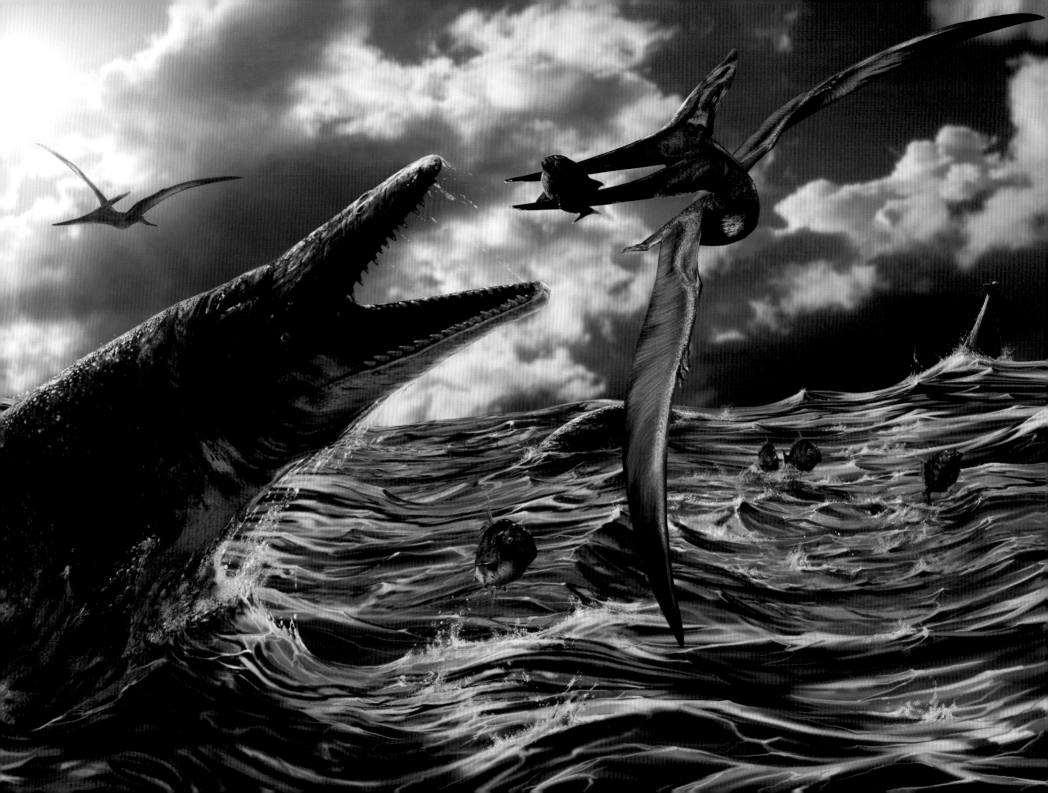

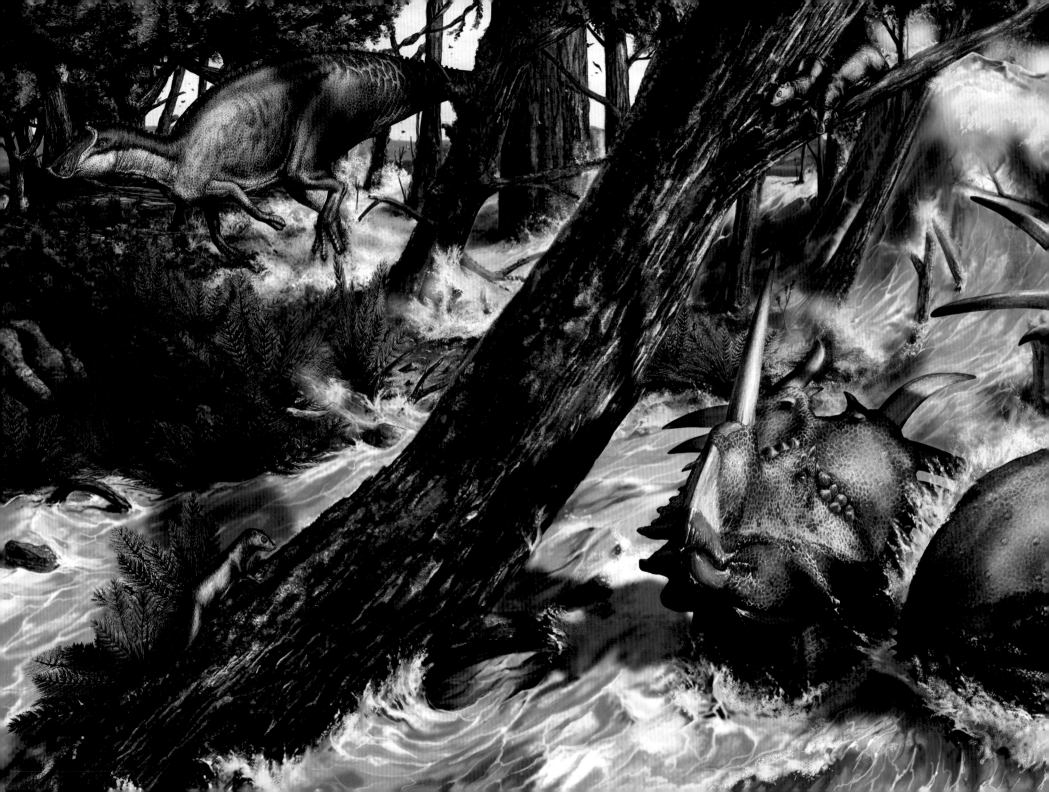

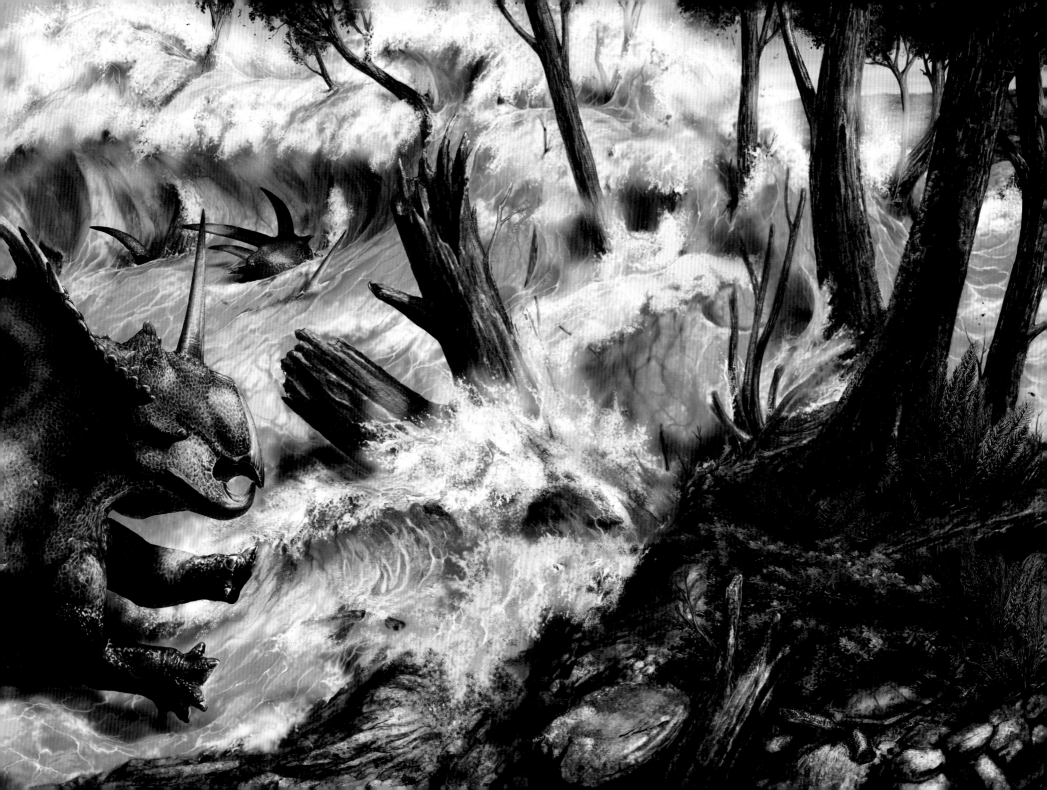

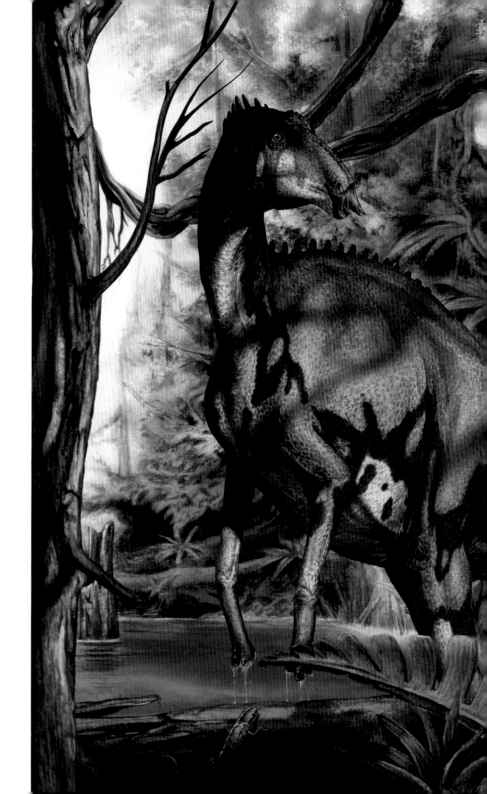

p.90-91

The Tsunami

A huge wave devastates the prehistoric Alberta coast, overwhelming a *Styracosaurus* herd.
A *Saurolophus* adrosaurid and some small mammals, *Eodelphys*, try to escape, some by
running and some seeking refuge in the trees.

Alberta, Canada - Upper Cretaceous

Scientific supervisor: Simone Maganuco (Museo di Storia Naturale di Milano)

Client: *Dinosaurs in the Flesh* traveling exposition

Tempera and digital

Tethyshadros insularis

A pair of dwarf hadrosauroids, *Tethyshadros insularis*, roaming the forest.

Italy, Liburnian Formation - Upper Cretaceous (late Campanian – early Maastrichtian)

Scientific supervisor: Simone Maganuco (Museo di Storia Naturale di Milano)

Client: Museo Geologico "G. Cortesi" (Castell'Arquato, Italy)

Tempera and digital

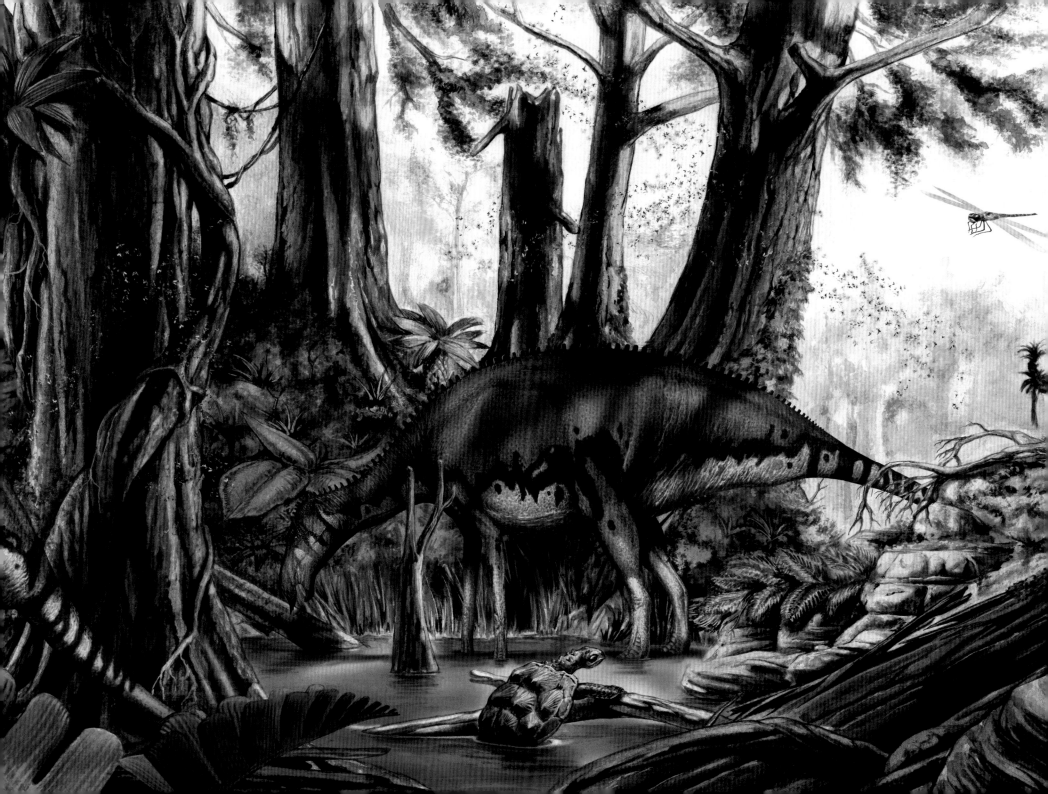

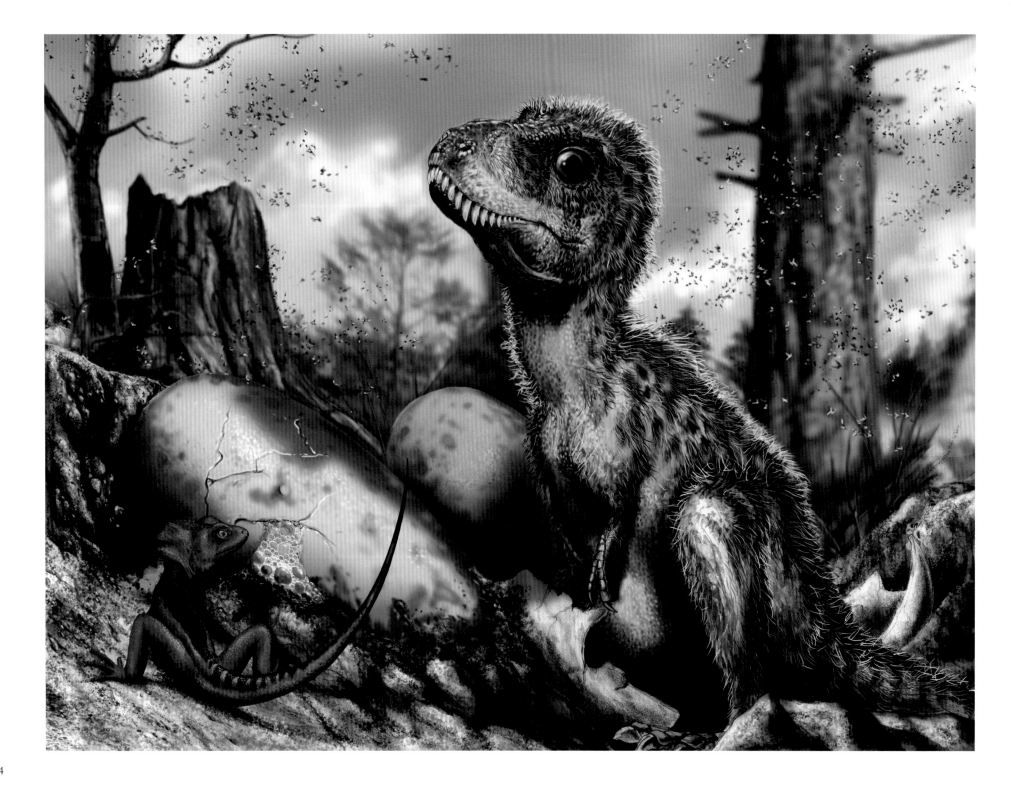

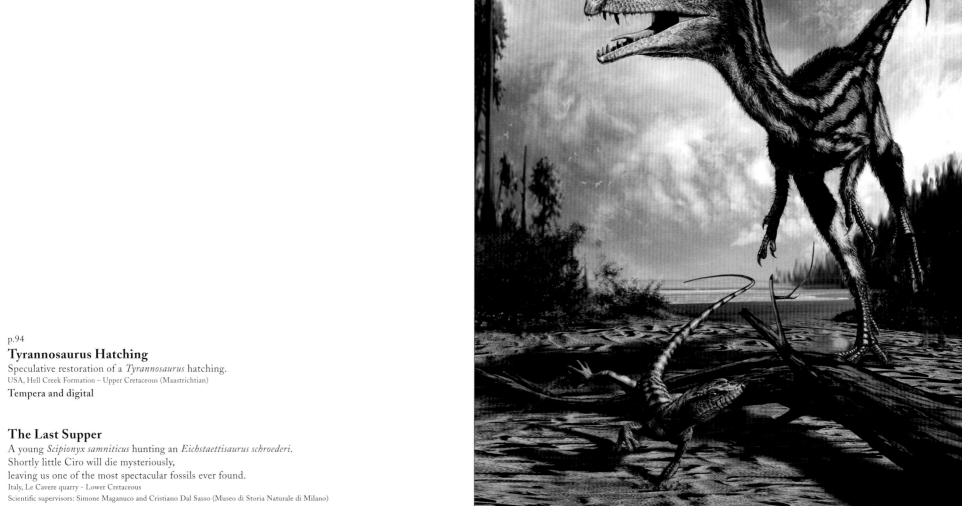

p.94
Tyrannosaurus Hatching
Speculative restoration of a *Tyrannosaurus* hatching.
USA, Hell Creek Formation – Upper Cretaceous (Maastrichtian)
Tempera and digital

The Last Supper
A young *Scipionyx samniticus* hunting an *Eichstaettisaurus schroederi*.
Shortly little Ciro will die mysteriously,
leaving us one of the most spectacular fossils ever found.
Italy, Le Cavere quarry - Lower Cretaceous
Scientific supervisors: Simone Maganuco and Cristiano Dal Sasso (Museo di Storia Naturale di Milano)
Tempera and digital

Sergey Krasovskiy

Sergey Krasovskiy, a freelance paleoartist, lives in the Donbas in Ukraine. Born in 1975, he is a graduate of Lugansk Art College. He creates paleoillustrations for a number of publishers. He has worked with a number of paleontologists, including Christophe Hendrickx from Portugal. Four years ago he switched to a graphics tablet for greater time economy, but he still uses traditional art media upon request and at times for pleasure.

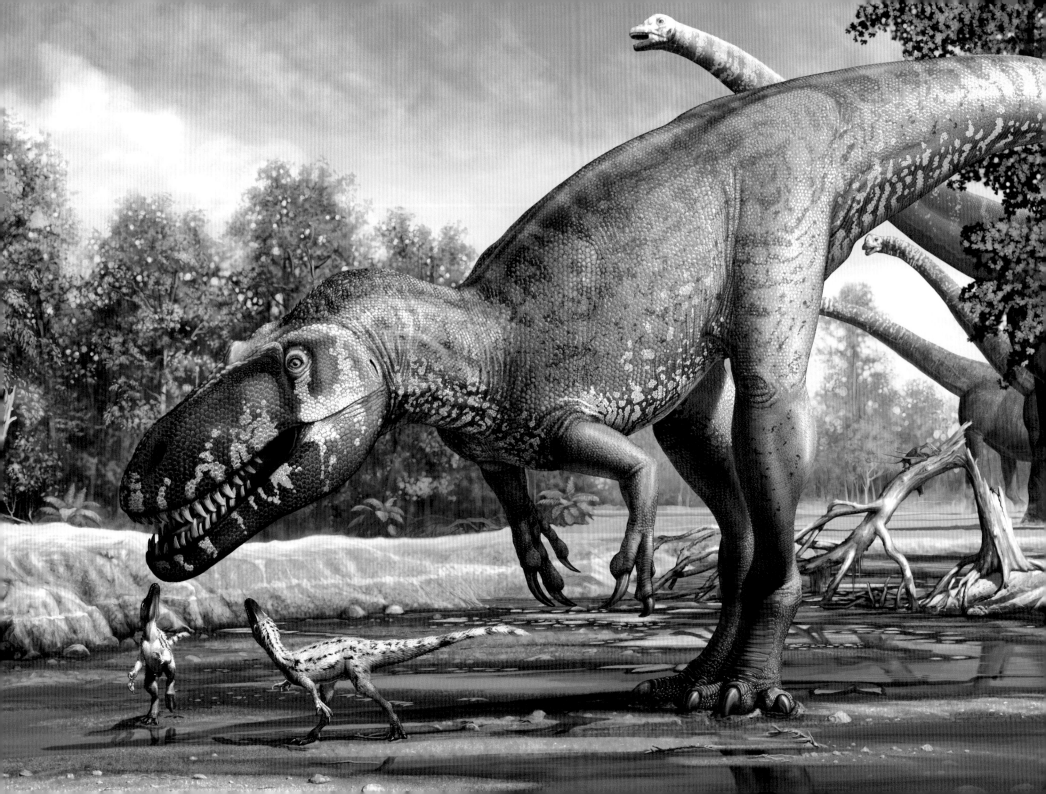

I've been drawing dinosaurs since I was seven years old. At that time I was greatly impressed by their wild beauty, and I began to make tracings of dinosaur drawings that I found in books. The artist who first impressed me was Zdenek Burian, in his colorful illustrated albums, published in the USSR by the Czech publishing house Artiya.

Another major influence was Ruben Varshamov, a Soviet and then Russian animal artist and illustrator of children's books. Books with his illustrations became available in the late 1980s. His soft watercolor technique is fascinating. I also remember the illustrations by Konstantin Flerov in *Children's Encyclopaedia*. You can see his work in the Museum of Paleontology in Moscow. And of course I want to mention Zdeněk Burian. An art book with his illustrations came into my hands in 1986, and I copied pretty much all of his illustrations, probably more than a hundred.

You could say that I became an artist because of my love of dinosaurs. I was very fond of drawing, so I entered Lugansk Art College, where I studied classical painting. The textbooks were filled with the landscapes and nature scenes of Ivan Shishkin and Alexei Savrasov, which had a lasting impression on me.

In the 1990s we started seeing foreign literature translated into Russian. That was when I first saw the work of John Sibbick and Douglas Henderson. Oh! It was magnificent. Now, in the era of the Internet, access is much better; you can easily get information about all the new discoveries in paleontology and keep an eye on new trends in paleoart.

In my works I try to accommodate different styles and trends. I read the viewers' comments carefully. I try to have a thoughtful attitude towards criticism; it helps me to come to the right conclusions. In general I try to give the audience what they want. You could say that the consumers determine my style.

When I'm working on an illustration, I want it to look a bit retro, even if I use digital technology. I consult with professional paleontologists about the anatomy and the habitat of the dinosaurs I'm drawing. It's invaluable to work directly under the supervision of a paleontologist, like the time I did some illustrations of *Torvosaurus gurneyi* under the direction of Christophe Hendrickx, a paleontologist from Portugal.

Dinosaurs fire my imagination. I imagine the Mesozoic landscape as full of beautiful colors and shades, although dinosaur coloration is the fantasy of the artist, since we don't know what color they were. That's changing, though. Recent studies have identified the color information in cells called melanosomes. For example, when studying the remains of a microraptor, scientists determined from a fragment of an impression of its plumage that the microraptor had iridescent black feathers.

I don't have a special attachment to any particular kind of dinosaur. Maybe I am attracted to the whole group of theropoda. In my childhood I loved predators, like most boys I guess. That infatuation has stayed with me all these years. Most often I am asked to draw dinosaurs, although I have worked on Permian reptiles, and at times on Cenozoic mammals.

As a paleo-animalist, I consider many factors: the lifestyle of the animal; its character; the habitat where it lived. I compare the dinosaur's habitat to that of today's animals and I build my own color scheme.

I hope that eventually my illustrations will inspire people and make them fall in love with paleontology and dinosaurs.

Torvosaurus gurneyi
I created this illustration at the request of Christophe Hendrickx. Christophe, in collaboration with world-renowned paleontologist Octavio Mateus, wrote a description of *Torvosaurus gurneyi*, the giant monster from Portugal.
My illustration, which accompanied the text, was presented at two international competitions,
VI International Contest of Scientific Illustrations of Dinosaurs, 2014 and *International Dinosaur Illustration Contest (CIID) 2014*.
It received jury awards.
2D digital

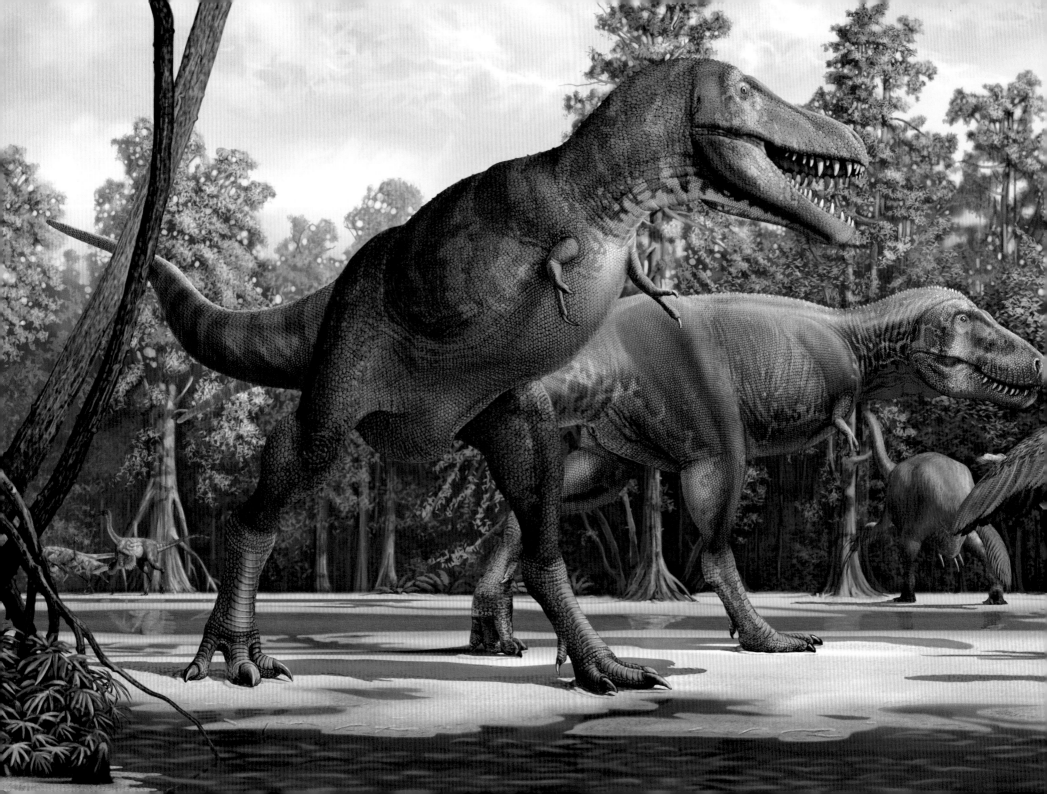

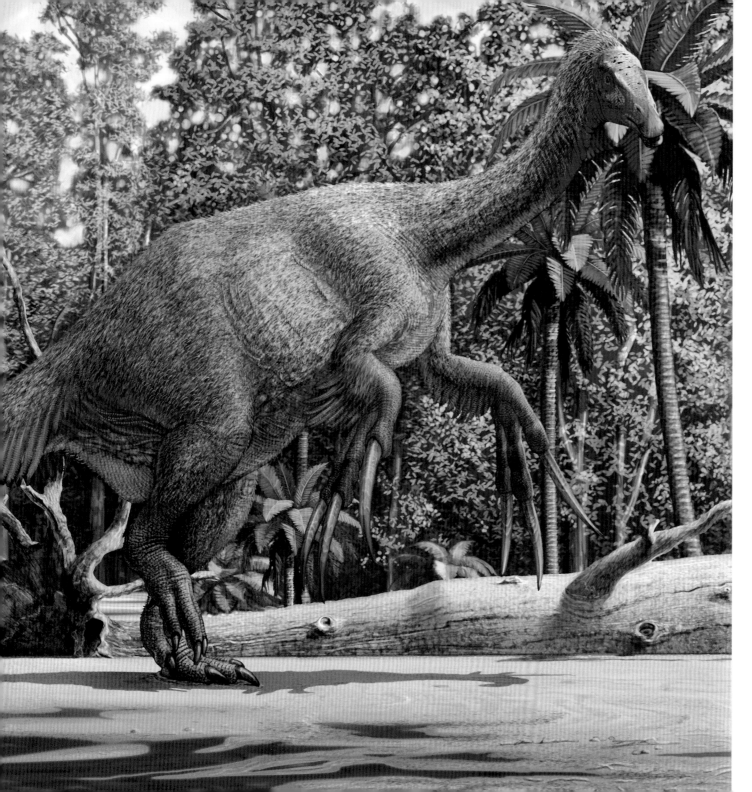

Cretaceous Mongolia
Male and female *Tarbosaurus bataar* following a
Therizinosaurus cheloniformis.
Upper Cretaceous Mongolia.
2D digital

101

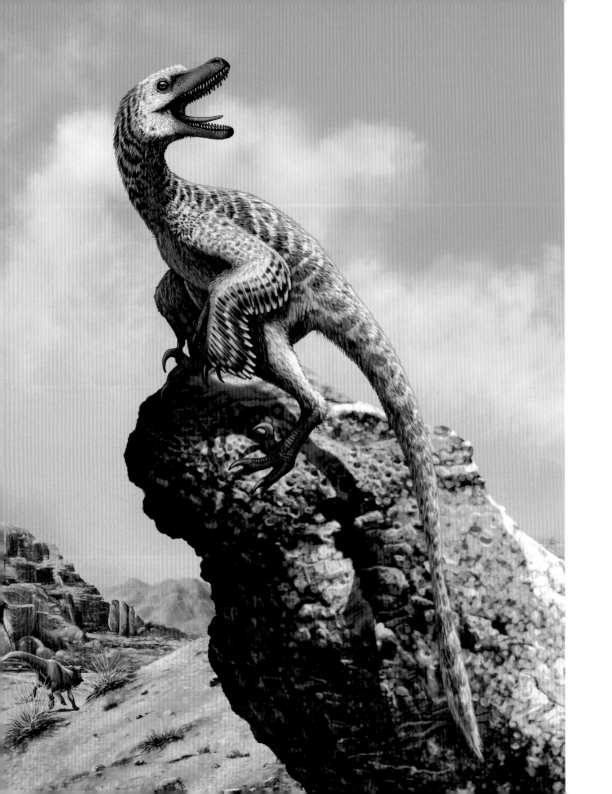

Velociraptor mongoliensis
Velociraptor mongoliensis is a representative Cretaceous Mongolian fauna.
This small hunter probably had feathering; traces of feather attachments have been found on
Velociraptor mongoliensis bones.
2D Digital

p.103
Tarchia kielanae vs Saurolophus angustirostris
These creatures, also from Cretaceous Mongolia, are confronting two herbivores.
This would not have been a common sight, but when an uninvited guest approaches her sculpted
nest, the mother had to do whatever she could to protect her eggs.
Traditional watercolor/gouache

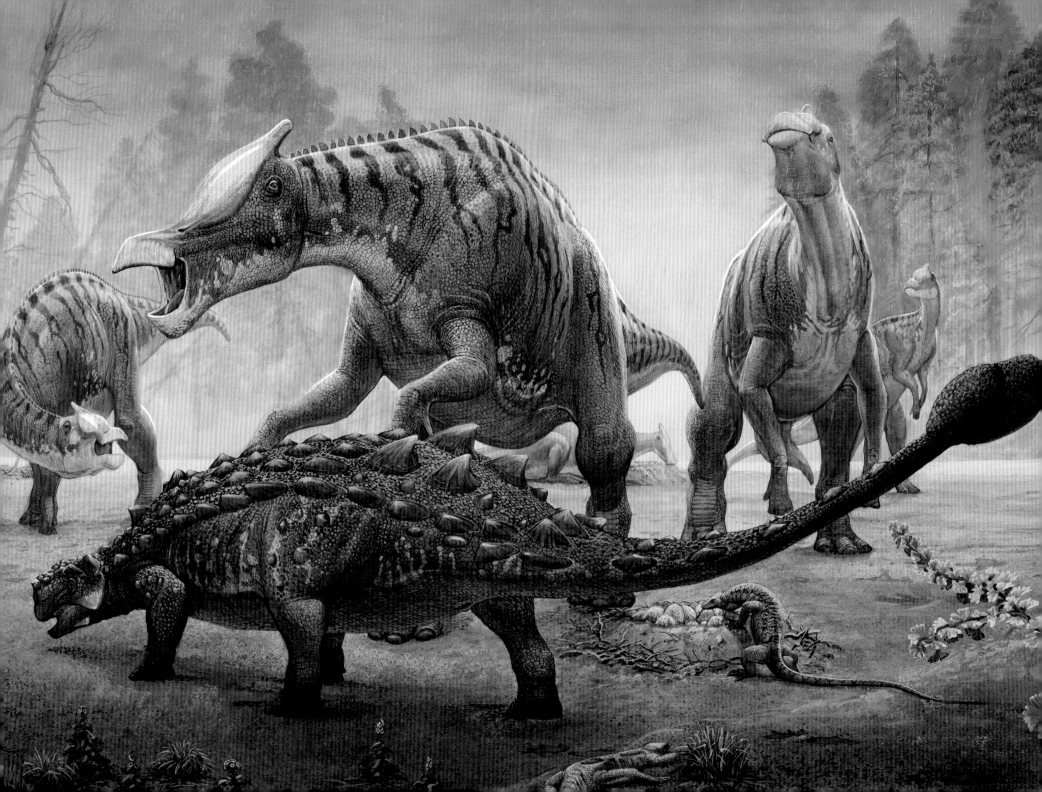

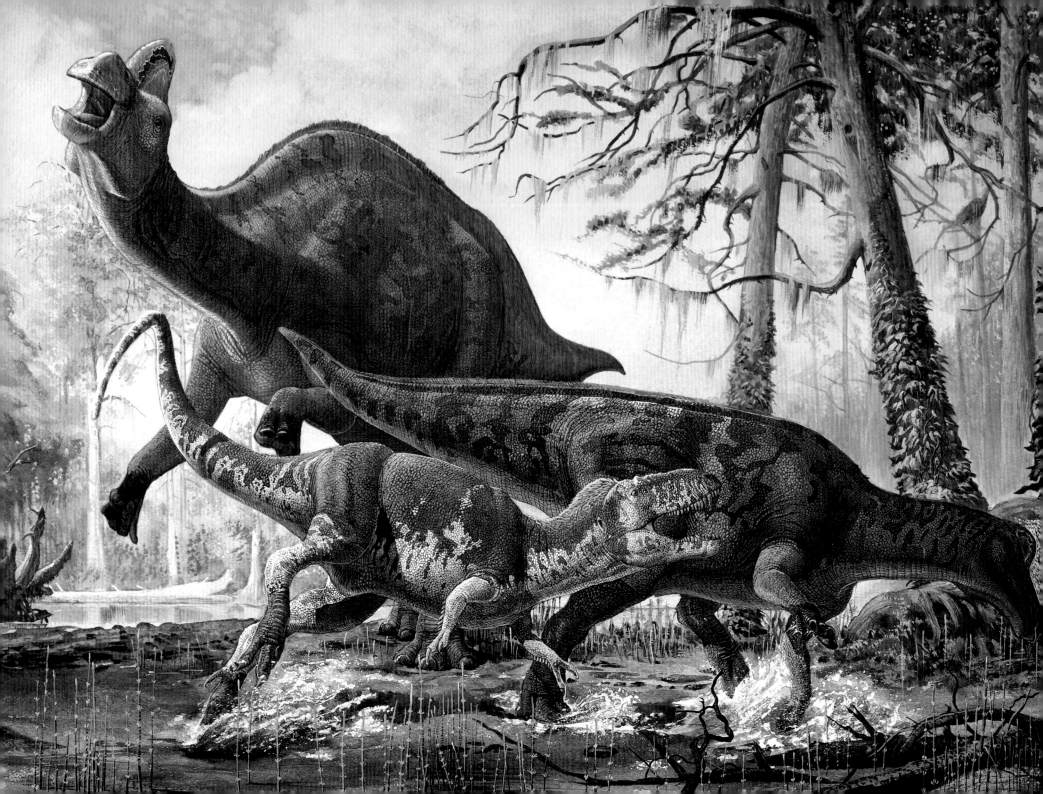

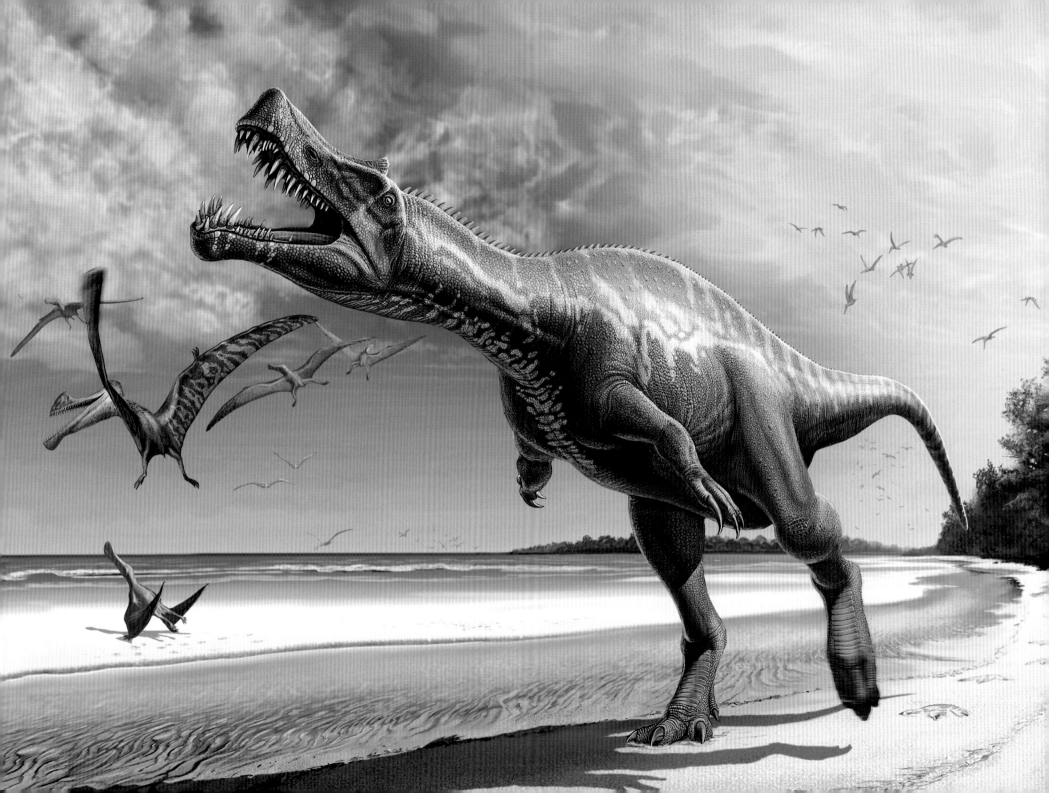

Liopleurodon ferox
A typical pliosaur from the Jurassic period in England, with a long narrow head. The four powerful fins, which this pliosaur moved much as a bird moves its wings, suggest that *Liopleurodon ferox* was a good swimmer.
2D Digital

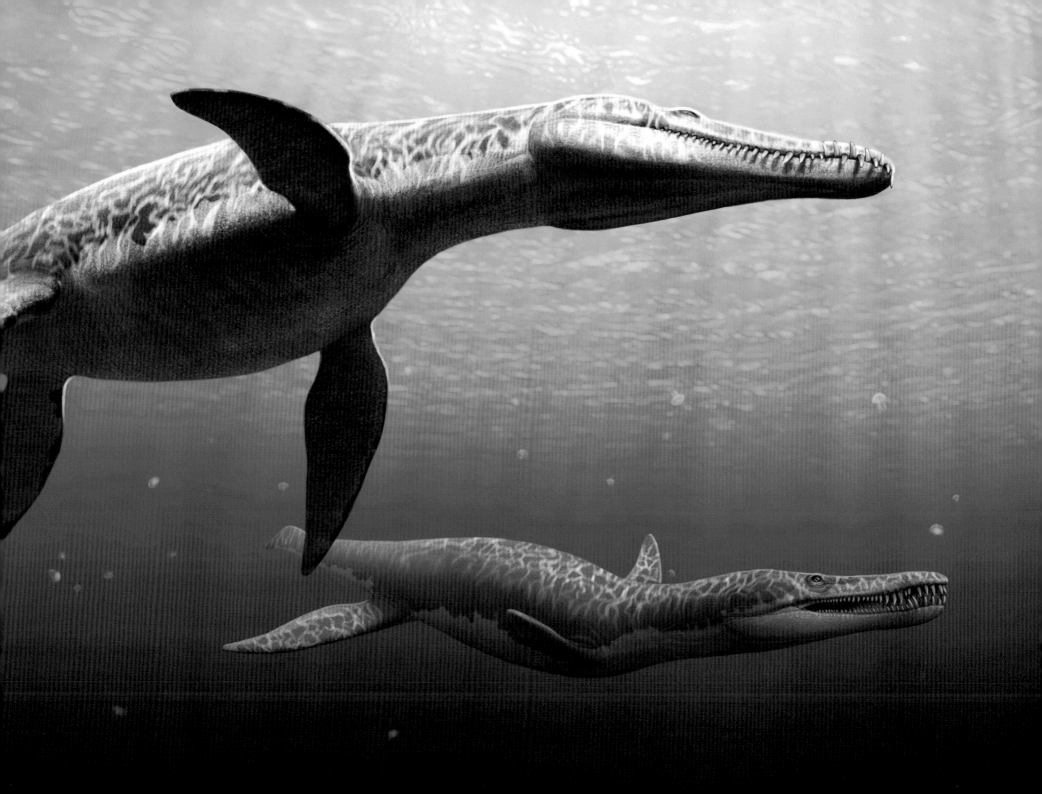

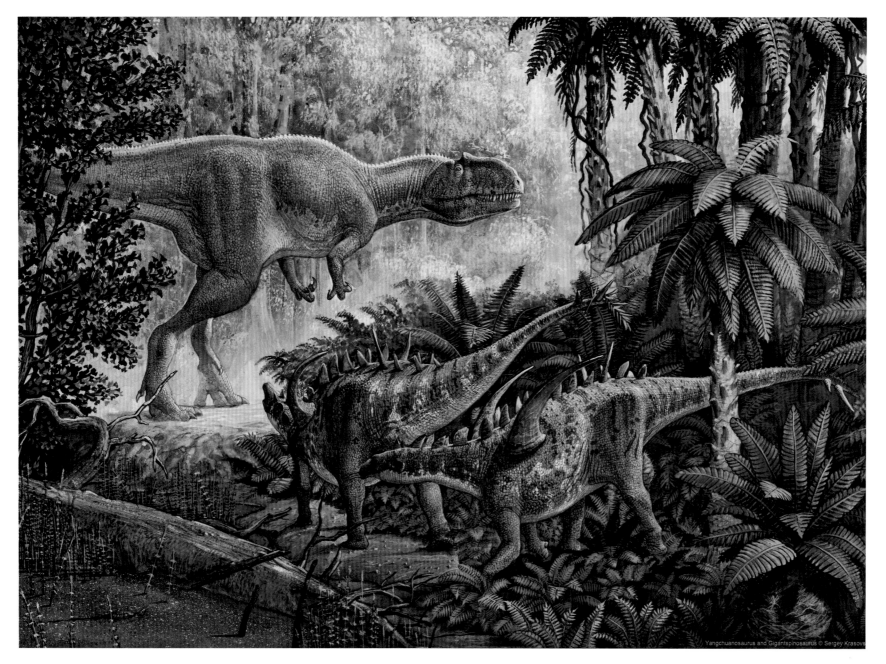

Yangchuanosaurus and Gigantspinosaurus © Sergey Krasovs

p.109

Jurassic China
Yangchuanosaurus shangyouensis and *Gigantspinosaurus sichuanensis*.
The *Gigantspinosaurus* is roaring menacingly and flicking its tail nervously.
Traditional, watercolor/gouache

Amurosaurus riabinini
These bird-hipped dinosaurs, from the subfamily Lambeosaurinae, lived at the end of
the Cretaceous (upper Maastrichtian). They were found in Blagoveshchensk in Russia.
Traditional, watercolor/gouache

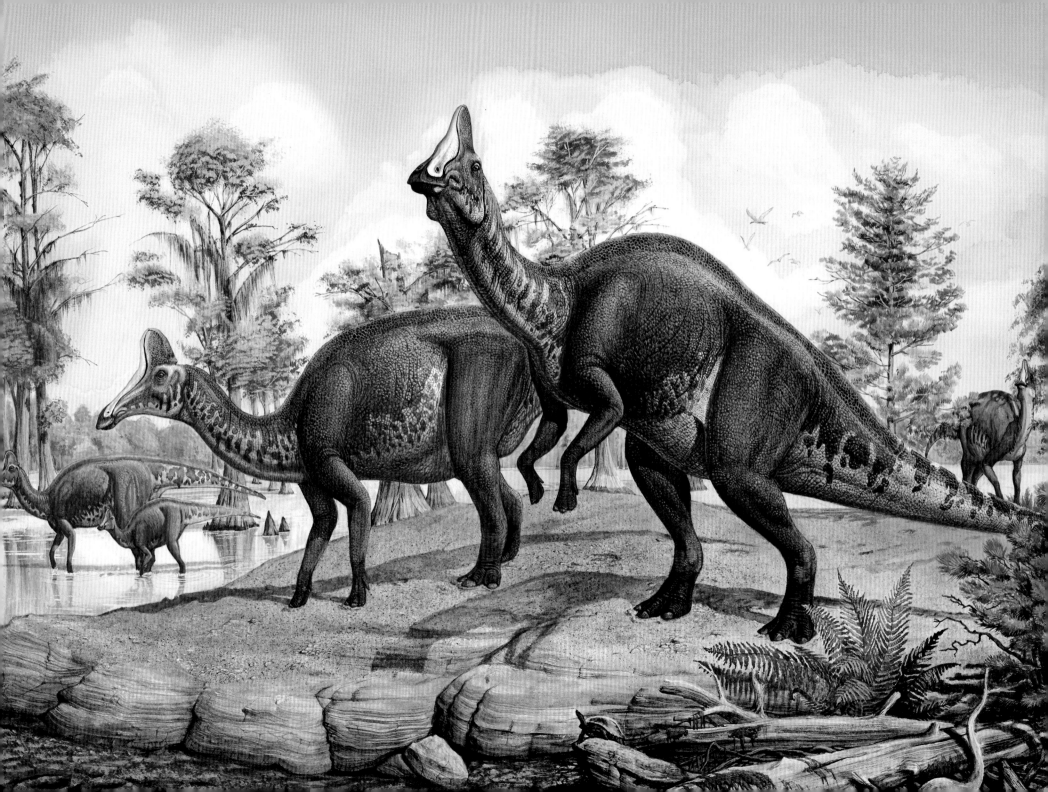

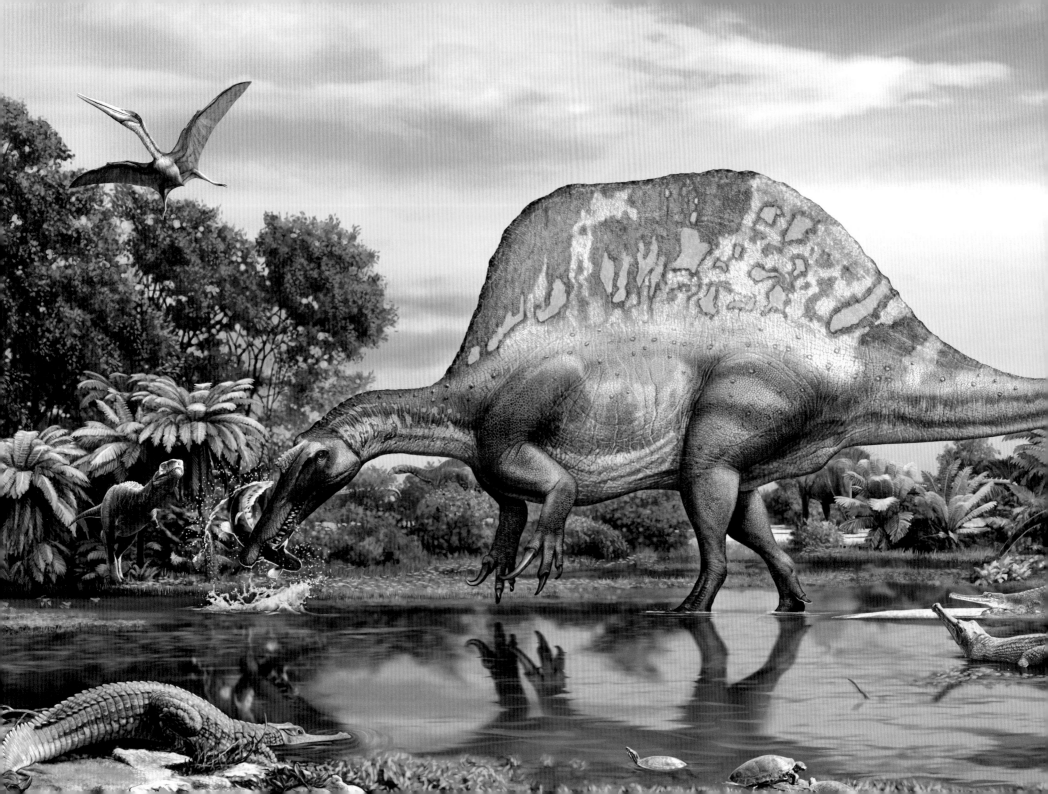

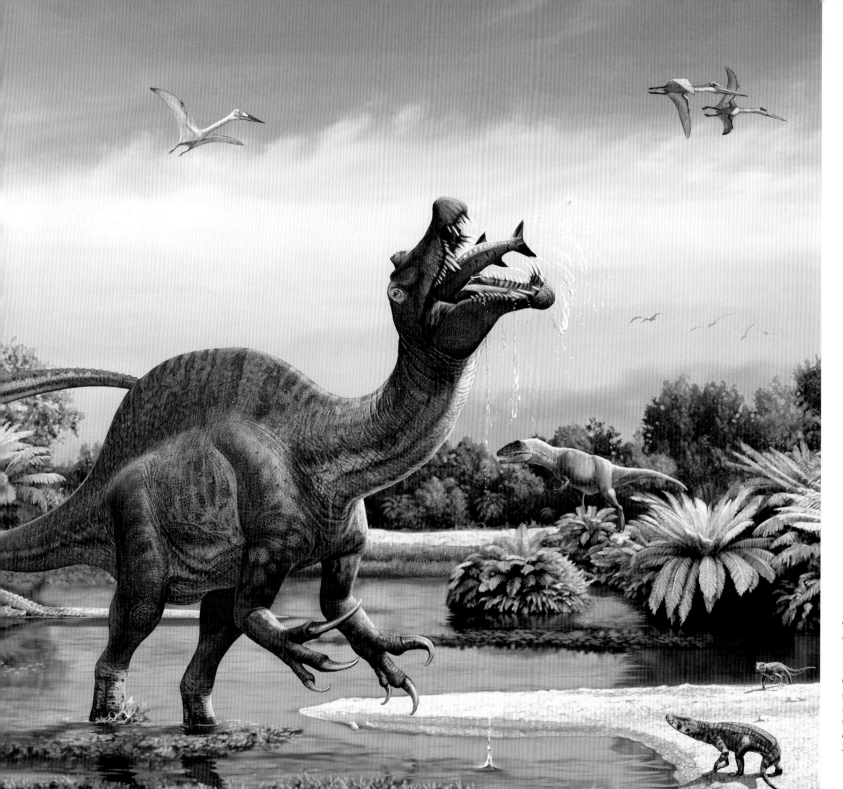

The Kem Kem Formation
Two species of Spinosauridae,
Spinosaurus aegyptiacus and
Sigilmassasaurus brevicollis, from
Cenomanian North Africa. Also within
sight are the small crocodylomorpha
Hamadasuchus rebouli (right) and the
neosuchian crocodyliform *Elosuchus
cherifiensis* (left).
2D Digital

111

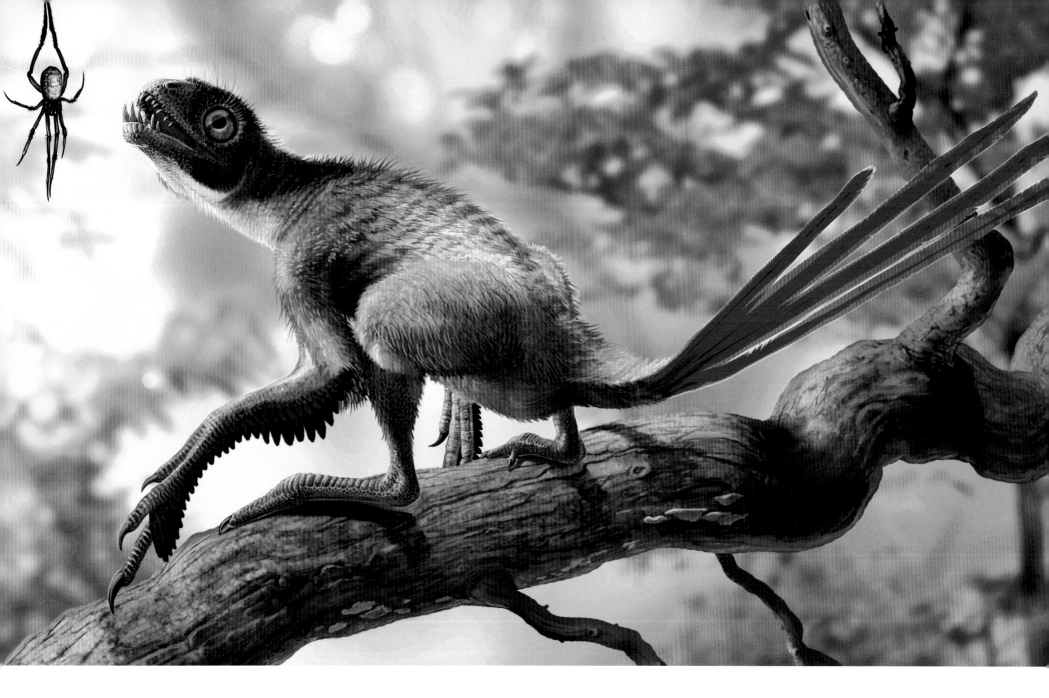

Epidexipteryx hui and Nephila jurassica
Epidexipteryx hui, a feathered theropod dinosaur of the family scansoriopteryx,
lived in China 165 million years ago. *Nephila jurassica* is a spider from genus nephila.
2D Digital

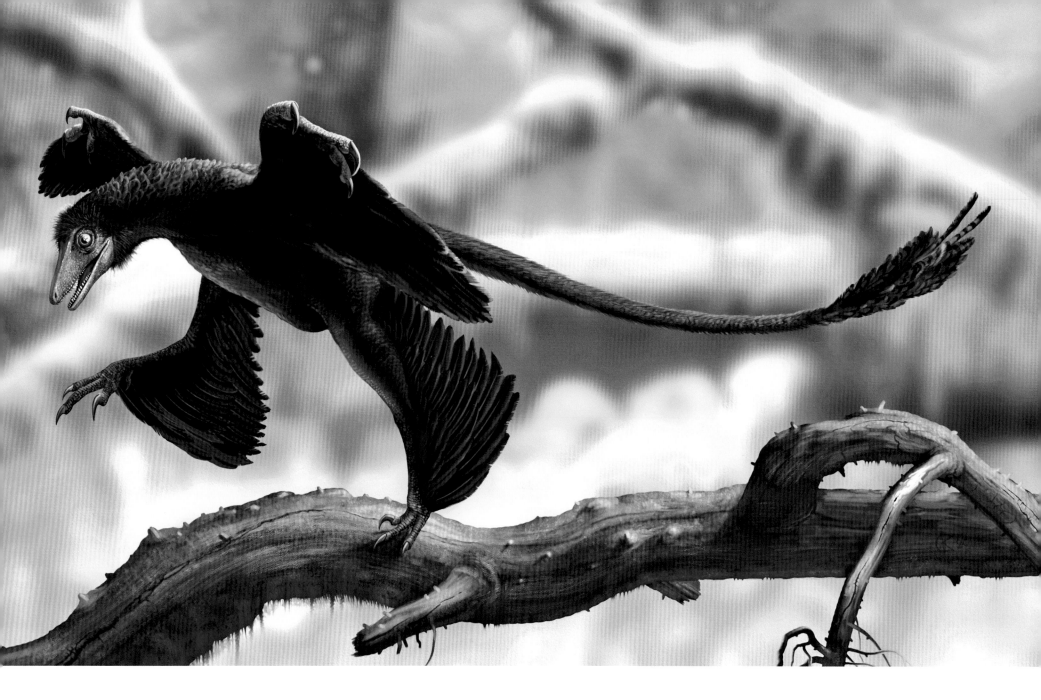

Microraptor gui
Perhaps the smallest known dinosaur, *Microraptor gui* is unique
in that it had four wings that also functioned as hands and feet.
2D Digital

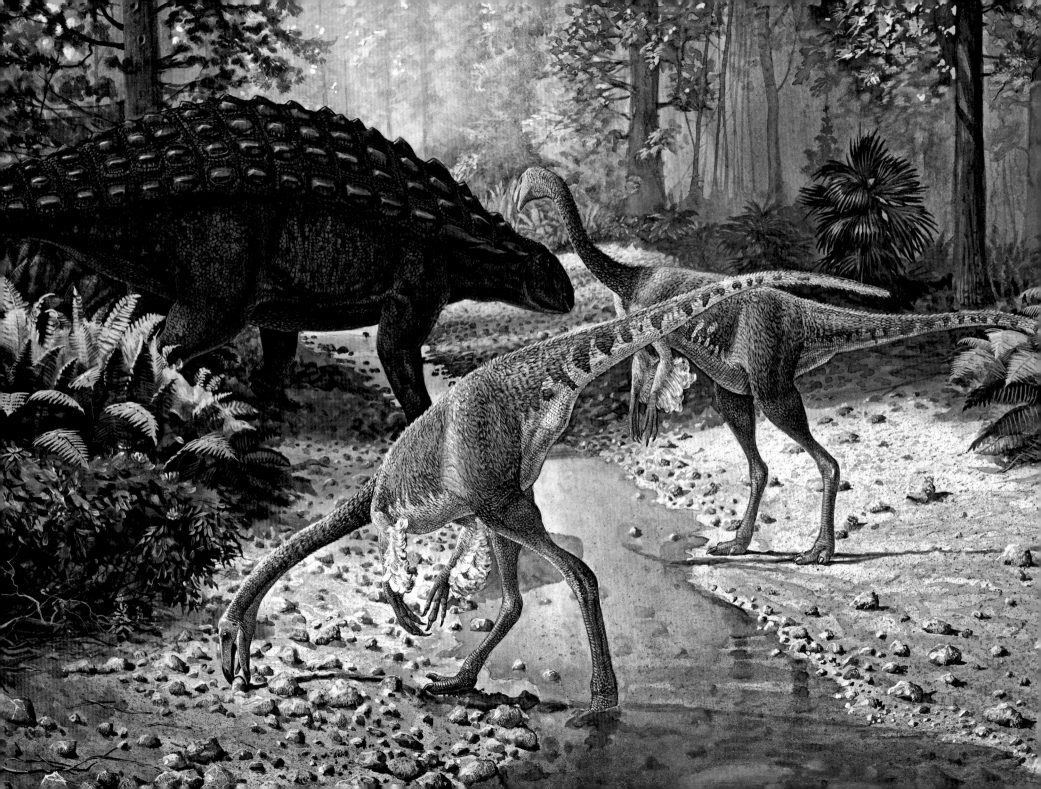

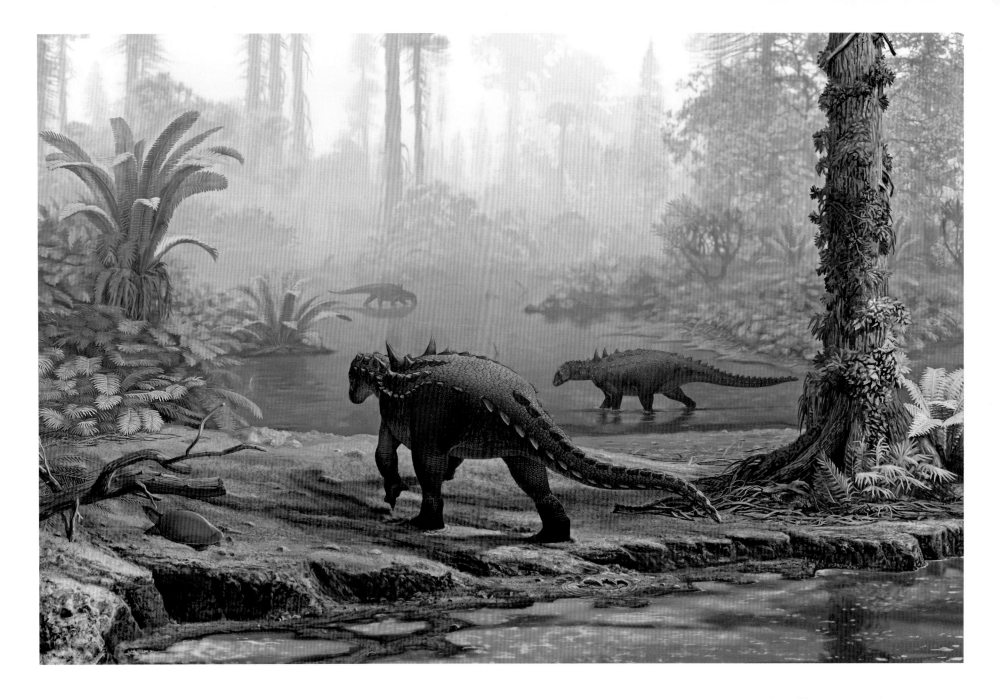

p.114

Ornithomimus and _Panoplosaurus_
Ornithomimus (foreground) and _Panoplosaurus_ (to the rear) inhabited the territory of
North America in the upper Cretaceous Period.
Traditional, watercolor/gouache

Struthiosaurus austriacus
The armored _Struthiosaurus austriacus_
lived in Europe in the Late Cretaceous period.
3D Digital

Rodolfo Nogueira

Rodolfo Nogueira is a paleoartist and a graduate in industrial design. He developed and published a scientific methodology, Paleodesign, for restoring extinct animals. He has worked in museums in Brazil, Argentina, Spain, the United States, Portugal, Germany and Georgia. With more than 15 years of experience in artistic illustration and 10 in scientific illustration. His illustrations have been printed on Brazilian postage stamps and in the *Dinosaurs of Brazil* line of toys. He has published illustrations in textbooks, scientific journals (*Plos One, Cretaceous Research, Journal of Vertebrate Paleontology*, and others) and in magazines such as *Scientific American*, *BBC* and *National Geographic*. He has received eight international awards including the 2015 Lanzendorf Scientific Illustration Award. He is the creator of the characters of the virtual reality exhibition *Dinos from Brazil*, and the illustrator of the book, *Brazil of the Dinosaurs*. He teaches in the Megafauna Project, and he designed the spaces of the project *Geopark Uberaba – Land of the Dinosaurs of Brazil*. He currently leads Prehistoric Factory, a design company focused on scientific illustration.

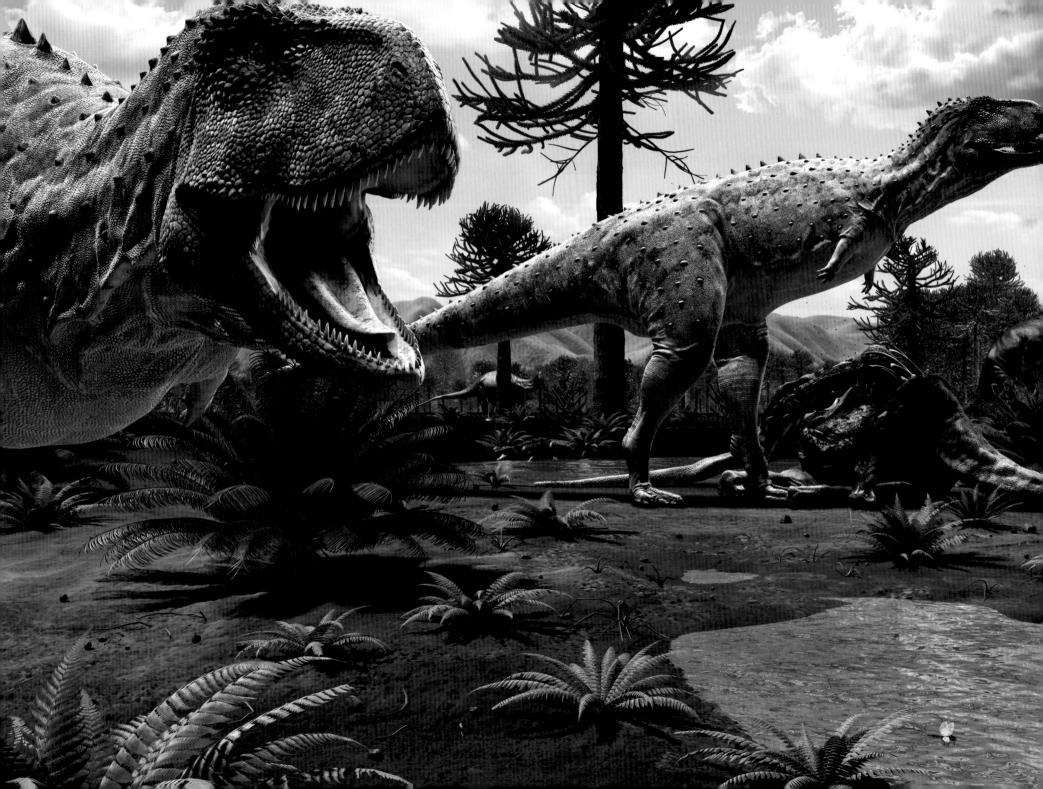

I was a peculiar kid, passionate about certain subjects. For example when I was eleven I wanted to be an oceanographer or a twister hunter. I was quite taken with the Disney movie, *Dinosaur* and the dinosaur theme caught me for good. At that time I went to drawing classes in the hope of becoming a less hyperactive child; the secrets of drawing gave me great personal power.

I imagine the age of dinosaurs as an untouched Eden, a paradise lost in time, a reliquary of mysteries that can only be unveiled through the application of art to science. I think dinosaurs are an expression of nature's audacity and evolution in creating such diverse and powerful forms. They are a great mystery because we do not know exactly what they were like, and this lets our imagination fill the gaps, which we do as best we can. This delightful exercise makes the extinct animals very charming and ends up turning them into stars or dolls of science, stimulating thoughts and evolutionary questions in people's minds. In that sense dinosaurs and prehistoric animals have a great social responsibility in terms of education, science communication and the like.

I believe that extinct animals, mainly dinosaurs, remind us of a special, deep and forgotten time where the world was pure and untouched by human hands. I also believe they bring us some kind of insight into humanity with its hegemony and eventual extinction. We have hegemony over the planet but we need to transform ourselves to avoid the worst.

In that sense paleoart not only raises questions concerning the extinct geological past and even the preservation of our present Earth, but also about transforming ourselves, extinguishing our inner giant beasts of pride and presumption and letting our light feelings come to the fore.

In my work I first focus on the scarce, objective scientific data and go as far as I can without losing scientific coherence. Then I try to portray dinosaurs as real and natural animals that sleep, breathe and simply live, but at the same time have this fantastic, grandiose aspect.

My work usually goes in four steps. First I gather all the data I need to know about each species that I am going to restore, usually in a briefing. Then I rebuild each animal from the inside

out in a neutral posture, first the skeleton and the musculature. Then, based on the behavior patterns associated with the environment of related or similar contemporary animals, I restore the skin and coloration.

Depending on the requirements of the work, I apply the same process to each animal and plant that shared that space, and reconstruct the whole environment. Finally I insert the main model and give it interactions with the environment (shadows, reflexes, movements).

Although I love drawing with pencil and ink, I usually work in the digital environment from beginning to end, from the first draft to the final render. I build the elements through 3D modeling by changing the coordinates of millions of polygons' vertices. It is very similar to the construction of a real mockup or diorama, in which I sculpt each element, pose it, illuminate it and then photograph it. I believe that digital techniques, mainly 3D modeling, allow superior dynamism and enable the use of technological resources such as virtual reality, augmented reality and prototyping.

Daily Life in the Brazilian Cretaceous
This scene is in what is now Brazil's state of Minas Gerais, 70 million years ago.
The climate changed from semiarid to rainy at certain times of the year.
Temporary rivers formed and vegetation appeared, including cicas,
araucariaceas and ferns. Here terrestrial crocodiles, carnivorous dinosaurs such as
Abelissaurus and giant sauropods have gathered to feed.
3D digital sculpture and digital illustration

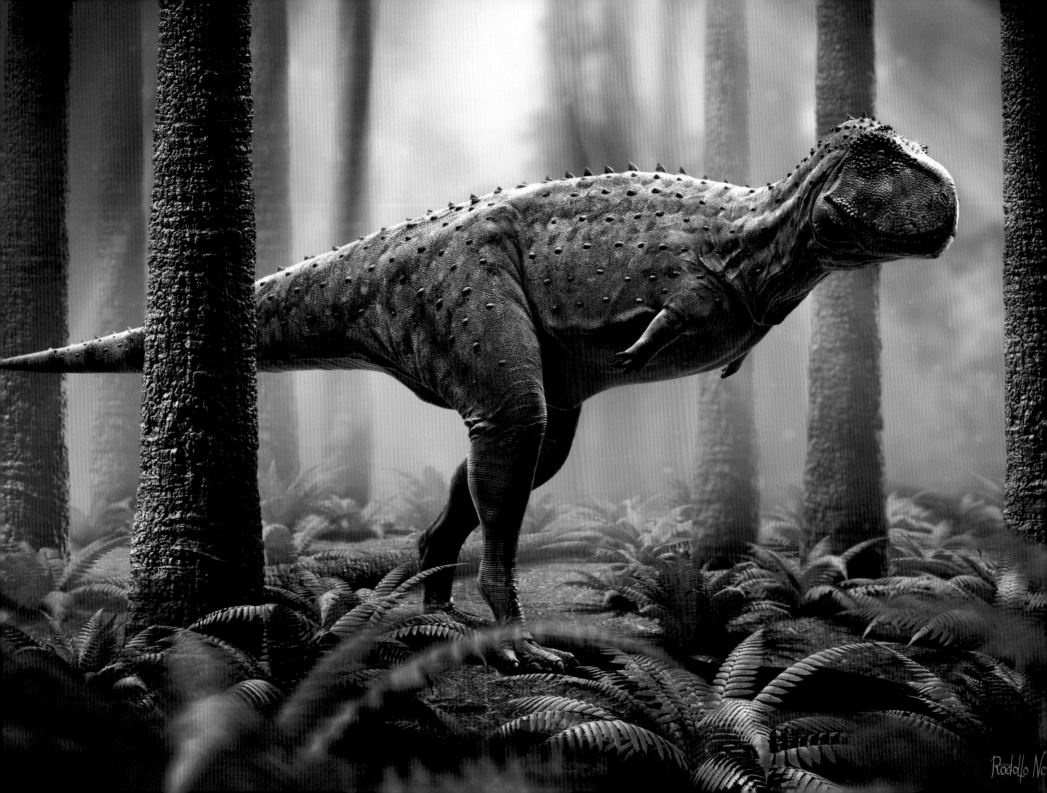

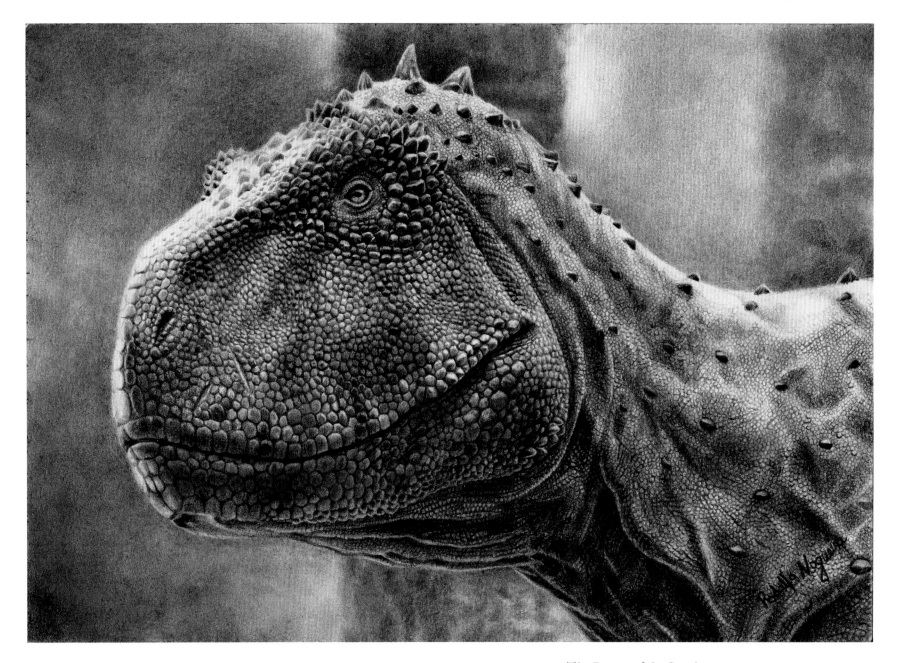

p.120
Silence in the Forest
All the animals would fall silent when a seven meter predator like
Skorpiovenator bustingorryi walked through the woods in search of prey.
These abelissauridae dinosaurs were the dominant predators of the southern
regions of the planet in the Cretaceous period.
3D digital sculpture and digital illustration

The Prince of the South
Skorpiovenator bustingorryi, a genus of abelisaurid dinosaur from the late
Cretaceous period in Argentina, lived 95 million years ago.
It reached seven meters in length and its name, "scorpion hunter,"
refers to the abundant scorpions present at the dig site.
Graphite pencil

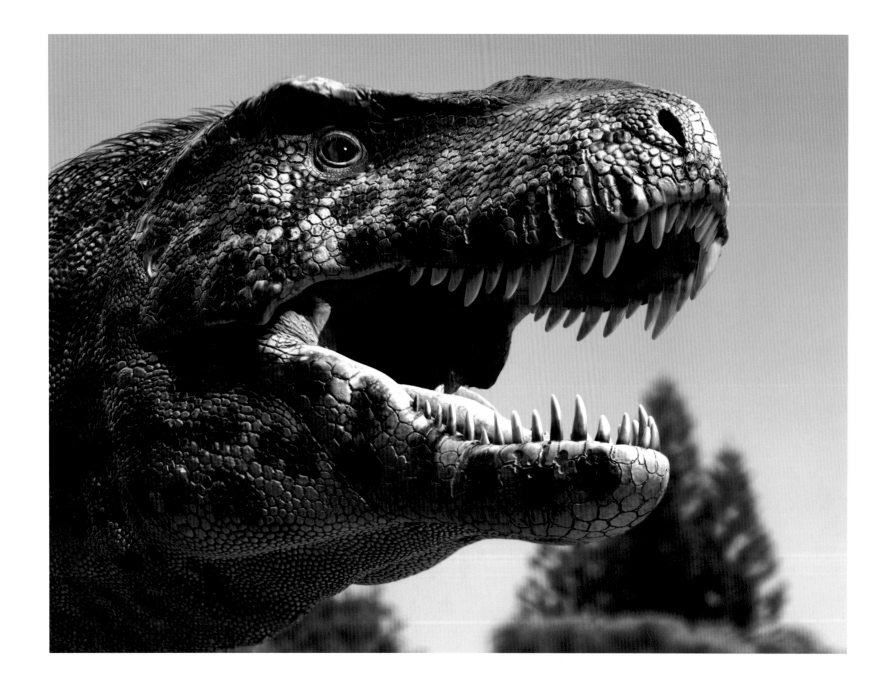

The King Close Up
Every paleoartist pays homage to *Tyrannosaurus rex*, the king of the dinosaurs.
This is my vision of this incredible 12 meter predator.
3D digital sculpture and digital illustration

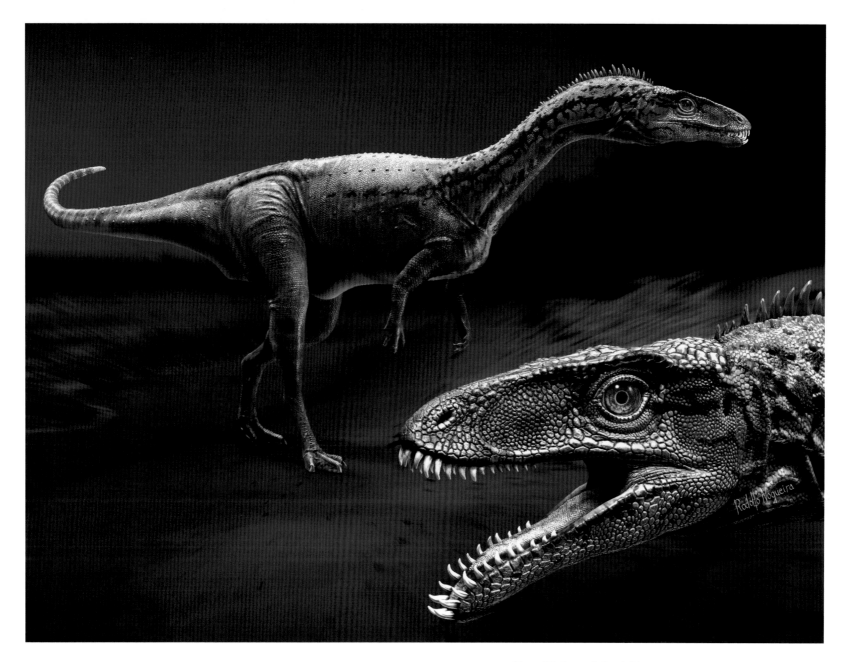

Grandfather of the Africans

The fossils of this two-meter predator were found in 2001 in Madagascar, but in 2012 very similar teeth were found on Cajual Island in the state of Maranhão in Brazil. Probably this *Masiakasaurus* found in Brazil was an ancestor of the animals whose remains were found in Africa. It belongs to the noasauridae group, small to medium size fish eaters with relatively long arms.

3D digital sculpture and digital illustration

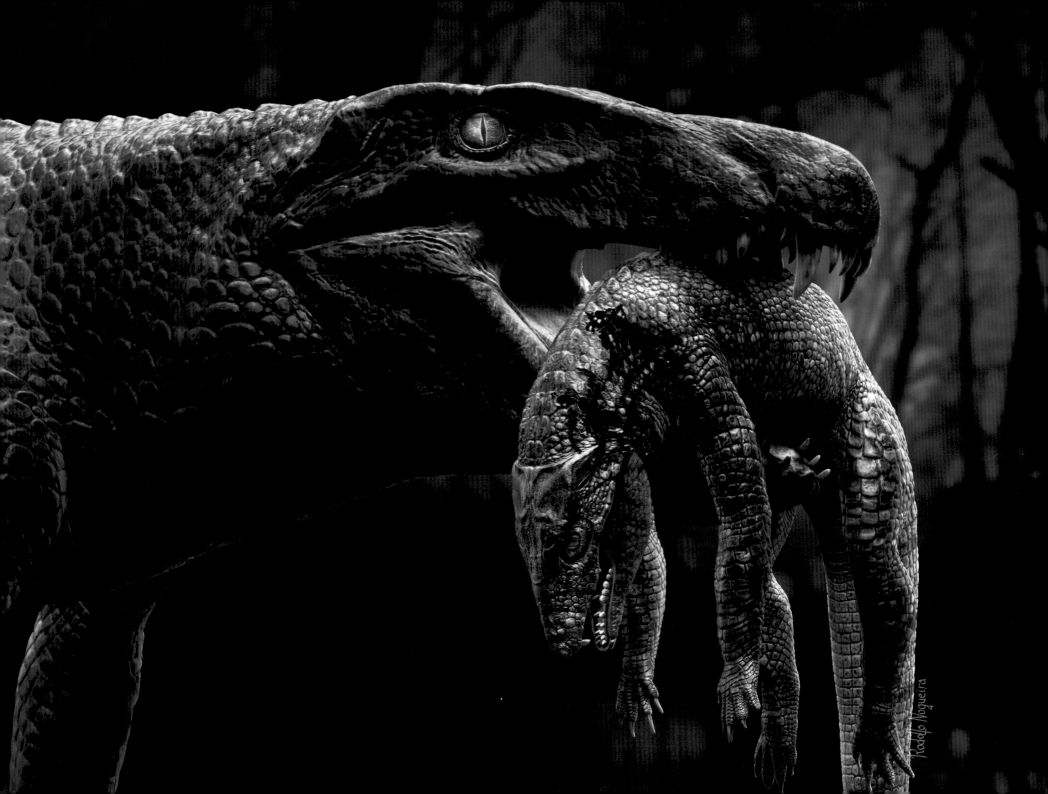
Rodolfo Nogueira

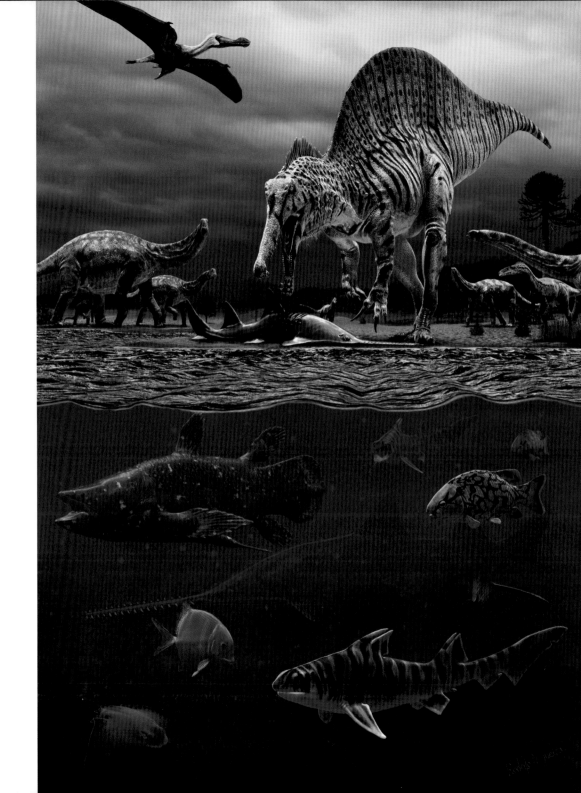

p.124
Dining in the Cretaceous
Terrestrial crocodiles with large, body-length dorsal ridges were a plague in
the Brazilian Cretaceous. This baurusuchidae, *Aplestosuchus sordidus* "filthy,
gluttonous crocodile", lived in southeastern Brazil 90 million years ago.
The fossil skeleton of this creature, more than two meters long, was found
preserved inside the abdominal cavity of another fossil crocodile from the
sphagessaurids group.
3D digital sculpture and digital illustration

Party on the Island
This illustration shows some of the magnificent cretaceous fauna whose
remains were found on Cajual Island in the state of Maranhão, Brazil.
On the left, a pterosaur, *Anhangueridae*, is flying above a family of
Titanosauridae, herbivorous dinosaurs. Looming on the right,
Oxalaia quilombensis, one of the largest carnivorous dinosaurs of Brazil,
is about to feed on an atlanticopristis shark. Some sauropod dinosaurs,
Andesaurus, stand by in the distance on the right and a smaller carnivorous
dinosaur, *Masiakasaurus*, is in the foreground. Under the surface of the water,
we can see a fish of genus mawsonia and a tribodus shark in the foreground.
3D digital sculpture and digital illustration.

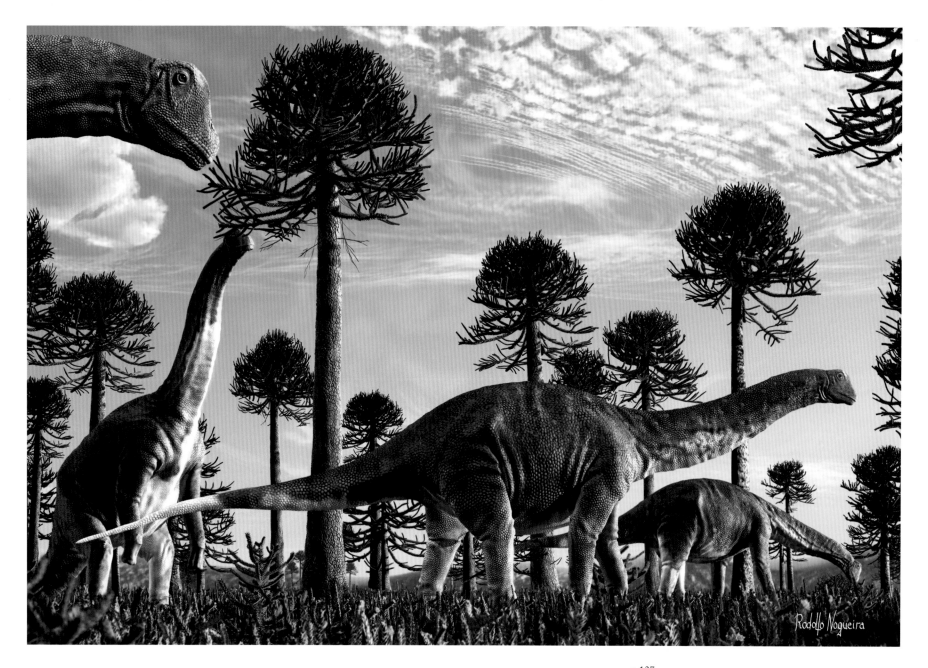

Rodolfo Nogueira

The Dawn of the Titans

65 million years ago, the sun rises in what is now Minas Gerais state in
Brazil, lighting up the breakfast of the largest Brazilian dinosaur, *Uberabatitan
ribeiroi* (titan of the city of Uberaba).
3D digital sculpture and digital illustration

p.127
The Giant in Bones

Uberabatitan ribeiroi, a dinosaur belonging to the titanosauridae group, could
reach 25 meters in length. It has been found in the most recent rocks of the
Brazilian Cretaceous, which date to 65 million years ago.
3D digital sculpture and digital illustration

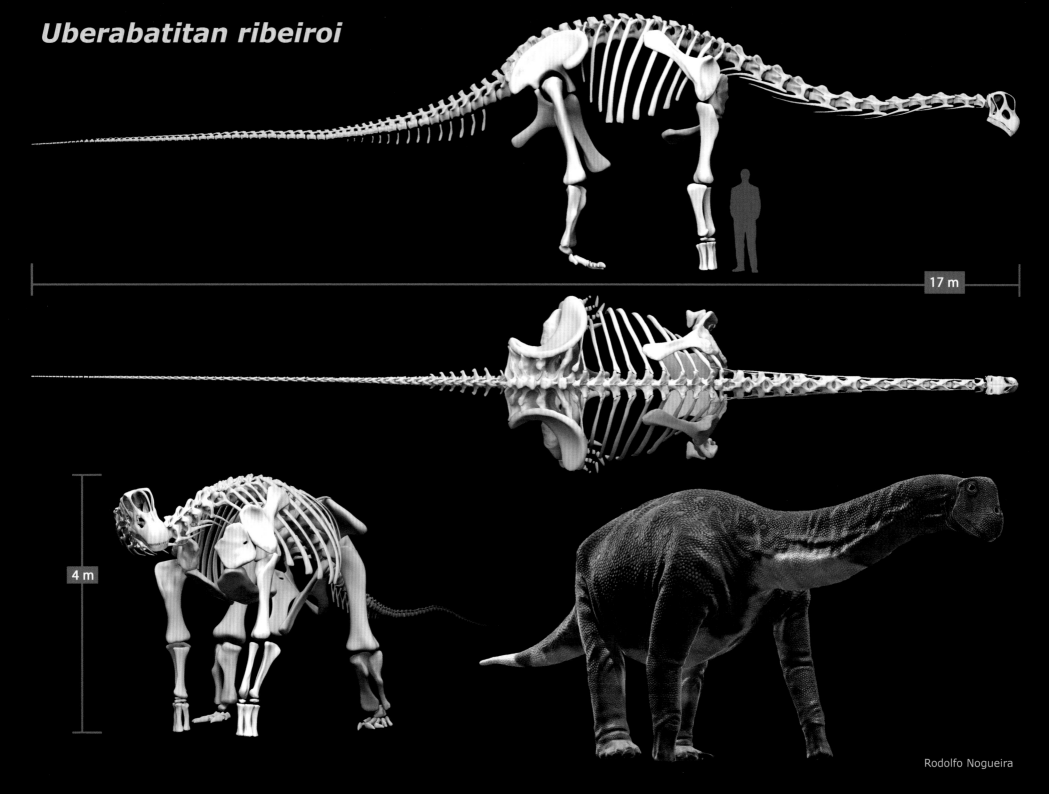

Uberabatitan ribeiroi

17 m

4 m

Rodolfo Nogueira

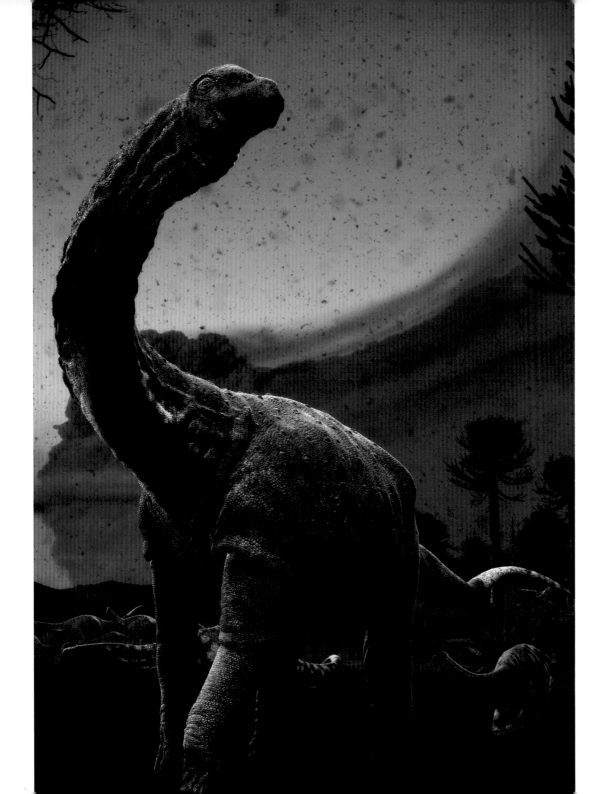

The Titanic Volcano
At the end of the Cretaceous, in the region that is now Minas Gerais, a super volcano erupted and spread its ashes for a radius of more than 150 km, covering the environment where the giants *Uberabatitan ribeiroi* and *Abelissaurus* lived. This super volcano may have been responsible for a local extinction.
3D digital sculpture and digital illustration

p.129
Celestial Majesty
Tupuxuara is a genus of crested, toothless pterodactyloid pterosaurs that lived 110 million years ago.
Up to five meters long, they had crests some 60 centimeters high.
Tupuxuara means "a familiar spirit" in the indigenous Tupi language.
3D digital sculpture and digital illustration

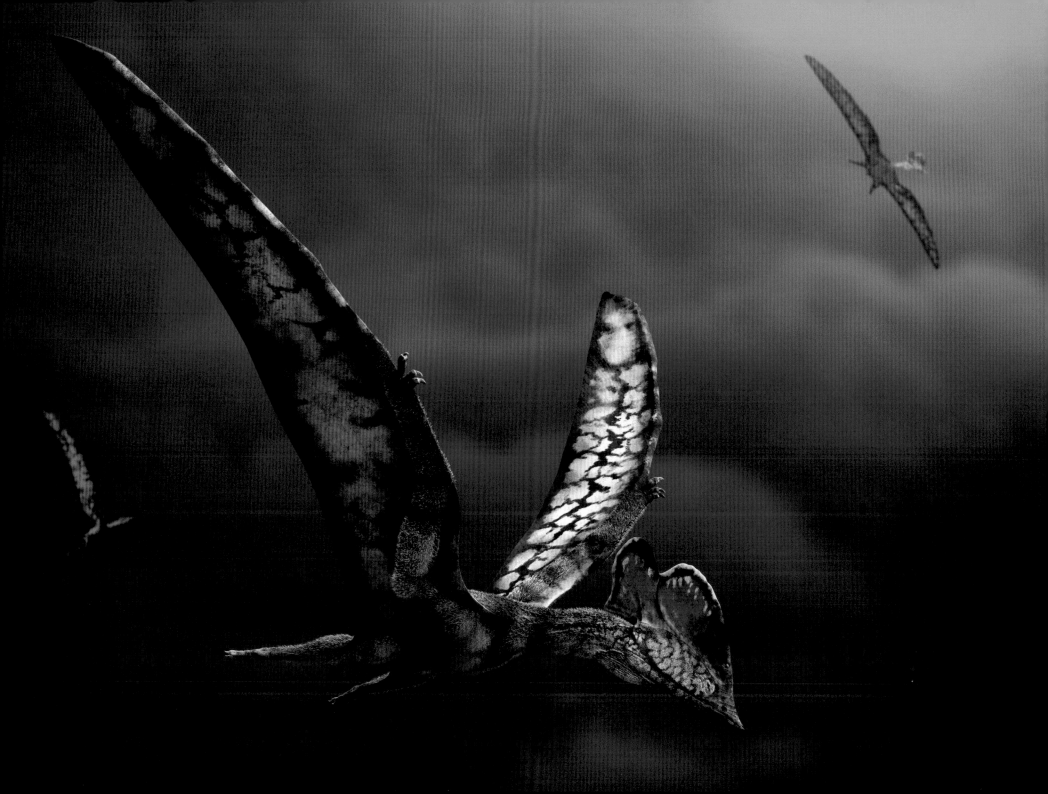

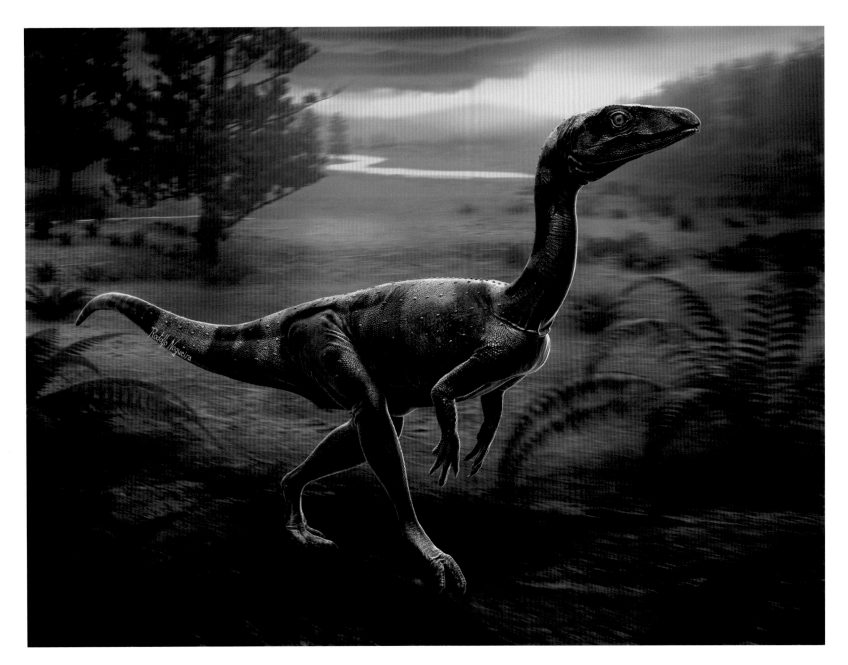

The Pampa Racer
Pampadromaeus barberenai is the oldest dinosaur found in Brazil.
It was probably a basal sauropodomorph about 1.2 meters long.
It lived in the southern region of the country 230 million years ago.
Its name means "pampa racer."
3D digital sculpture and digital illustration

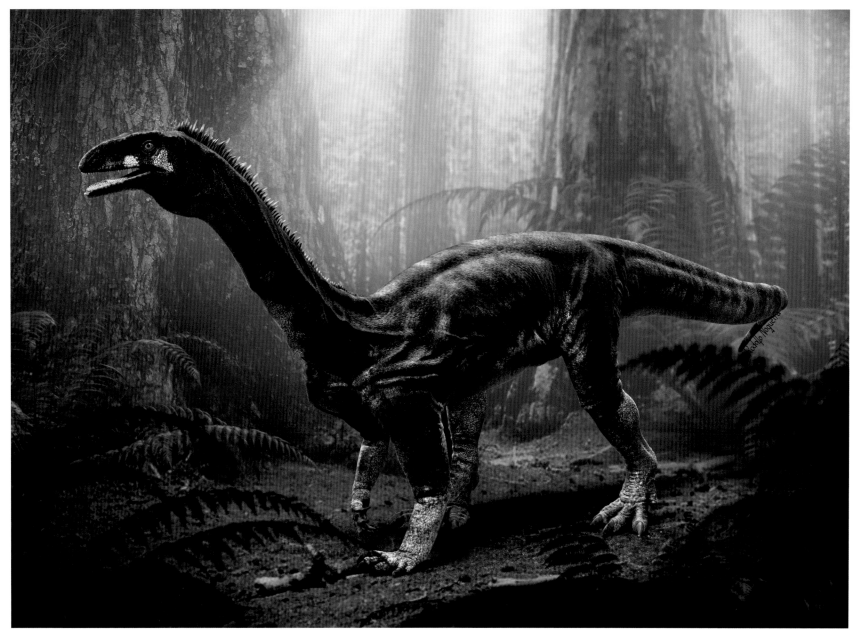

Ancient Carnival

Saturnalia tupiniquim is a primitive dinosaur found in rocks 225 million years old.
It has a slightly confused phylogeny; probably it belongs to the group of sauropodomorph
dinosaurs, but it has characteristics of theropods as well. It reached 1.5 meters in length.
Its remains were found during carnaval, a festival originating from the feast of the Roman
winter solstice in celebration of the god Saturn.
3D digital sculpture and digital illustration

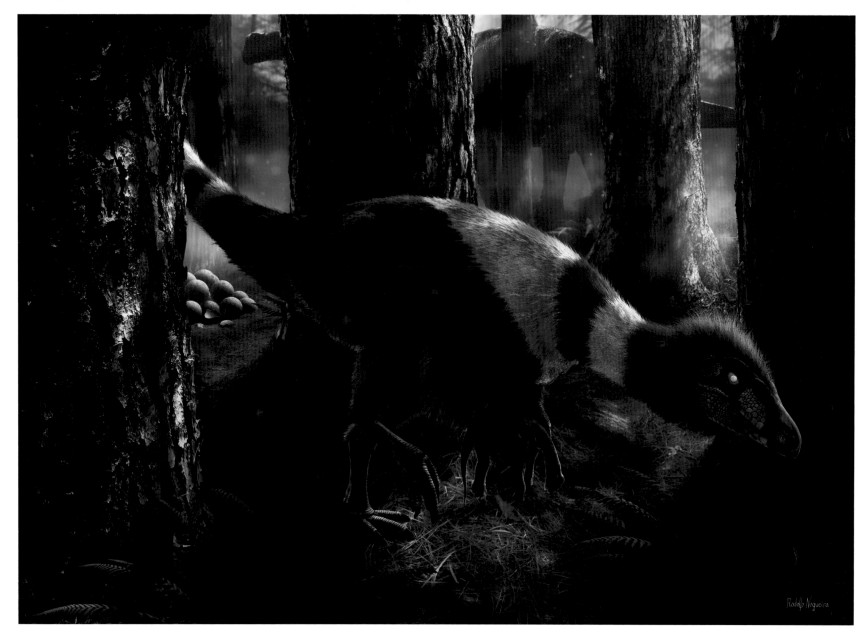

The Night Thief
This is a representation of what may have been a carnivorous dinosaur belonging to the group maniraptora, which lived in Brazil 70 million years ago. The only fossil found, a 4.5 cm claw very similar to those of animals of this group, proves the existence of raptors in the Brazilian Cretaceous. In this scene, he is carrying a *Titanosaurus* fetus. *Titanosaurus* was one of the giant dinosaur species abundant in the region.
3D digital sculpture and digital illustration

p.133
The Southern Cross Lizard
Staurikosaurus pricei is one of the oldest dinosaurs on the planet. It was found in 225 million year old rocks in the southern region of Brazil, and is probably related to the Argentine dinosaur *Herrerasaurus*. It was 2.5 meters long and fed on smaller animals. Its name means "lizard of the Southern Cross" (a constellation visible only in the southern hemisphere).
3D digital sculpture and digital illustration

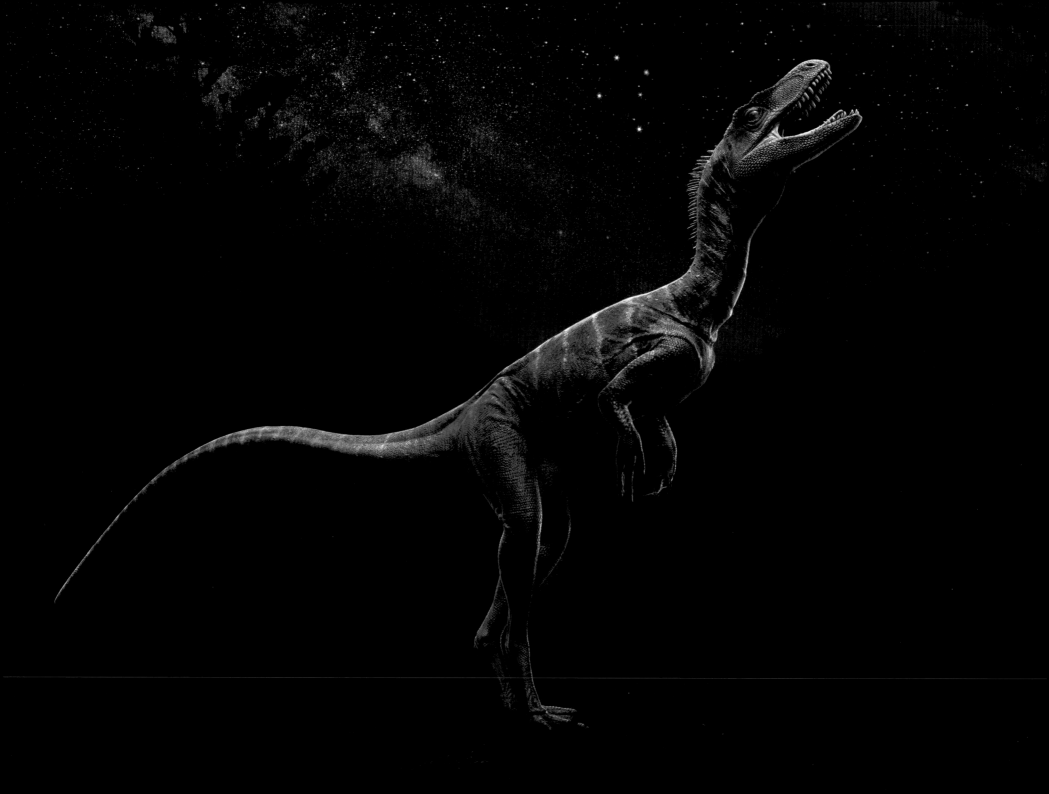

Masato Hattori

Masato Hattori was born in 1966 in Nagoya City, Japan. His long-term artistic theme is *life*, which includes reconstructed images of dinosaurs and other paleoorganisms. He has shown his works, mainly acrylic paintings, in numerous solo and group exhibitions in Tokyo and Nagoya. Since 2005, though, he has gradually shifted to digital creation, and this is now his main focus. In 2013, he created reconstructed images of two new discoveries: *Aurornis xui*, a newly unearthed species of dinosaur announced in *Nature*; and a *Therizinosaurus* nesting site in Mongolia, announced by the Society of Vertebrate Paleontology. In 2014, he created an image of the body of a dead dinosaur drifting under the sea in ancient times —based on remains found by Hokkaido University in Hobetsu, Hokkaido—as well as a new reconstructed image of *Deinocheirus*. In 2015, he drew two other new discoveries, *Nipponoolithus ramosus* and *Huanansaurus ganzhouensis*. Digital tools are very empowering for drawing things like the scales on dinosaur skin, and for retouching, which is a useful medium for interacting with researchers. Mr. Hattori hopes to continue creating his vivid images of ancient creatures, based on insights gained from discussion with researchers.

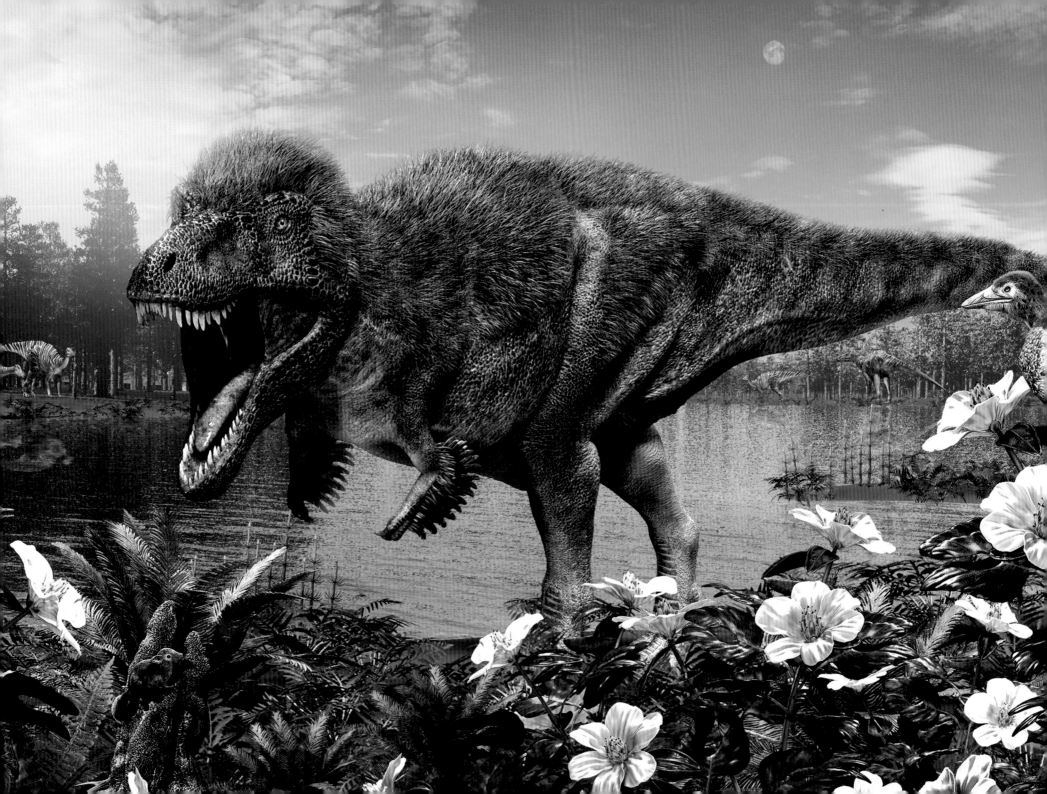

When I was a kid, I was obsessed with Godzilla. I clearly remember spending every spare moment drawing pictures of him. Now that I think about it, that passion for Godzilla led to my current work creating reconstructed images of dinosaurs. As a child I liked drawing living creatures and I often went to the zoo to make sketches of all kinds of animals. Now I create images of dinosaurs as if I were drawing them from life. But dinosaurs no longer exist, which stimulates my imagination. What was it like on Earth when dinosaurs were alive? How would I draw that scenery? One day, with questions like that in mind, I did an acrylic panorama of the dinosaur age. I took the painting to the Nagoya City Science Museum, which was nearby, and they agreed to show it in a regular exhibition.

That created an interesting opportunity for me: I started spending time with the staff at the Nagoya City Science Museum; eventually that led to commissions to create images for dinosaur exhibitions at various museums.

For me the most exciting part of all this is corresponding with dinosaur researchers. For example, I often get sudden urgent requests from Prof. Yoshitsugu Kobayashi of Hokkaido University. Although collaboration often forces me to make a lot of changes, it seems that the images created through collaboration with researchers have an awesome persuasive power. I always look forward to sudden requests.

What I find intriguing about paleoart is seeing ancient scenes, which in reality no one could ever see, take tangible form in my work. It is a great chance for me as an artist to show my ability to create works that are not just explanatory but also have a realistic, dramatic quality that will captivate the viewer. Paleoart has been evolving constantly in response to new discoveries, so there is no definitive, final form. I find that aspect exciting too, imagining various new forms for the next project.

I often try to imagine how it would feel if I slipped back to the Mesozoic period all by myself. I'm sure I would feel quite anxious, because there would be no other person around, and surely it would be impossible for me as a human being to live in the Mesozoic period. If there were a group tour visiting the Mesozoic, I would definitely join. If I could travel freely back and forth between the present and the Mesozoic, it would be fantastic, much better than any theme park. I believe that the period when gigantic dinosaurs swaggered around in spectacular nature was the most animated time in the history of the earth.

I love dinosaurs, and it would be difficult to say which one I like best. My list would have to include *Rex*, the superstar. The latest research suggests that *Tyrannosaurus* might have been covered in feathers, so I'm still stimulated when I wonder they really looked like. Dinosaurs also attract me because of their huge size, so I can't leave *Argentinosaurus*, one of the biggest dinosaurs, off my list. Furthermore, *Toroodon*, a clever dinosaur, is charming to me. It is fun to imagine that if they had survived they could be the dominant life form on earth, instead of humans.

Lately Japanese dinosaurs have been attracting attention: I'm very curious about the future of the *Hadrosaurid* dinosaur found in Mukawa, Hobetsu Town in Hokkaido. In the future there might be even more exciting new species of dinosaurs found there. I really look forward to the day when I get a chance to create astonishing new reconstructions based on some new discovery that changes the boundaries of what we call common knowledge.

Tyrannosaurus **with Feathers**
Recently a theory has been going around that *Tyrannosaurus* had feathers,
although it seems it's not conclusive.
Dinosaur figures have been changing day by day; it's as if they were alive.
One of the charms of dinosaurs is the aspect that nobody has ever seen one and nobody never will.
3D digital

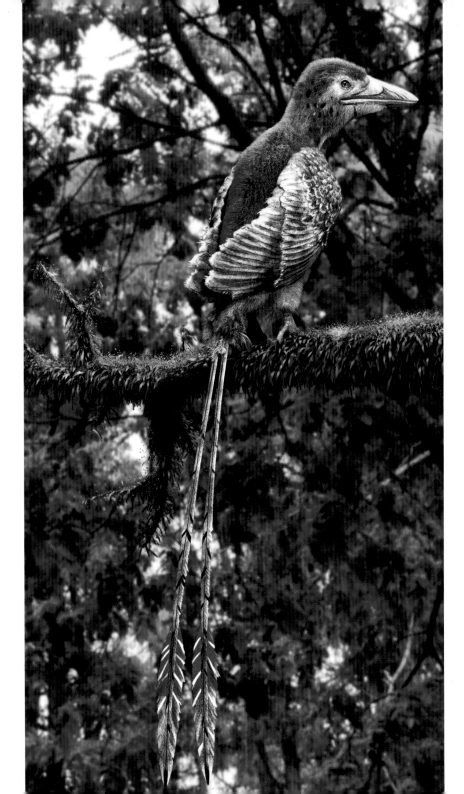

Cratoavis cearensis
The unique characteristic of this Cretaceous period avian species is its two beautiful decorative tail feathers. This is a new species, announced recently. Every time a new species is announced, my creative drive is stimulated.
3D digital

p.139
Two-fingered Therizinosauridae
This reconstructed image was created at the request of Dr. Yoshitsugu Kobayashi.
Although established theory holds that *Therizinosaurus* had three fingers, there is another hypothesis that Therizinosauridae with two fingers may have existed. Two challenges were depicting a dinosaur pulling tree branches and creating wings. Wings are very difficult to represent because the other and inner sides are different.
3D digital

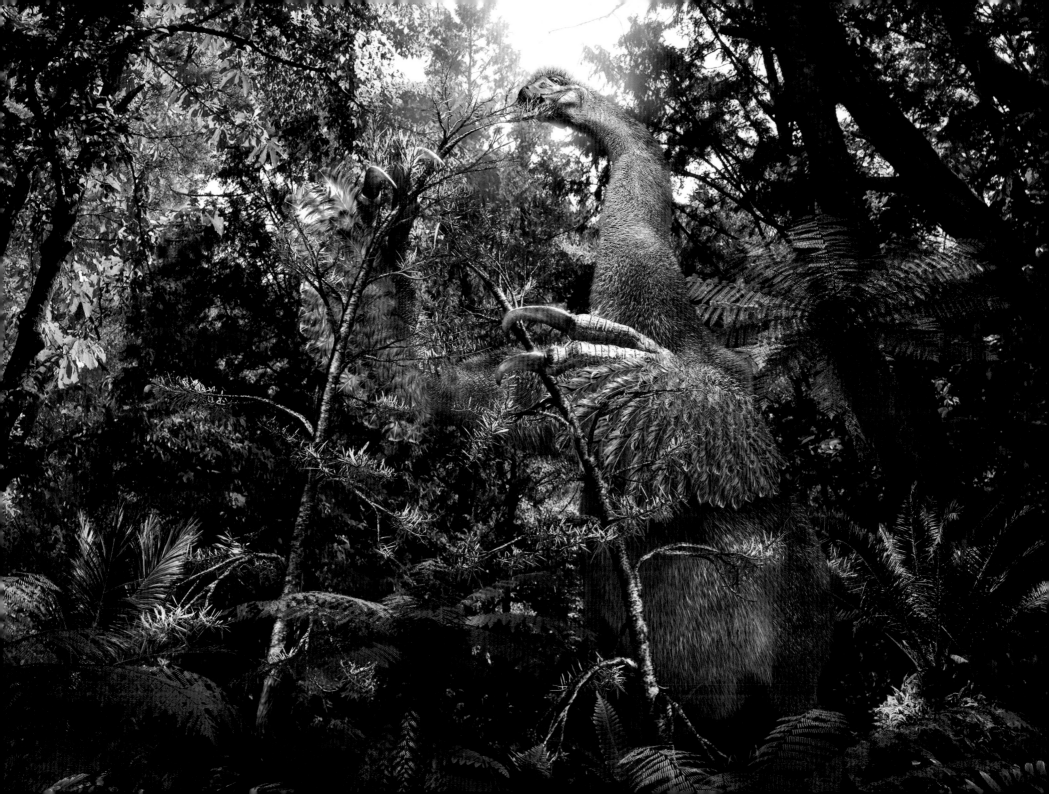

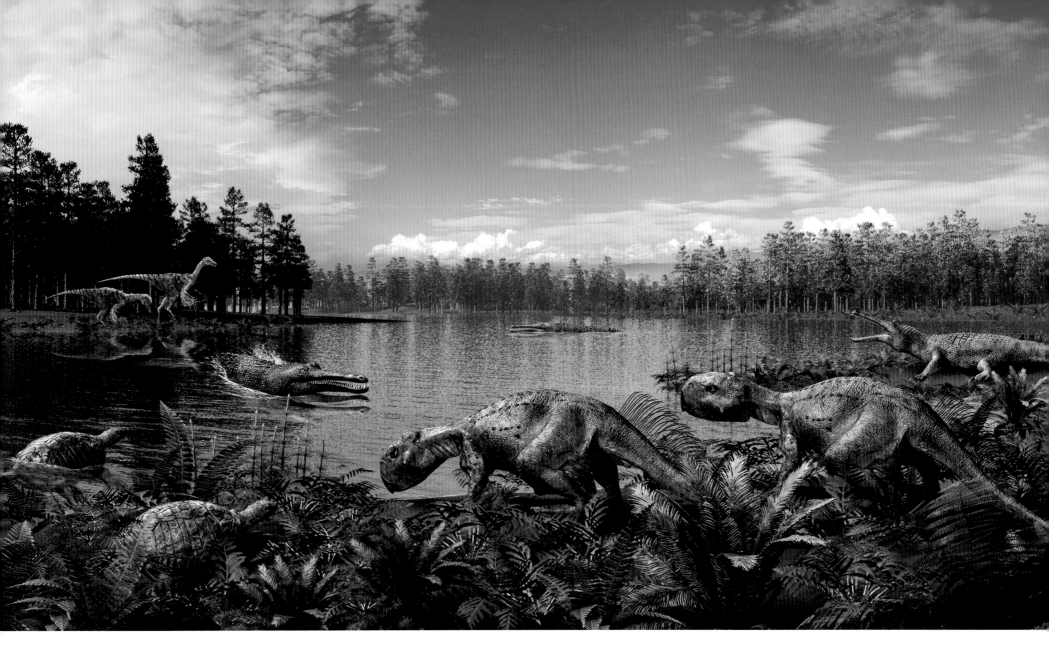

A Lake in Mongolia 120 Million Years Ago
This picture of a lake in Mongolia 120 million years back was created at the request of
Nagoya University Museum. At present that part of Mongolia is desert,
but there was a time when it had a humid climate and was inhabited by various animals including
Argentinosaurus, *Giganotosaurus*, *Harpymimus* and tortoises.
3D digital

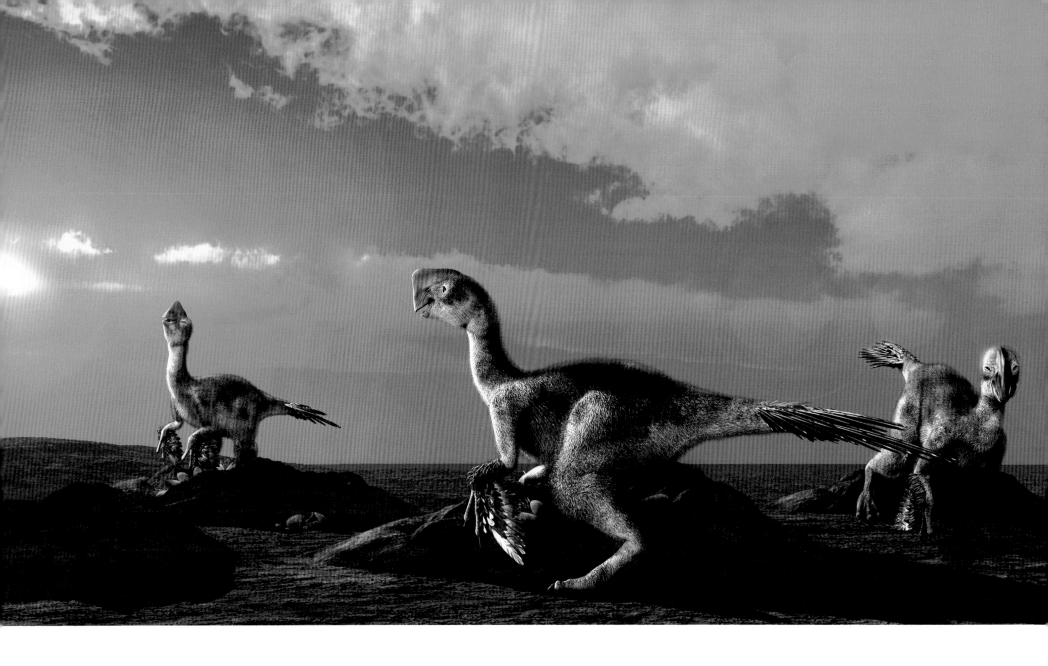

Oviraptors **Sitting on Their Eggs**

Oviraptor means "egg snatcher" in Latin. However, in this reconstruction three *Oviraptors* are gently brooding their eggs.
Our impression of a dinosaur can swing 180 degrees, depending on human interpretation.
Is it only me who thinks that we will never know what they were really like unless we visit their era by time travel?
3D digital

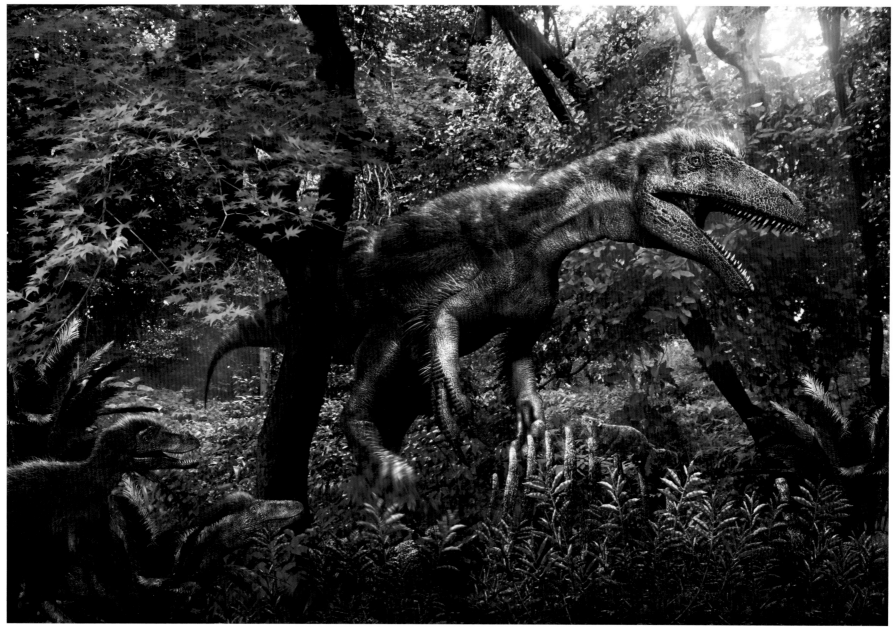

Siats meekerorum

This image features *Siats meekerorum*, which was the king of dinosaurs
98 million years ago, striding leisurely through the forest just before dawn.
At its feet is a mammal, *Gobiconodon ostromi*. The ancestors of *Tyrannosaurus*,
still small at that time, are hiding quietly in front of *Siats*.
3D digital

p.143

Impending End of the Age of Dinosaurs

Tyrannosaurus, the king of dinosaurs, is attacking a herd of *Edmontosaurus*.
Pteranodons are flying in the background. When I try to imagine these dramatic scenes,
which were so common in the late Cretaceous Period when the age of dinosaurs was ending,
my creative urge gets even stronger. At that time a gigantic meteorite was heading straight for Earth…
3D digital

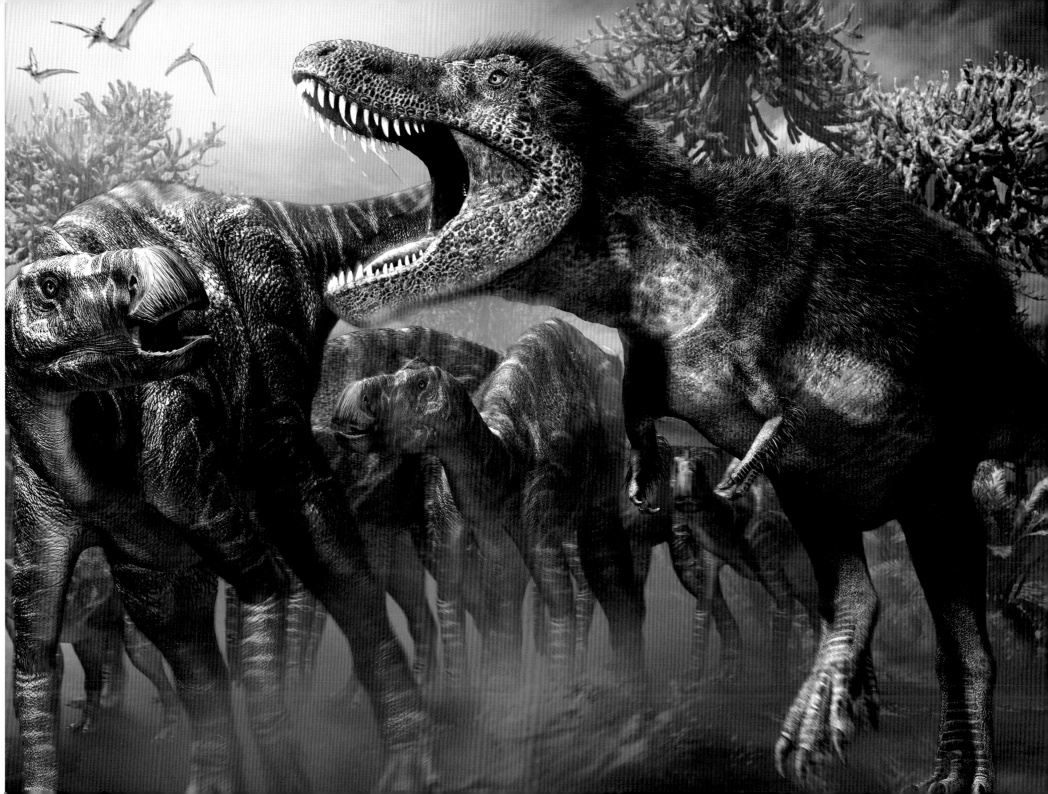

Sinosauropteryx

Soon experts will be able to determine even the feather colors of this dinosaur. When I create backgrounds like this, I sometimes fabricate them from photographs I took myself. When I do that kind of work, I try to get the opinions of experts, but there are still a lot of unclear aspects. One of my creative pleasures is combining photos and computer graphics in a natural way.

3D digital

p.144

Tarbosaurus vs. Deinocheirus

Deinocheirus, whose complete body structure was finally known in 2014, had an incredibly strange shape, as if several types of dinosaurs were mixed together. This sunset scene shows the dramatic final attempt by *Deinocheirus* to fight back against *Tarbosaurus*, the king of dinosaurs at that time.

3D digital

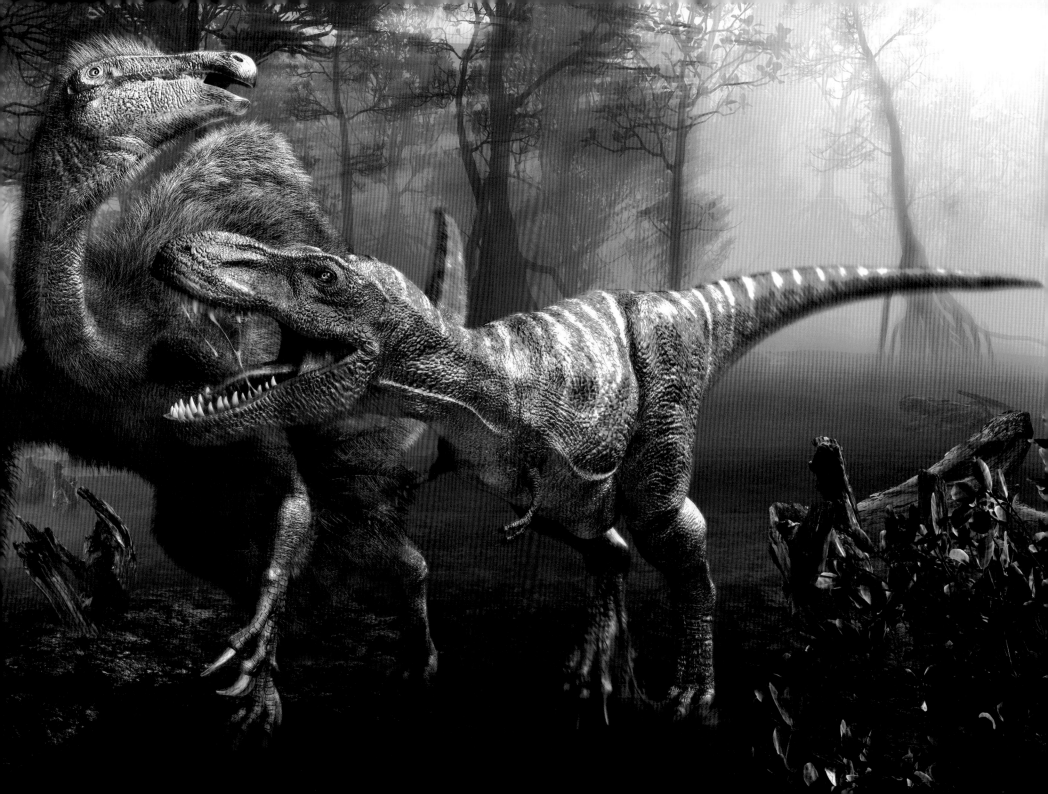

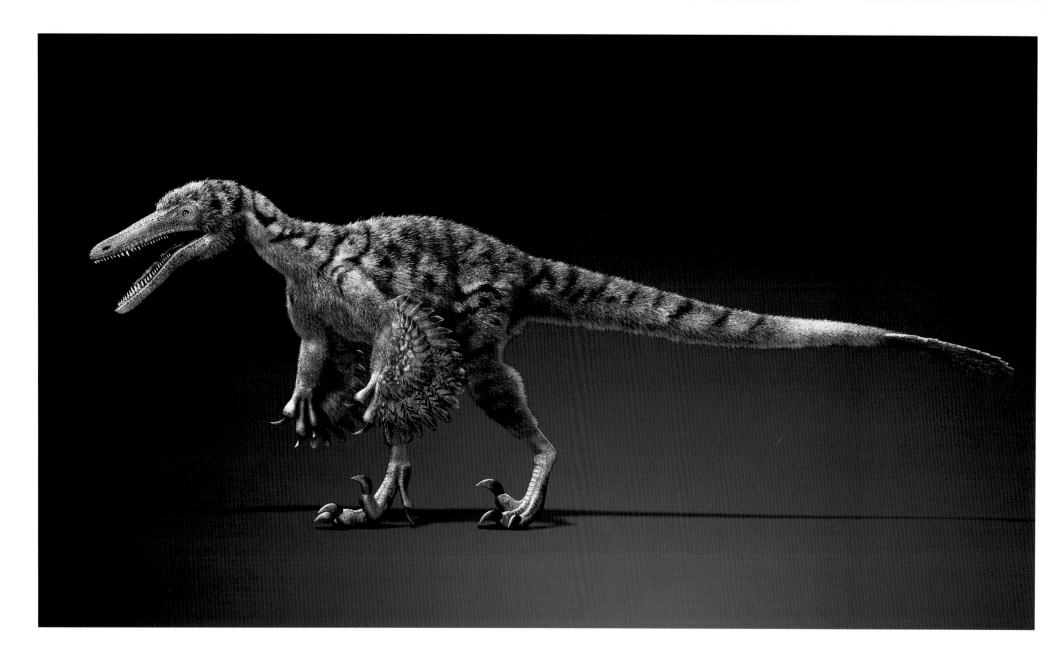

Austroraptor

It is fun to see *Theropoda* in a variety of size and shapes. Each has a distinctive feature and it would be more enjoyable if you could distinguish those characteristics in detail. The colors of *Austroraptor* here are largely based on my imagination. The combination of green and orange might seem unusual, but I was trying for a very bold effect. In the world of nature there are often things beyond our imagination, so in reality dinosaur shapes and colors could be really eccentric. Who knows?
3D digital

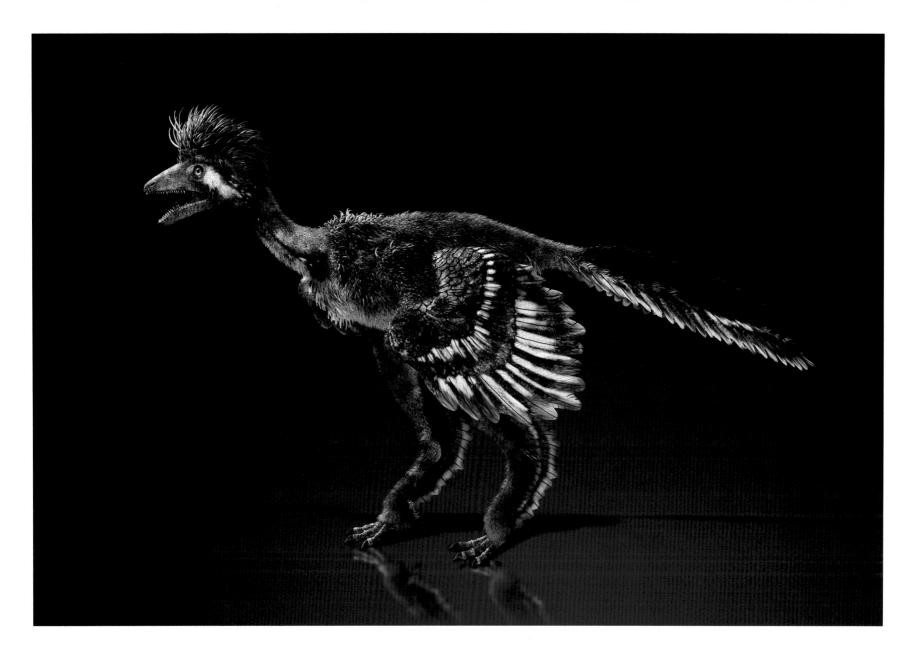

Xiaotingia zhengi

This Jurassic dinosaur, *Xiaotingia zhengi*, is one of the candidates for the origin of the avian species. This image is created largely from my imagination but I think there might have been a lot of male dinosaurs that tried to attract females with bright colors and extraordinary figures, just like animals in modern times. This point gives me a real thrill when I exercise my imagination in my reconstructions.
3D digital

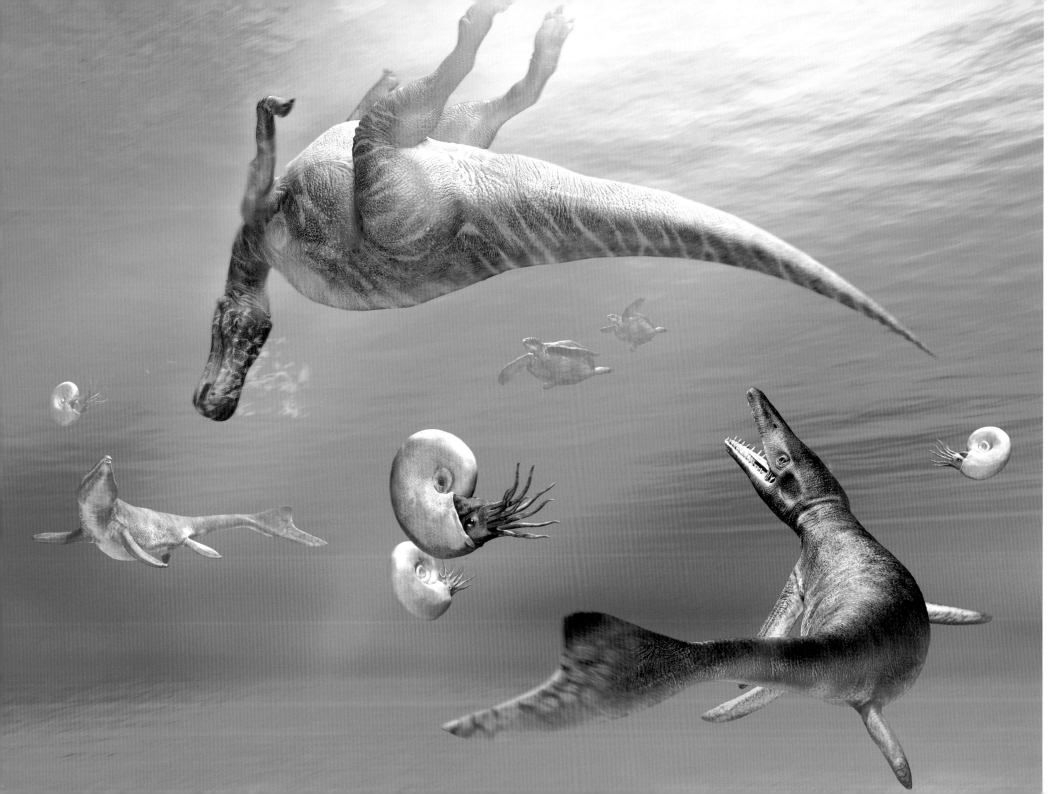

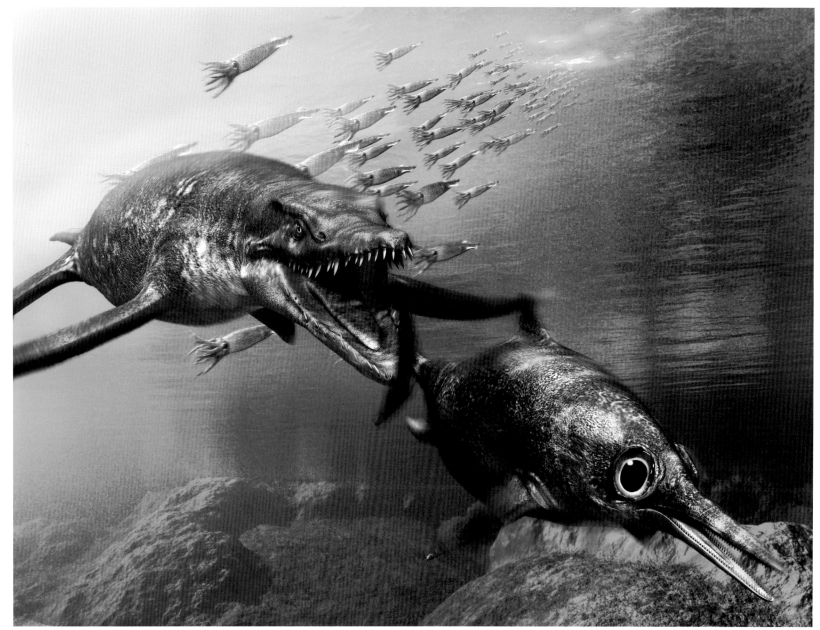

p.148

Hadrosauridae Found in Mukawa, Hokkaido

Mosasaurus is heading for a dead hadrosaur sinking in the water. I got a sudden urgent request to create this reconstructed image, and it had to be completed in a short time. I needed extensive discussion with Dr. Yoshitsugu Kobayashi. He gave me a lot of essential advice that only researchers could give, such as the fact that the body would float belly side up since a lot of gas would form in the belly after the dinosaur died. The shape of this dinosaur's head had not been determined at that time and now it seems likely that this species might be a new discovery, depending on the outcome of the ongoing excavation. I am looking forward to hearing news of that decision.

3D digital

Jurassic Period Ocean Scene

In the Jurassic Period, there were tremendous battles for survival in the ocean too. Here a huge-eyed *Ophthalmosaurus* is being chased by a giant-headed *Liopleurodon*. In the background, a herd of *Sichuanobelus*, usually the prey of *Ophthalmosaurus*, have managed to get away.

3D digital

Happy Family Scene

Even *Tyrannosaurus*, with its ferocious image, might have taken
time to relax with the family. The distinctions between male and female
Tyrannosaurus are still not completely known.
I want to let the viewer judge which is male and female.
The scene with the animals visiting the water is quite picturesque,
and even more beautiful with the setting sun.
3D digital

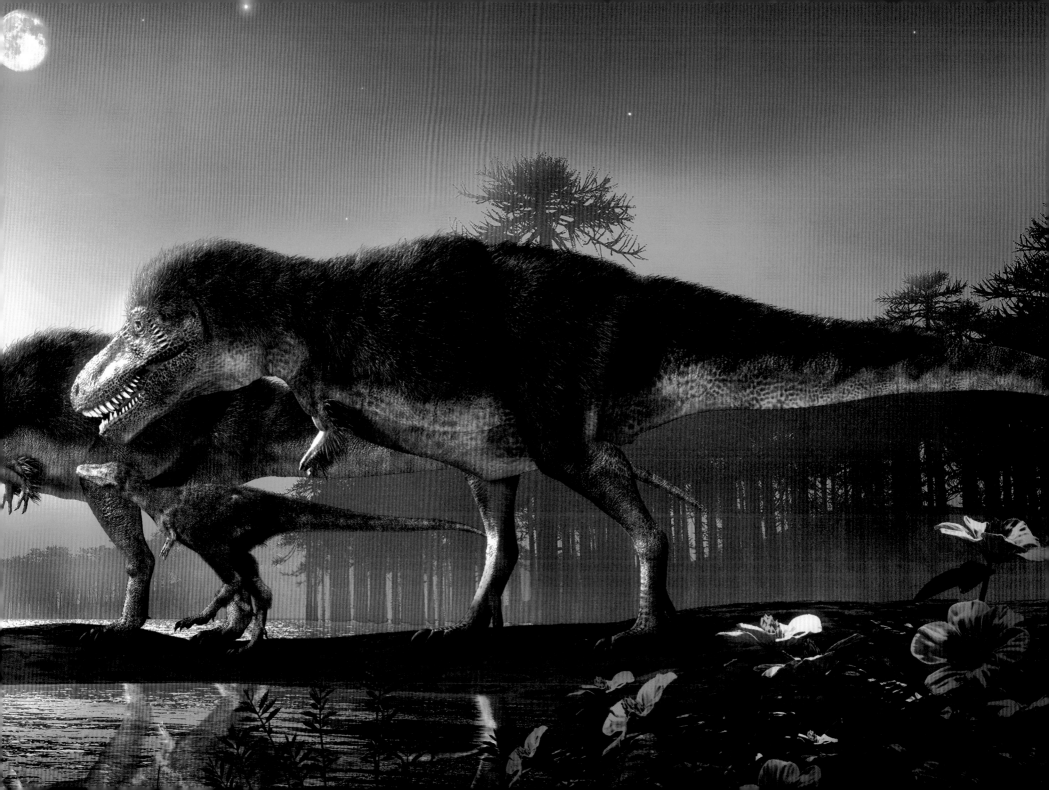

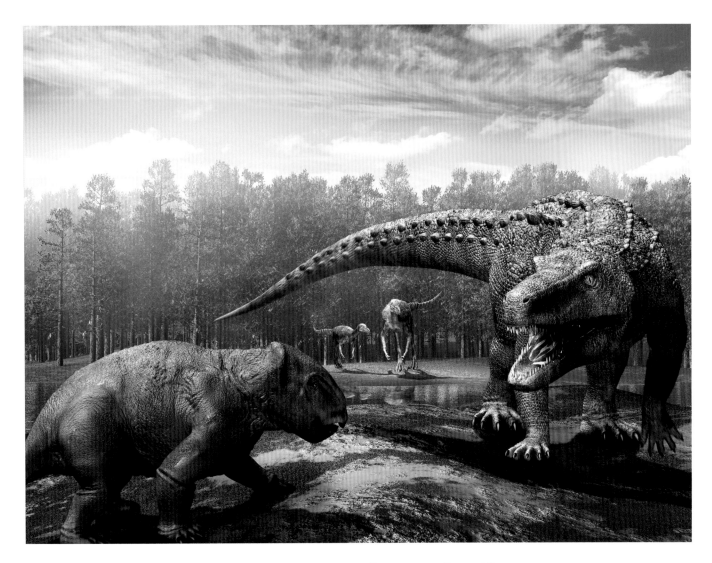

Triassic Afternoon
Tension in broad daylight: in the Triassic period *Saurosuchus*, a large carnivorous reptile (right), confronts *Ischigualastia*, a herbivorous synapsid reptile (left). This was in the time before dinosaurs flourished. *Eodromaeus*, a dinosaur, is watching the situation from the distance.
3D digital

Dinosaurs in Laramidia
This scene is in humid Laramidia. I focused on the creation of a quiet, moist forest environment. There are *Lythronax* in the foreground and *Parasaurolophus* in the pond, and *Purgatorius*, the oldest mammal, is sitting on a tree branch. I created *Archaeanthus*, the plants in lower right foreground, and *Archaefructus*, the ones near the water, by modeling.
3D digital

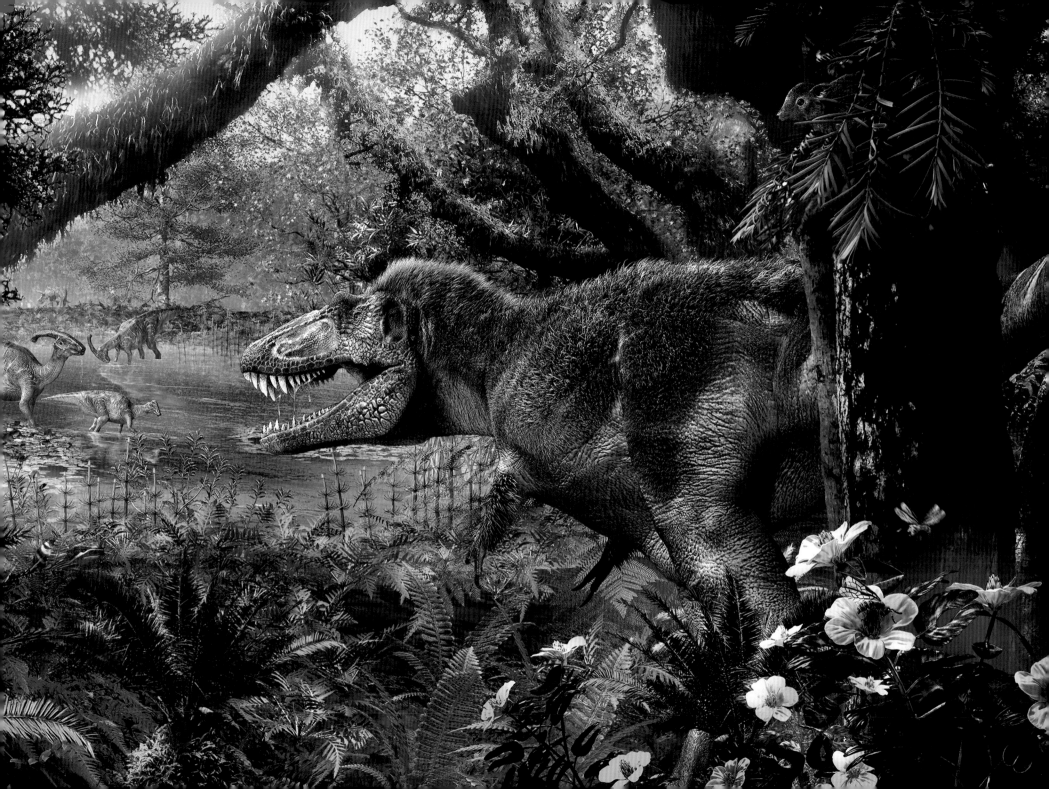

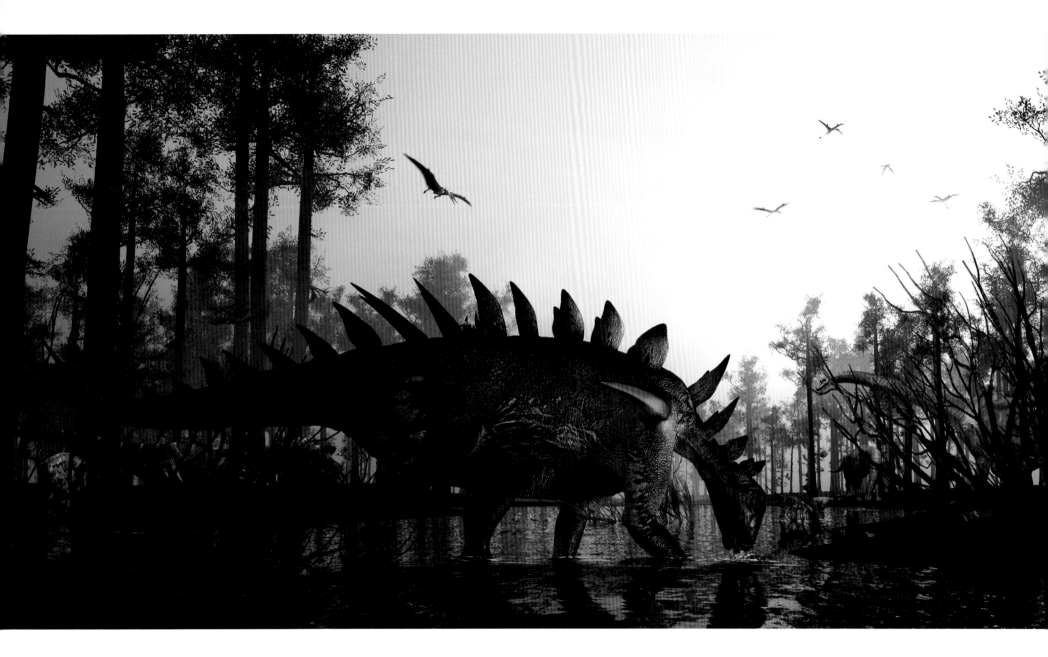

By the Water
I created this image emphasizing the atmospheric scene.
I think there aren't so many romantic or comforting pictures of dinosaurs being produced yet.
I am sure that dinosaurs had some different aspects other than the ferocious image we have of them.
I believe that any scene depicting a part of the natural world is unconditionally beautiful.
3D digital

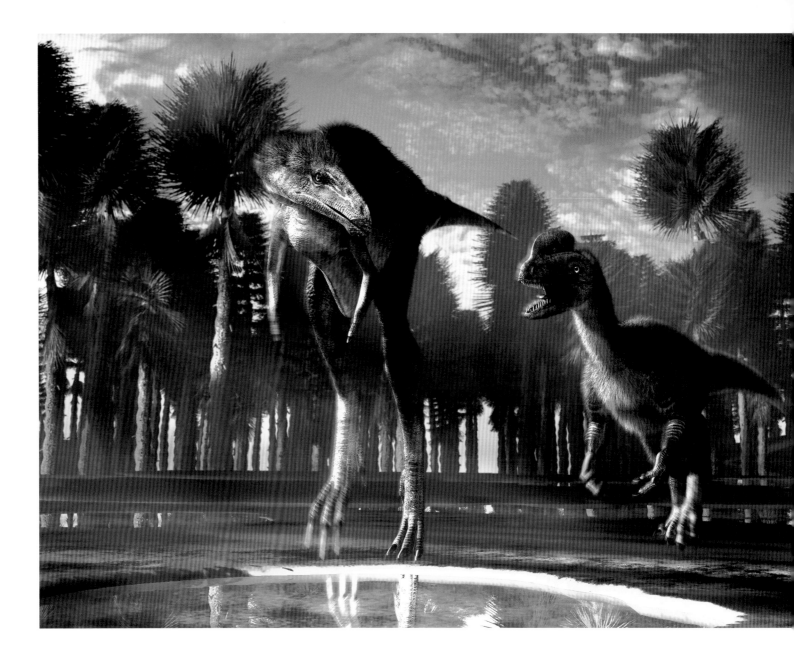

A *Limusaurus* Chased by a *Guanlong*

Here a *Guanlong* is chasing a *Limusaurus*, and the *Limusaurus* is about to
fall into a *Mamenchisaurus* footprint, a hole over one meter deep.
The fossil remains of five dinosaurs were found in this depression.
It is tantalizing to try imagine what sort of drama played out here.
3D digital

Sleeping *Mei long*

This *Mei long*, which was excavated in a sleeping position, is quite unusual among dinosaurs, and contrasts with our violent image of them.
Because of the extraordinary situation, reconstruction artists have been stretching their imagination to present *Mei long* with various expressions.
I wonder what sort of dream *Mei Long* was having when it died in its sleep?
3D digital

Emily Willoughby

Emily Willoughby is an American scientific illustrator best known for her reconstructions of feathered dinosaurs, both living and extinct. Her work has been featured in a variety of forms, online and off, including the National Geographic Society, the Denver Museum of Nature and Science, the Shanghai Natural History Museum, and in various paleontological research reports in journals such as *Evolution* and *Nature News*. Her first book, a recently released coauthored work featuring a series of her paintings of feathered dinosaurs, is relevant in the context of evolution/creation controversy in the US. Emily enjoys working in a variety of media, from digital painting to acrylics, oil, gouache and watercolor paints to bird photography. As a result of her background in biology, her primary focus is the fusion of research, realism and aesthetics in artwork. Emily lives in Minneapolis, Minnesota, where she is studying for a Ph.D. in behavior genetics.

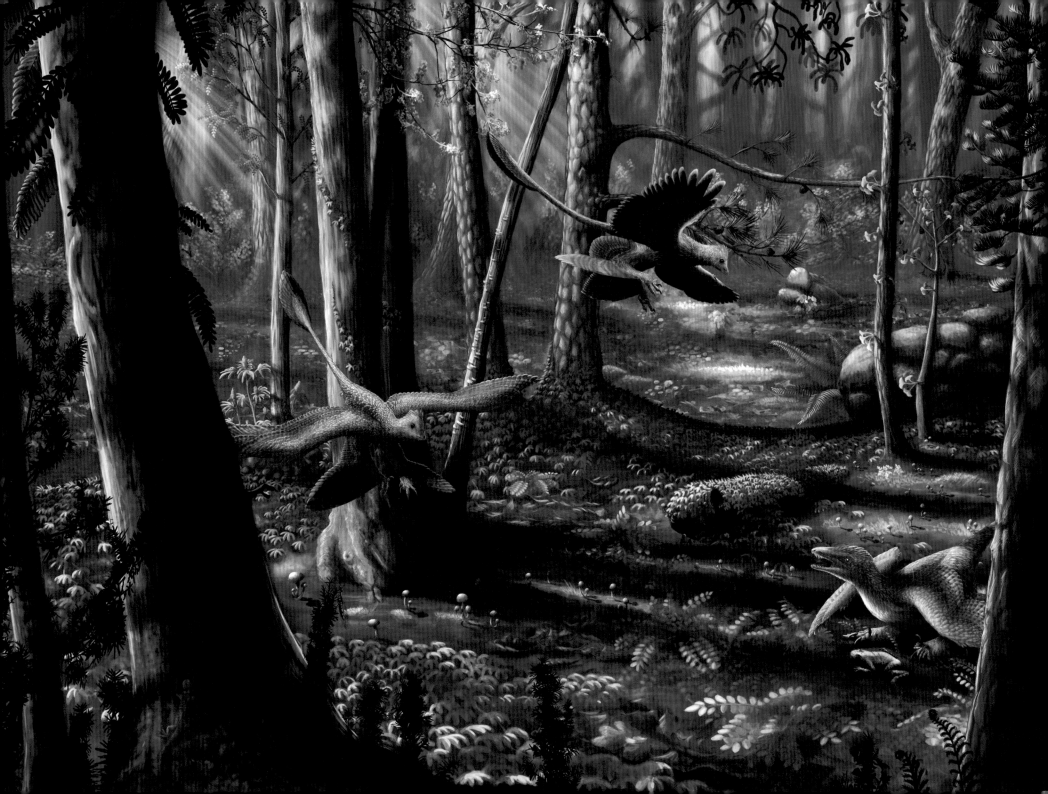

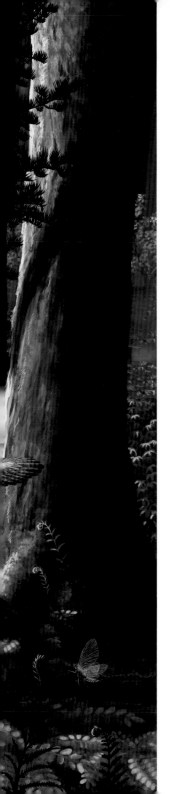

I have lived and breathed paleoart for most of my life. As a child I was drawing the moment I could hold a pencil, and then, as now, my subjects were winged, toothy, furred and feathered things. Today, my interest in paleoart is driven by both the desire to realize the strange beauty of these animals as they may have existed, and the importance of communicating their beauty and strangeness to the public.

My preferred subjects in paleoart have always been feathered dinosaurs, particularly dromaeosaurs, primitive birds and their kin. These animals appeal to me in large part because historically there has been so much controversy over how they looked and behaved, with much of cultural perception reducing them to either scaly, reptilian monsters, or prehistoric doppelgangers of modern birds. In reality, they must have been absolutely unique animals with features and behaviors unlike anything we see today.

Two feathered taxa frequently appear in my work, and my fascination with them stems not just from the wealth of research we have on these genera but also from their unique aesthetic appeal. *Microraptor*, a pigeon-sized, four-winged dromaeosaur from Early Cretaceous China, is known from dozens of specimens and is represented by at least two separate species (*M. gui* and *M. zhaoianus*). *Microraptor* fascinates me, largely because it is functionally and anatomically unlike anything alive today, with a long, bony tail, and five lift-generating feathered surfaces on its wings, legs and tail. The *M. gui* holotype, first described in 2003, was the first clear evidence of voluminous flight feathers attached to the hind limbs of a dinosaur. Unlike similar structures found on some domesticated pigeons and chickens today, the "legwings" of Microraptor

clearly had an aerodynamic function.

Curiously, the existence of a four-winged bird ancestor was predicted in 1915 by American naturalist William Beebe, whose ontological observations of the fine filaments on the hind limbs of many bird embryos led to his conclusion that hind limb "wings" served a purpose early in bird evolution. Nearly a century later, Beebe's hypothetical four-winged "Tetrapteryx" was unearthed and named *Microraptor*, an elegant demonstration of the predictive power of evolutionary theory.

Deinonychus, the wolf-sized North American dromaeosaur, was first described by John Ostrom in the 1960s, and is largely responsible for our deepening understanding that dinosaurs were active, complex animals rather than tail-dragging behemoths. As far as I'm concerned, *Deinonychus* might well be the most beautiful animal that ever lived. It is a pure embodiment of predatory grace, from its long, powerful skull with blade-like teeth to the enormous curved claws on its hands and feet. Its proportions were built not for speed but for power, and it may have occupied a niche similar to that of today's big cats. *Deinonychus* lived around the same time as *Microraptor*, its tiny cousin, but it represents the opposite end of the feathered dromaeosaur spectrum.

These animals and many like them, in all of their splendor and strangeness, best capture the appeal and necessity of paleoart. Paleoart is important to me and, I think, important to society, because among all fields of study, paleontology uniquely requires the affordances of art to represent its findings. Before the invention of photography, artwork was the only visual method available to bring the natural world to the public. Today, sophisticated film technology is able to bring

nature to the public in their living rooms, and zoos and wildlife refuges can bring the public to nature. But like the subjects of paleontology, the methods of paleontological reconstruction are old: we must paint, sculpt and draw to bring the static bones of these animals to life.

Of course, paleoartists are not limited merely to bones. We have to know how to layer the bones, and for that we have the entirety of biological science at our backs, from ornithology to biology to paleontology itself, and the wealth of knowledge of phylogenetics, evolution and biomechanics that science provides to complement the fossils. Artists must always learn to be proficient with their materials, but a paleoartist can only be successful if she truly understands the animal she's painting. In that sense, the paleoartist is the perfect melding of scientist and artist, the only such hybrid in modern times.

Of all the living things that have come and gone upon this planet, we will only ever know a tiny fraction. As a paleoartist, I feel that it's our unique responsibility to make sure that these creatures are not forgotten, and that the public will come to know them in a way that not only represents them accurately, but pays respect to the individuals they were in life. Paleoart is more than a mere clinical representation of a taxon. It is an homage to the dead, a celebration of the individual lives that fought and loved and died eons ago. Through art, the public can come to know these dinosaurs as they were, not as movie monsters or mysterious creatures, but as real animals, full of beauty and life.

Liaoning Scene
The Liaoning Province of northern China was lush with feathered dinosaurs 120 million years ago. Here, two microraptorine dromaeosaurs try to drive *Sinornithosaurus* away from its prey, the early Cretaceous frog *Callobatrachus*.
2D digital

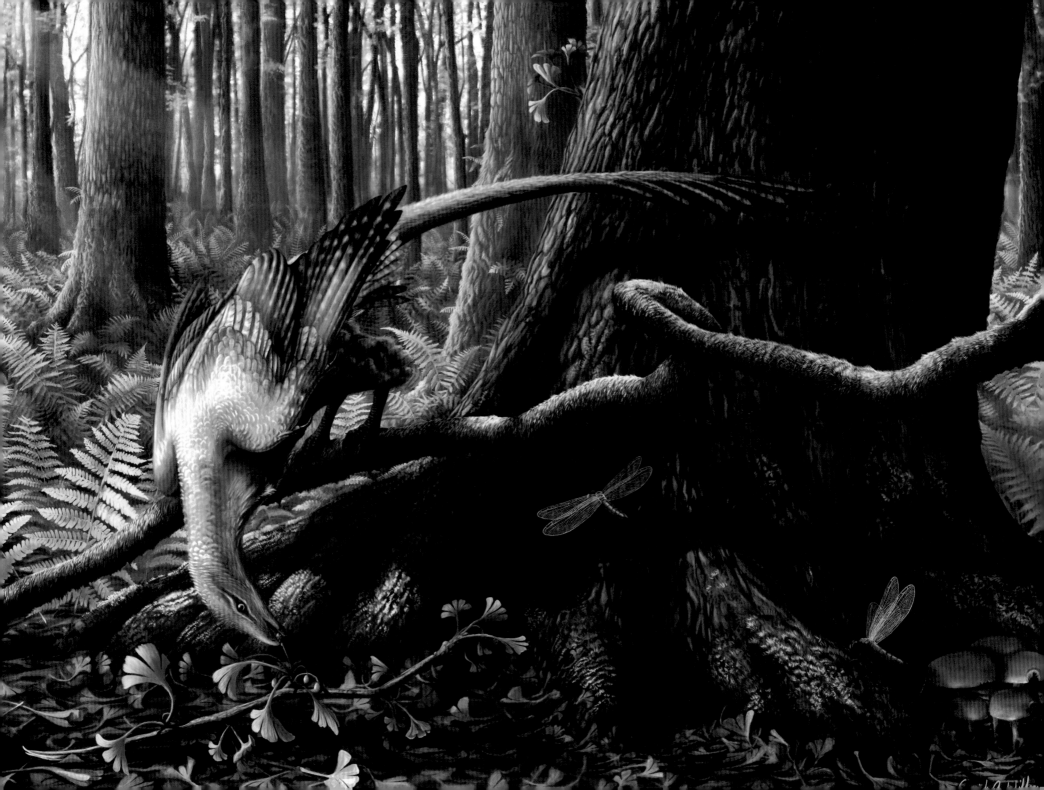

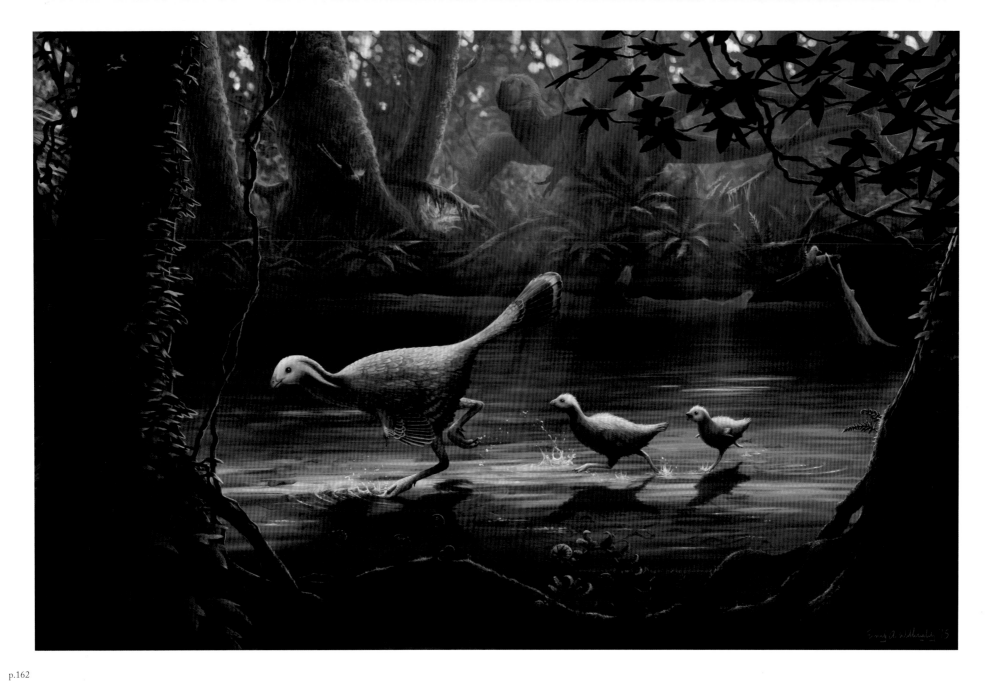

p.162
Jeholornis
Jehlornis prima of China's 120-million-year-old Jiufotang Formation was one of the earliest true birds, with flight-capable wings but also teeth, grasping hands and a long, bony tail. Its tooth and jaw anatomy suggests it was an omnivore.
2D digital

Caudipteryx **with Chicks**
The fossil record of Early Cretaceous China sports the full range of extinct feathered animals, from the tyrannosauroid *Yutyrannus* to the true bird *Changchengornis* including the pheasant-sized oviraptorosaur *Caudipteryx zoui*.
2D digital

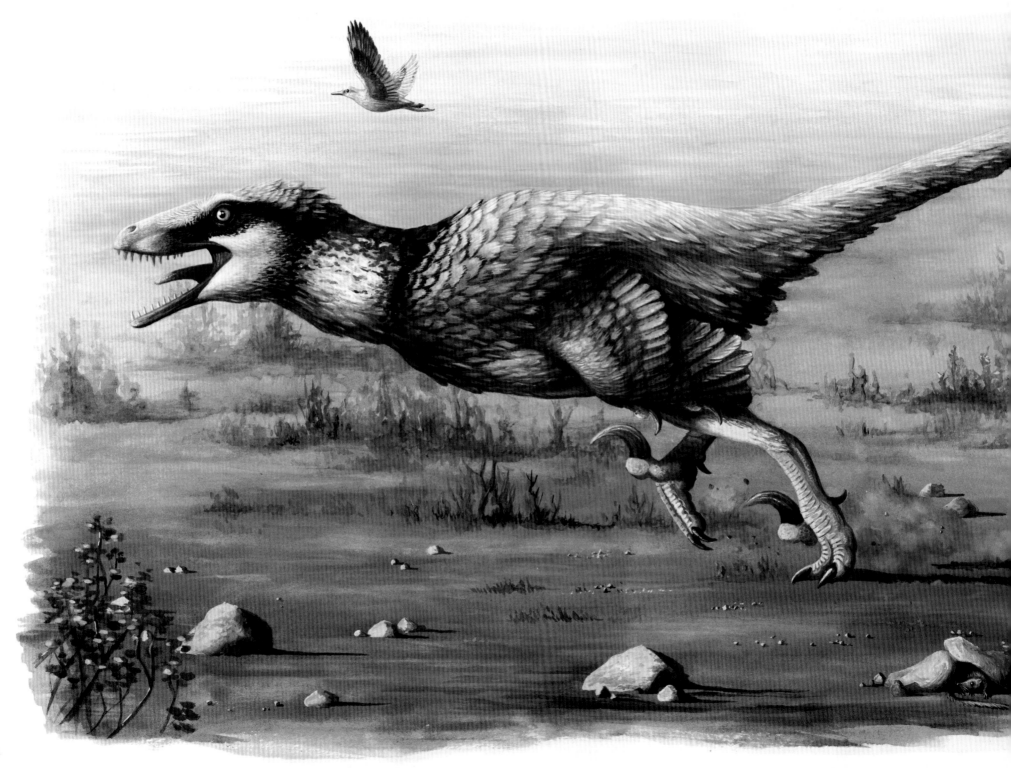

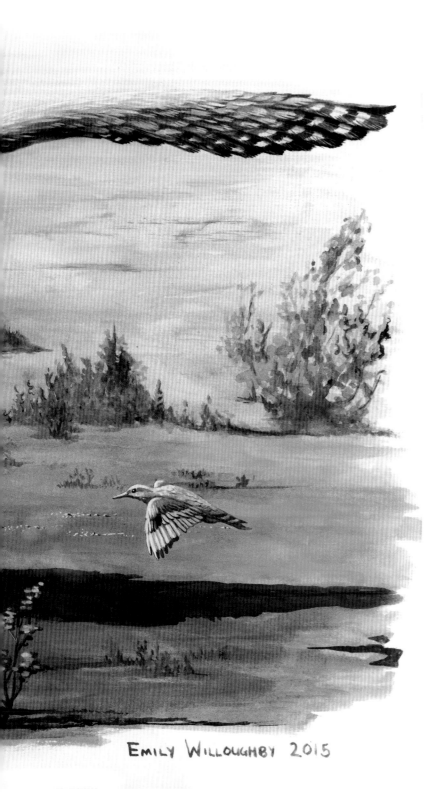

EMILY WILLOUGHBY 2015

Dakotaraptor

Dakotaraptor steinii hails from the Late Cretaceous Hell Creek Formation in North America and was among the largest known dromaeosaurs. It also likely sported large arm feathers, as evidenced by preserved quill knobs on fossil arm bones.

Gouache

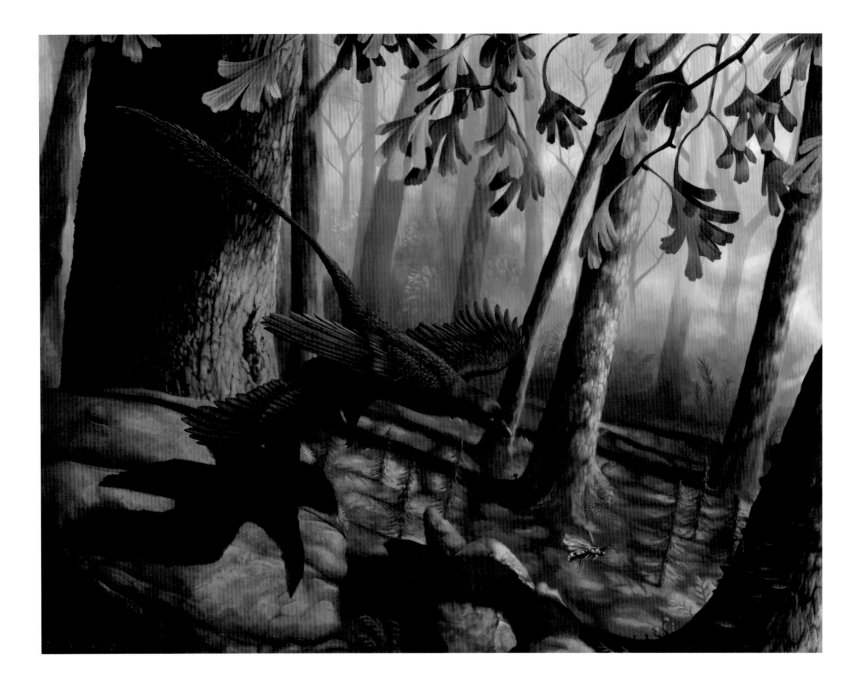

Microraptor Takeoff

Microraptor gui was a pigeon-sized feathered dromaeosaur in Early
Cretaceous China. Its many specimens have been the subject of considerable
study: we now know its coloration, diet, and probable flight style.
2D digital

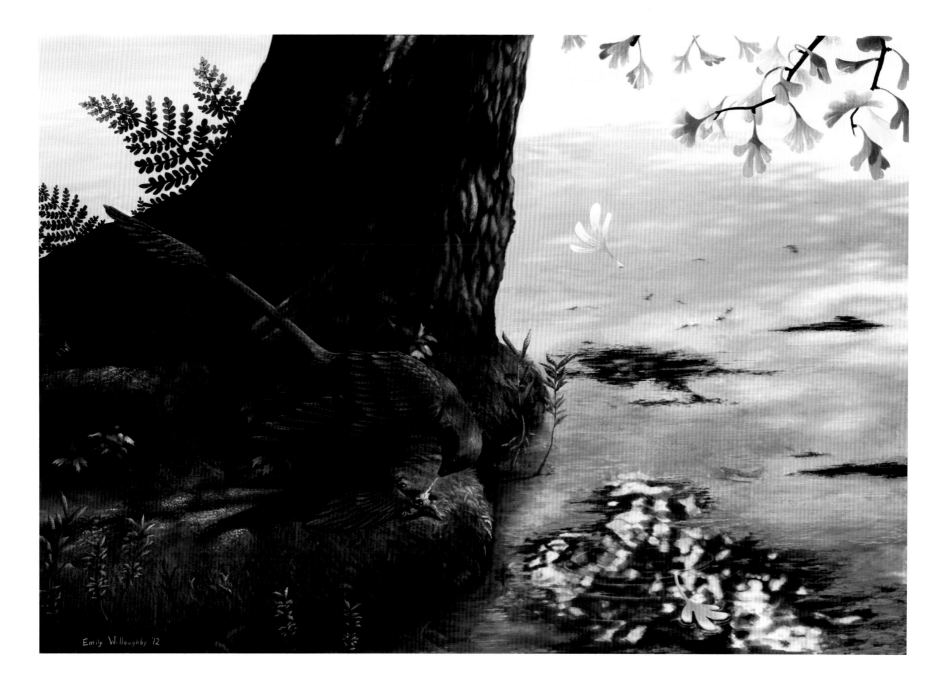

Microraptor Piscivory
Several specimens of *Microraptor* have been found with identifiable gut contents, including the bones of fish, birds, and small mammals, indicating that it was probably an opportunistic predator.
2D digital

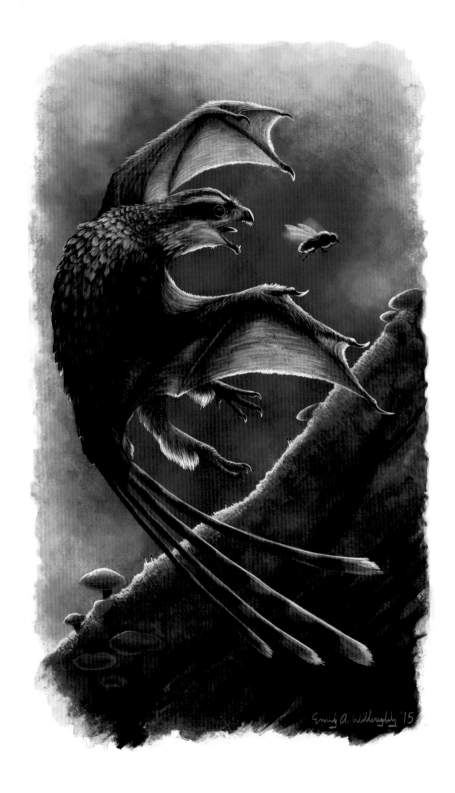

Emily A. Willoughby '15

Yi qi
Another oddity from Early Cretaceous China, *Yi qi* may be one of the most bizarre known dinosaurs. Rather than feathered wings, this tiny scansoriopterygid may have flown with skin membranes similar to those of a modern bat.
Gouache and 2D digital

p.169
The *Velociraptor* Hunting Dance
The famous turkey-sized *Velociraptor mongoliensis* is another dromaeosaur whose fossils feature quill knobs, anchor points for vaned feathers. This Late Cretaceous predator may have hunted both large prey and small, such as the early mammal *Zalambdalestes*.
Oil paint and 2D digital

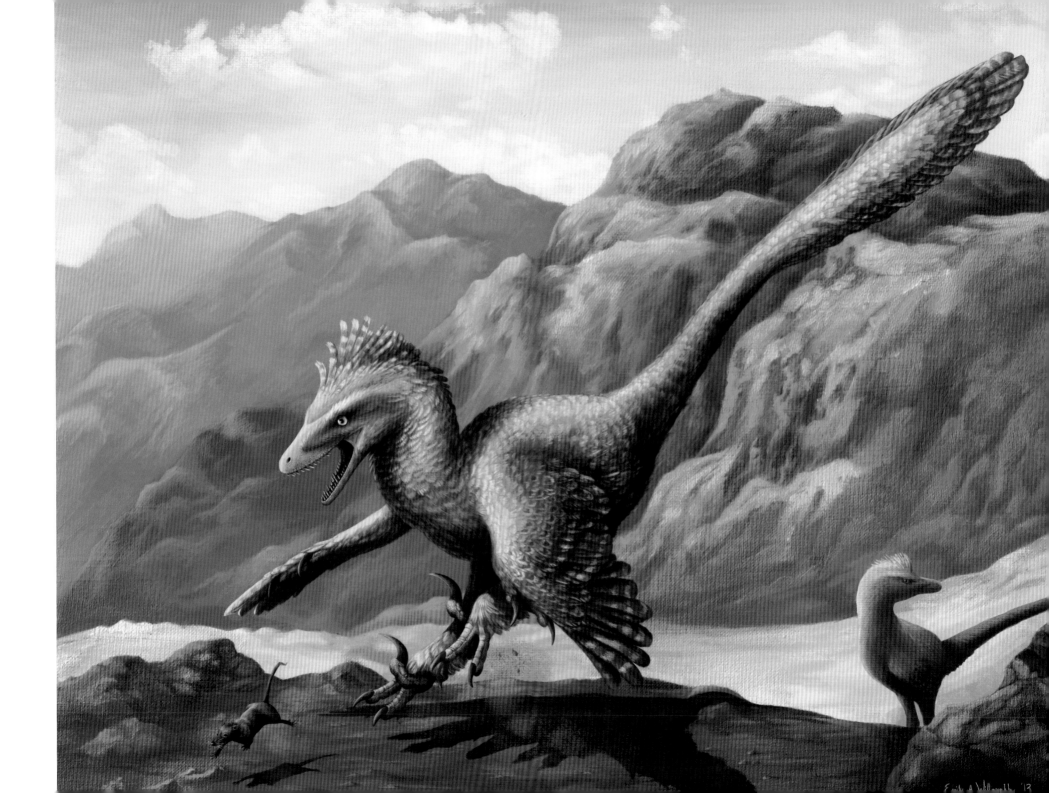

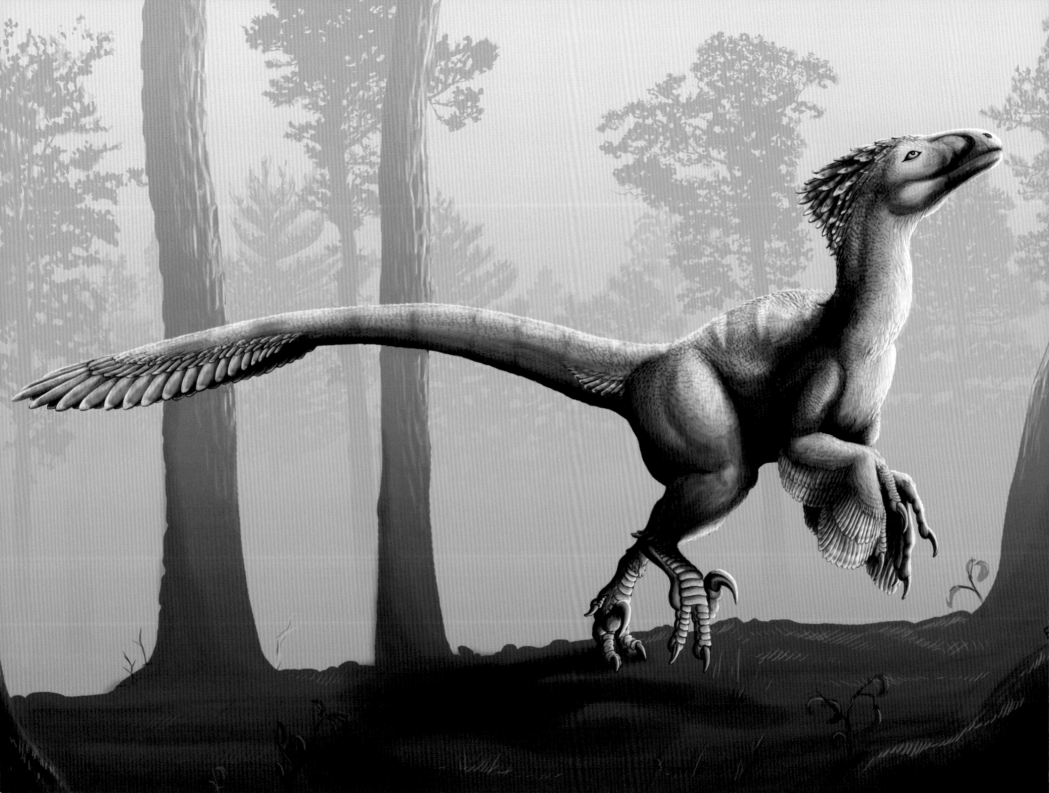

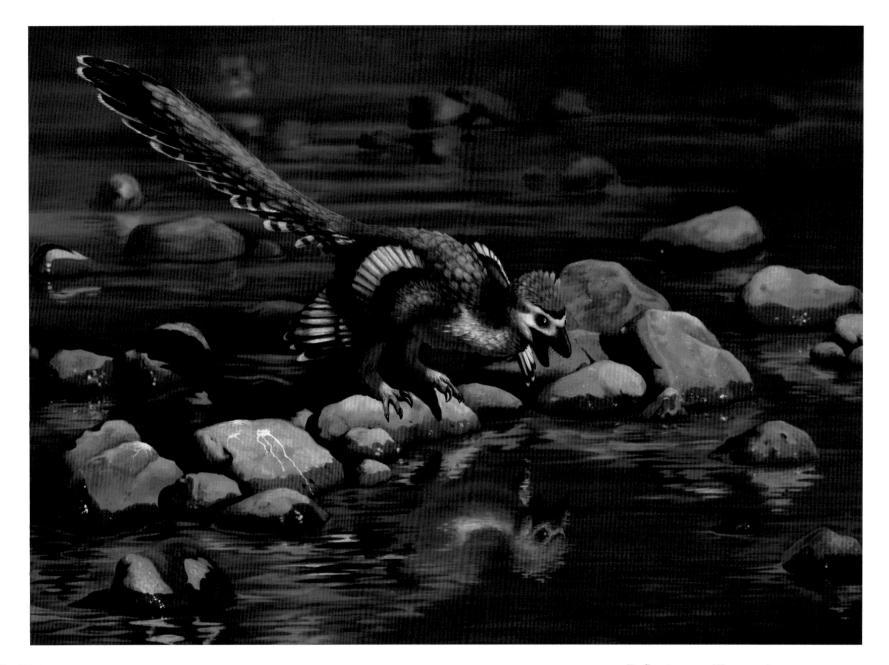

p.170

The Smell of Rain

Deinonychus was a wolf-sized dromaeosaur dinosaur from the Early
Cretaceous of North America. While it is not found in a formation where
feather imprints are likely to fossilize, we can infer with certainty that all
dromaeosaurs were as feathered like birds.

2D digital

Reflections on *Zhenyuanlong*

The Early Cretaceous Chinese version of *Velociraptor*, the turkey-sized
Zhenyuanlong, was discovered with voluminous feather imprints showing
well-developed pennaceous feathers on the wings and tail, despite its being
too large to fly.

2D digital

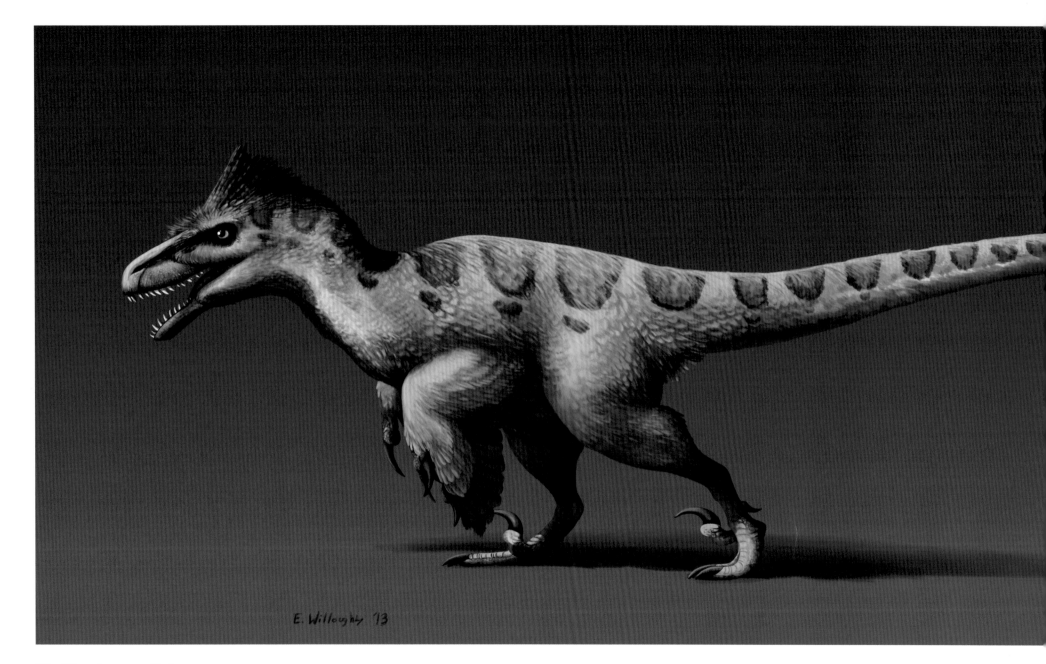

The More Accurate *Utahraptor*

Utahraptor is one of the largest known dromaeosaurs, with some of the largest specimens approaching seven meters in length. Thanks to a recent wealth of new specimens, *Utahraptor's* anatomy has undergone considerable revision. The animal was probably much shorter, stockier, and more powerful than was traditionally thought.
2D digital

The Noble Savage

Deinonychus is known from many specimens. One of the most famous specimens, showcased at the Yale Peabody Museum, has a strongly recurved sickle claw. This is probably a juvenile animal, and it is thought that the shaply curved claws may have aided in climbing to escape predators.

2D digital

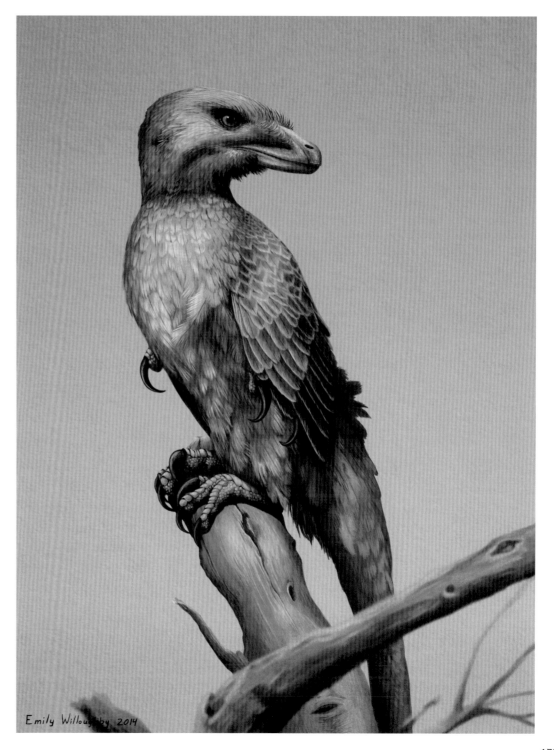

Emily Willoughby 2014

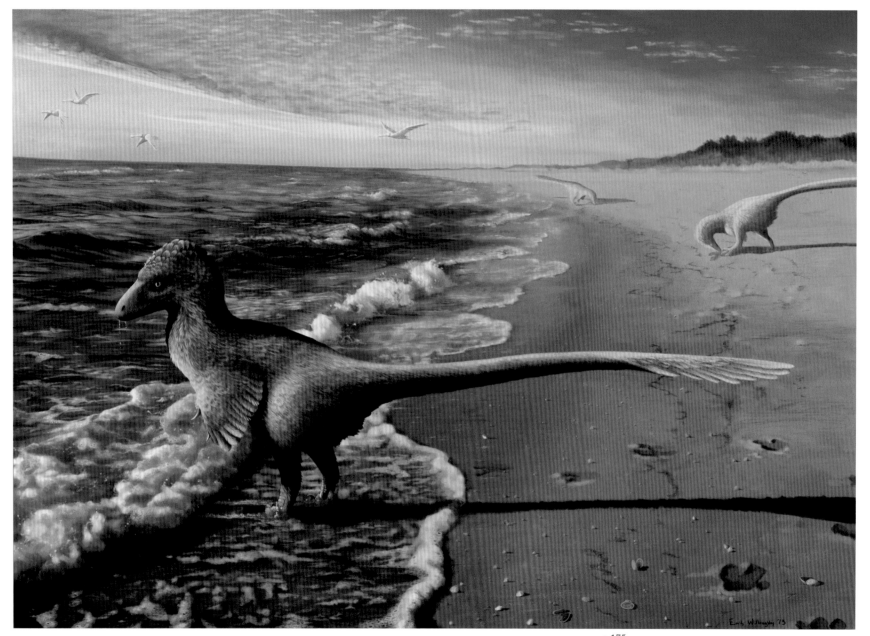

p.175

Utahraptor at Dawn

First described in 1993 from fragmented specimens, *Utahraptor* has long been thought to be a sort of scaled-up *Deinonychus*. It hails from Early Cretaceous North America, and may sometimes have combed the beaches of the great inland sea for food.

2D digital

Balaur bondoc is a Bird

Similar in size to Velociraptor, this Late Cretaceous Romanian dinosaur was originally classified as a dromaeosaur. More recent analysis has placed it as a primitive flightless bird, with its extra long "double" sickle claws a likely aid to perching rather than predatory behavior.

2D digital

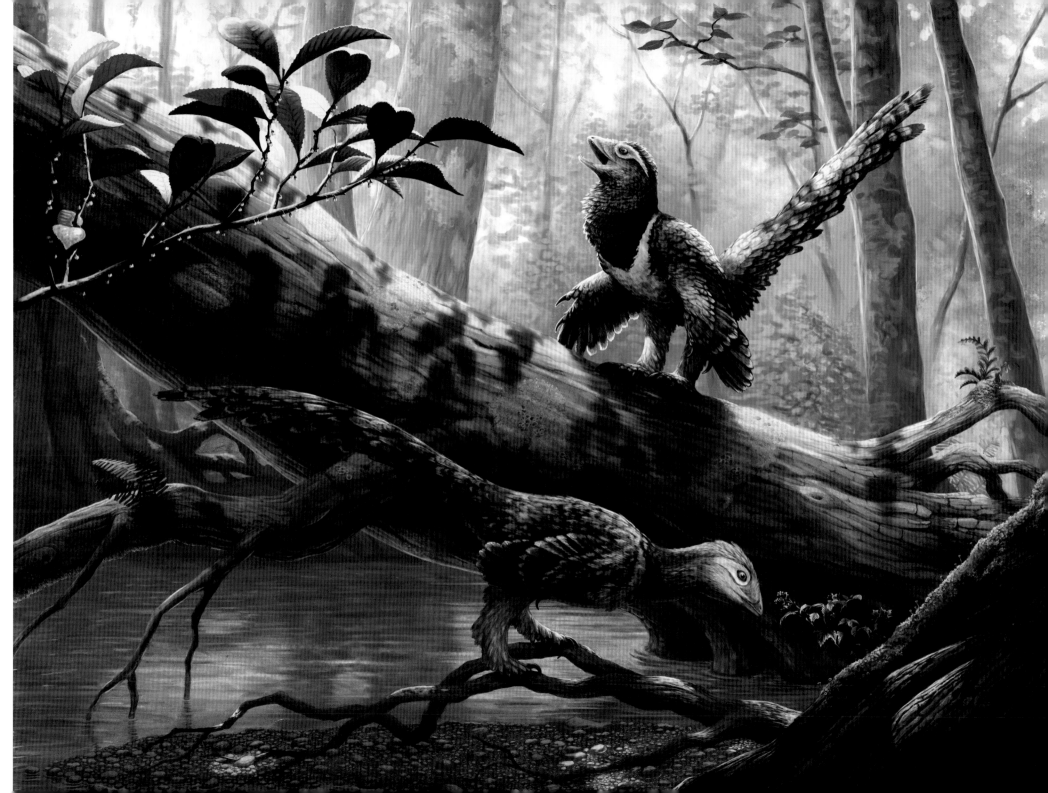

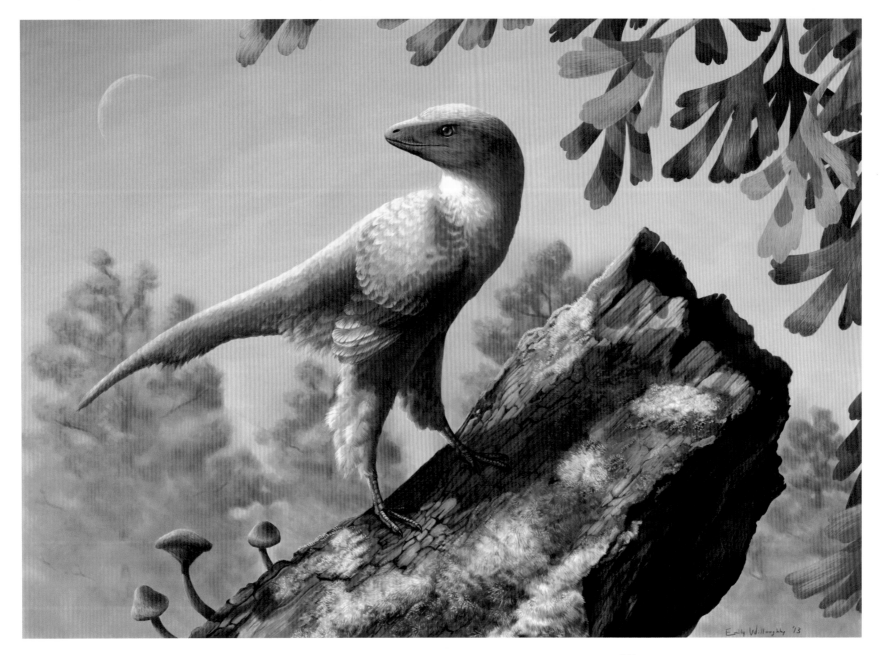

Eosinopteryx
This tiny Late Jurassic dinosaur hails from China's Liaoning province and was less than 30 cm in length. Its name means "dawn feather," and it is a very primitive member of the group of dinosaurs that gave rise to birds.
2D digital

p.177
The Earliest Birds
Whether *Archaeopteryx* (left) is truly the "first bird" is now a matter of some debate. One other possible contender is the slightly earlier Jurassic paravian *Eosinopteryx* (right).
Gouache and watercolor

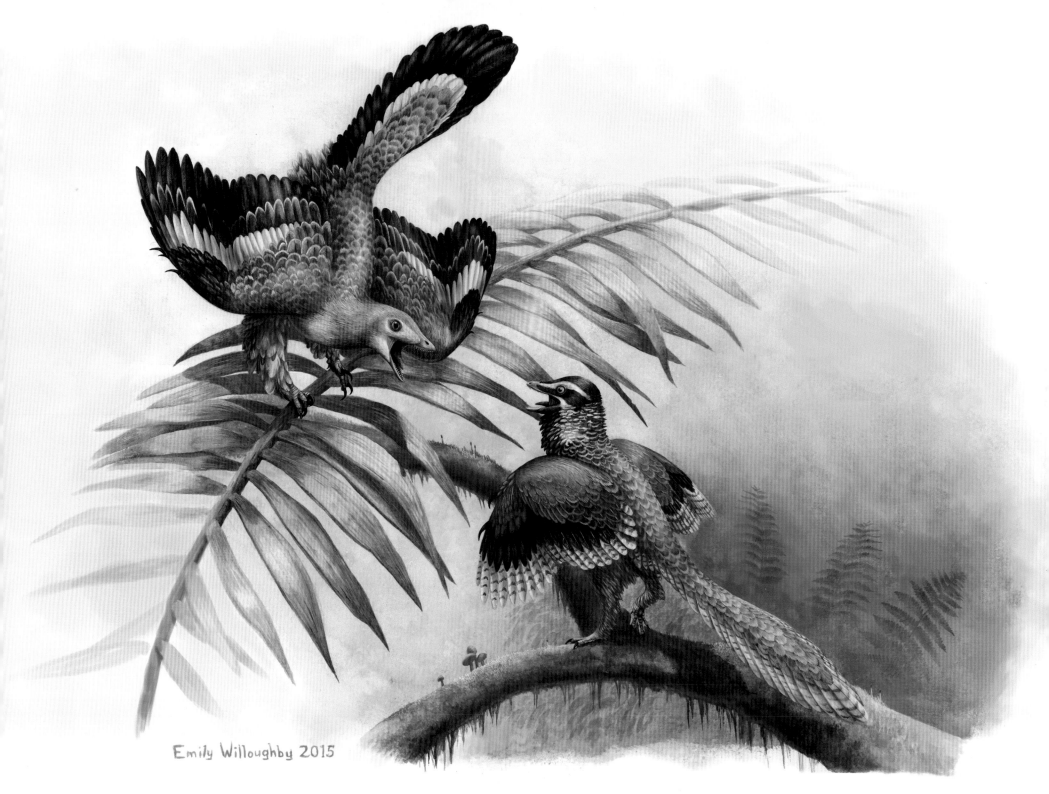

Emily Willoughby 2015

Raúl Martín

Raúl Martín is a Spanish illustrator, born in Madrid in 1964. He has been a professional illustrator for over 30 years and has had a deep professional and personal interest in paleoart for the last 20 years. These years of experience and ongoing study have given him a great deal of paleontological knowledge about fossil plants and vertebrate and invertebrate animals, since the Mesozoic and Palaeozoic eras are his specialty. He has worked for some of the most prominent palaeontologists, including Paul Sereno, Curry and Kristi Rogers, Jennifer Clack, Alan Titus and Jose Luis Sanz. He also works regularly for some of the leading scientific journals, including *Nature*, *Scientific American* and *National Geographic*, and collaborates in large scale projects for prestigious museums worldwide. He employs both traditional and digital techniques to achieve his realistic style. In his digital work, he avoids artificial methods such as photo-montage and rendering, so his digital creation process is identical to his work with traditional media like oil and acrylic.

In my illustrations I strive for realism and scientific accuracy. To maximize the accuracy of each reconstruction, I have to study the existing fossil evidence. One of my recent works, which received broad media coverage, is a reconstruction of *Concavenator*, a theropod dinosaur from the Early Cretaceous, found in the Spanish fossil site at Las Hoyas.

It was exciting to be the first artist to draw *Concavenator*, a brand new, never-before-seen species. Until then I had only reconstructed dinosaurs that had already been reconstructed. It was quite a challenge, but a very enjoyable one.

I work intuitively while maintaining scientific rigour. I generally start from skeletal reconstructions such as Gregory Paul's skeletons, which the majority of paleoartists think are a good reference point. I collect a variety of graphic documentation such as images of skeletons from museums, although sometimes I have to verify them if they are outdated or reconstructed badly. Sometimes, if time permits, I make a sculpture of the animal, but usually I just make numerous sketches until I get close to what I have in mind. This work requires both a good scientific base and a great imagination.

Working with colour in dinosaur reconstructions is purely speculative, just like for other extinct vertebrates, since their skin pigmentation disappears during fossilization (except for dinosaurs with feathers). I base the colors of my reconstructions on the colour patterns of reptiles and birds in today's world, but surely those colors are not accurate. Like other artists, I tend to give more uniform colours to larger animals and brighter colours to smaller ones, but for me color is only of secondary importance and a purely aesthetic matter.

Reconstructing sauropods fascinates me. I love them, and I find it incredible that such gigantic animals roamed this planet, maybe even in herds like today's elephants. It's a lot easier to imagine something like a *Velociraptor*, which was likely very similar to today's land birds, than a four-legged animal with an enormous neck and a massive tail, weighing as much as a whale. Giant sauropods are difficult to imagine, so I find it a challenge to recreate them realistically.

I would love to see a great theropod such as *Giganotosaurus*, *Spinosaurus* or *Tyrannosaurus* in real life, of course from a safe distance. Those animals are hard to imagine, but they must have been quite a spectacle. I wonder if perhaps in the future we might be able to see dinosaurs in person, although I'm sure that is highly optimistic.

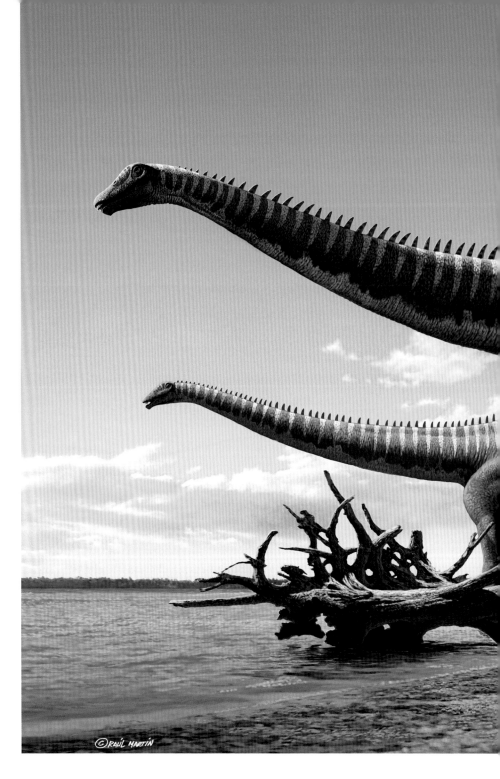

Diplodocus
A herd of *Diplodocus*, large herbivorous dinosaurs, at the water's edge.
Digital painting

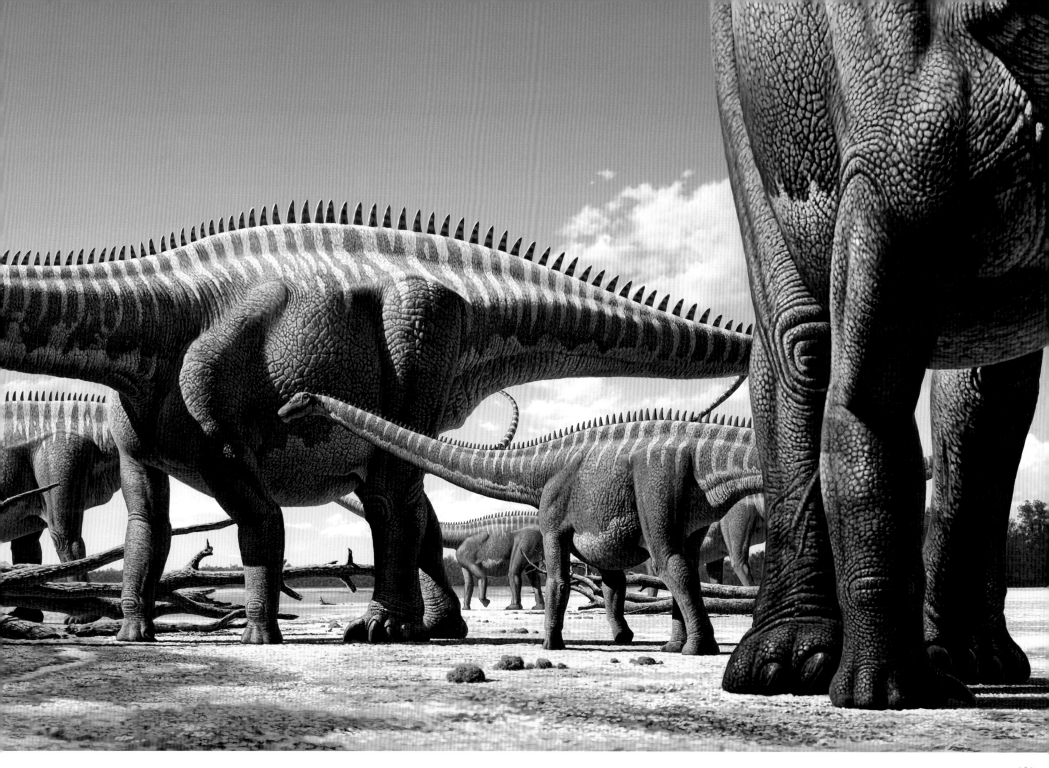

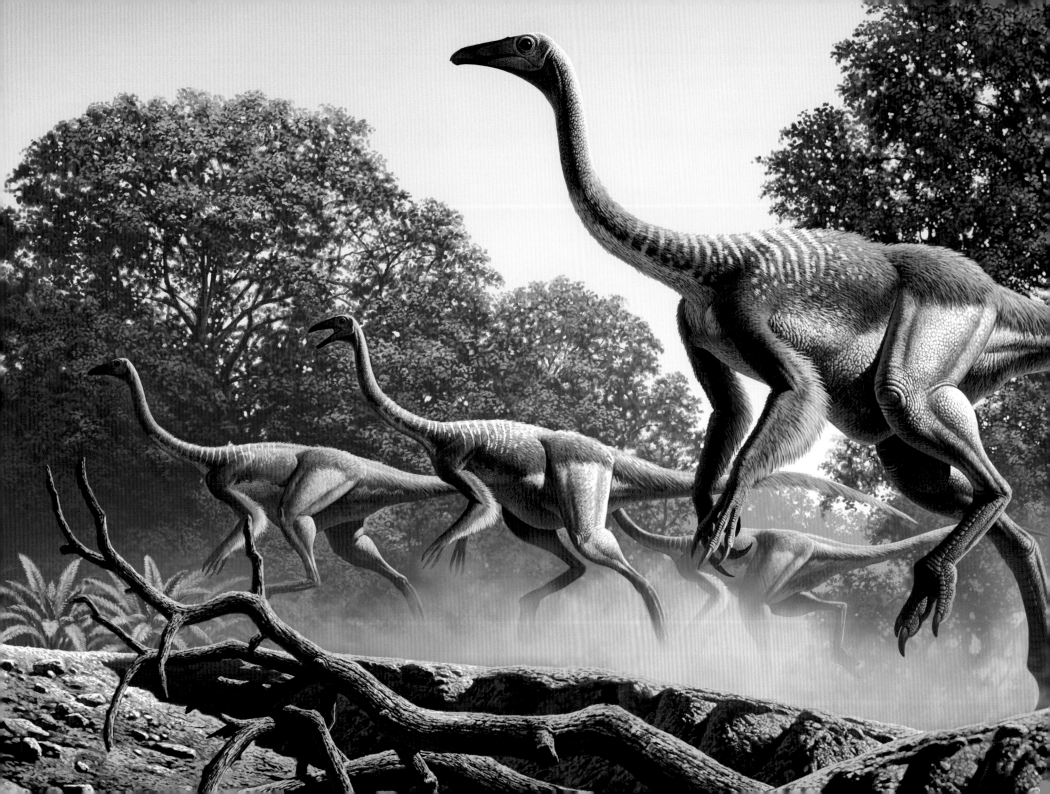

Struthiomimus

Struthiomimus, with its long, strong hind legs, was very agile and could run extremely fast.
Client: Fort Peck Interpretive Center
Digital painting

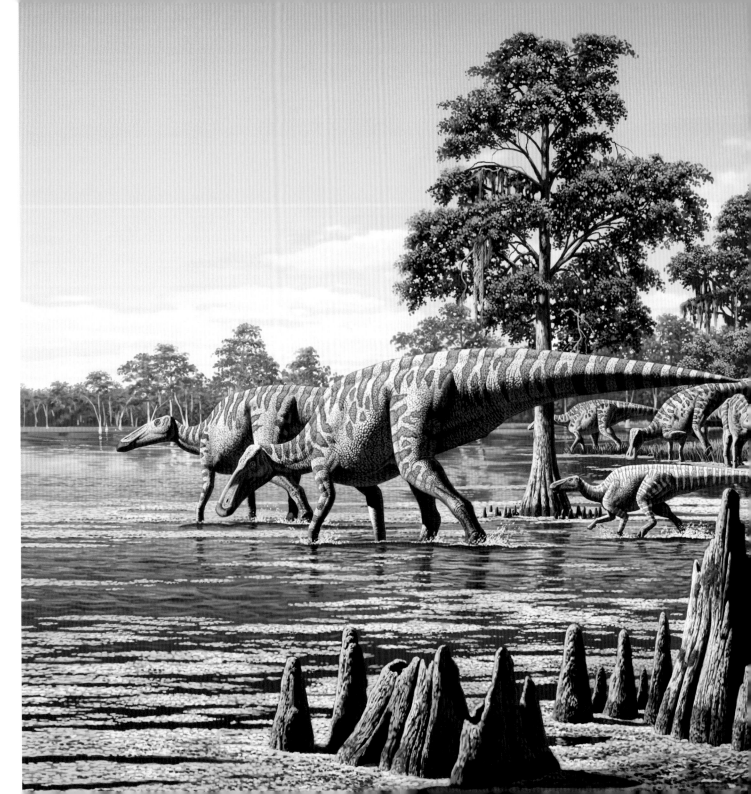

Tyrannosaurus and *Anatotitan*

A group of *Tyrannosaurus* have come near the water. They seem relaxed and at the moment appear to have no intention of attacking the herd of *Edmontosaurus*.

Client: Natural History Museum of Los Angeles

Digital painting

184

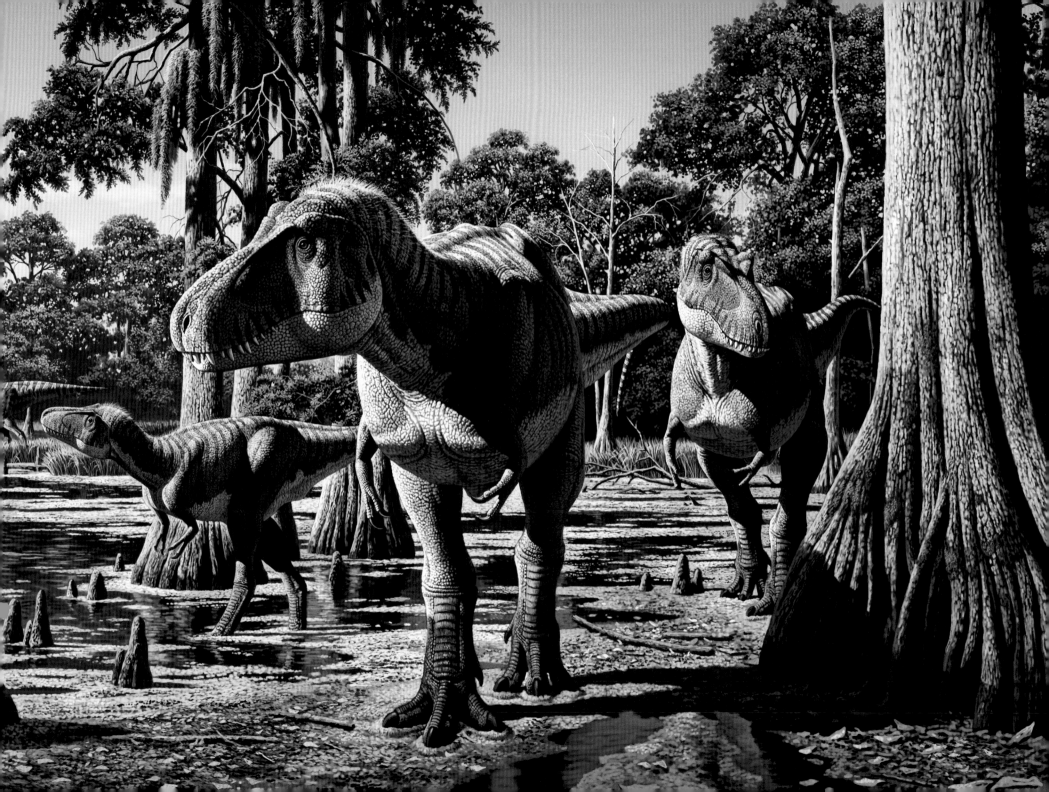

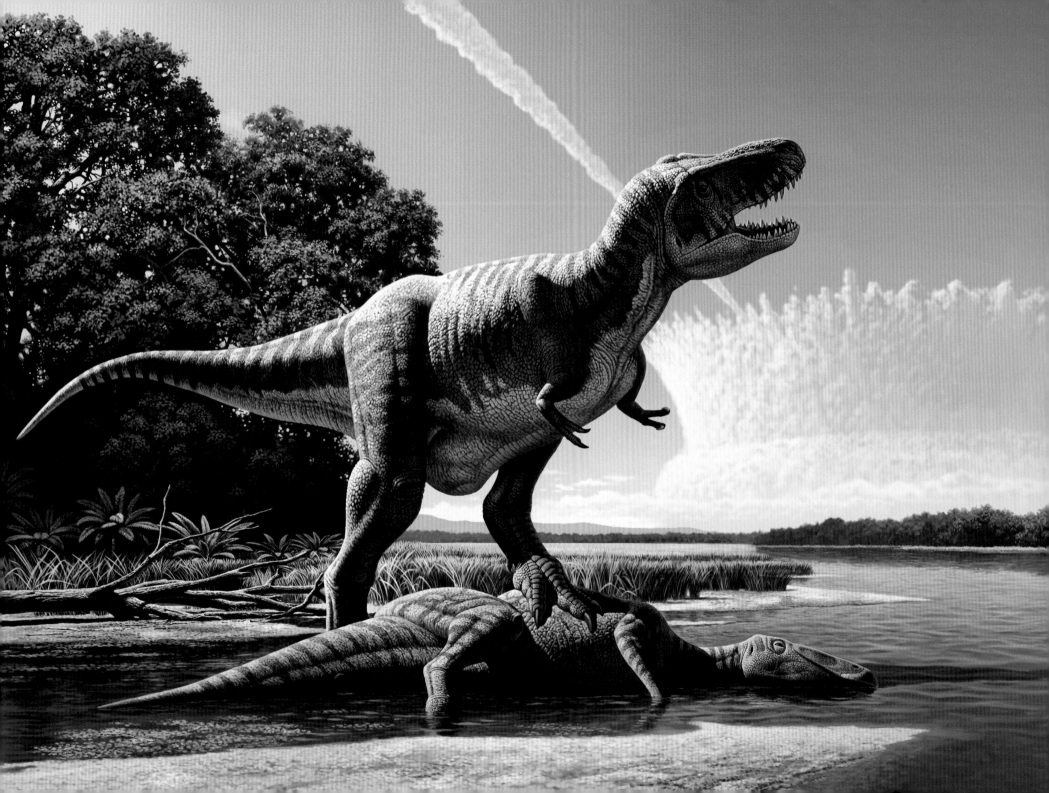

Asteroid impact

Tyrannosaurus, having killed its prey, is looking up at the sky
just after a gigantic meteorite has hit the earth.
Dinosaurs became extinct 66 million years ago
as a result of such a meteorite strike.
Client: Museo Nacional de Ciencias Naturales, Madrid
Digital painting

A Persistent Sense of Wonder

Makoto Manabe × Kazuo Terakado

Why do dinosaurs continue to fascinate us?
How have dinosaurs been depicted in art? How have images of
dinosaurs been changing as a reflection of various discoveries?
The following is a conversation between the leading authority
on dinosaur research in Japan and the editor of this book, as
they looked at masterpieces of dinosaur art from throughout the
history of the genre.

Makoto Manabe (left) and Kazuo Terakado (right) at the dinosaur
gallery in the National Museum of Science & Nature, Japan.
Makoto Manabe (PhD University of Bristol; MSc Yale; BEd
Yokohama National University) is a paleontologist at the National
Museum of Nature & Science, Japan. He is particularly interested in
the evolution of dinosaurs and other reptiles during the Mesozoic.
Kazuo Terakado is the editor of this book.

Fig. 1 **_Iguanodon_ and _Megalosaurus_**
Iguanodon (left) fighting _Megalosaurus_ (right), 19th century artwork. Created as an illustration for a book by Louis Figuier entitled La terre avant le deluge, published in Paris in 1863. The artist, Édouard Riou, was famous for his illustrations for the books of Jules Verne. ©Science Photo Library/Aflo

Terakado
Dinosaurs have always stimulated people's curiosity. Dinosaurs first appeared in human records in the 19th century. In 1824, William Buckland reported remains of _Megalosaurus_ and in 1825 Gideon Mantell reported _Iguanodon_. Those fossilized animals were named dinosaurs in 1842 by Richard Owen. Owen later was appointed superintendent of the British Museum's natural history collections, which had been neglected. He went on to campaign for the creation of what is now the Natural History Museum in South Kensington. This shows the growing interest in natural history from that time.

Manabe
According to the Bible, life on Earth and the Earth itself were divinely created a relatively short time ago. So, when dinosaur remains were first found the idea of such radically different extinct animals was a totally new concept for people; previously, extinct elephants, rhinos and so forth, not that different from living relatives, had been recognized, as well as giant versions of extant animals like sloths, and early mammals that were still recognizably mammalian. Also shocking was the size of those animals; they were humongous. In the 19th century, leading scientists of that time, including Georges Cuvier, thought that being big was an innate characteristic. They thought that mammals could become very large but that reptiles were unlikely to. However, Mantell, who showed that the _Iguanodon_ teeth and jaw bones he had discovered were very similar to those of modern day iguanas, insisted that _Iguanodon_ was a reptile. At first scientists rejected this claim, but they were gradually convinced to classify _Iguanodon_ as a reptile, and eventually Richard Owen was led to name a new reptile group, which he called dinosaurs.

Later, in 1859, Charles Darwin's On the Origin of Species was published; the notion of evolution was not widely accepted at first. As most people in the West held to the Christian view of life, the discovery of huge, monster-like animals was startlingly new and attracted a great deal of attention.

Terakado
This image of _Megalosaurus_ and _Iguanodon_ was created in 1863 (Fig. 1). You can see that they were depicted as very heavy.

Manabe
Yes, that's right. In the beginning dinosaurs' bodies were thought to be massive, but it was difficult to speculate on their actual size with only their teeth or a few bones as evidence. Now we have more evidence for estimation, but at that time there was no such evidence, so there were wild estimations that these dinosaurs were some 100 meters long. People wondered how these animals could support so much weight, which I think is the reason why dinosaurs were presented as rock solid and stout.

Terakado
This is one of the first paleoart works ever made (Fig. 2). It was published in 1830, before the concept of dinosaurs emerged. Here we see marine animals in the ancient sea. In 1812, when Mary Anning was collecting fossils on the beach in Dorset in southwest England for sale to collectors, she found an almost complete _Ichthyosaurus_ skeleton. In 1821 she found an entire _Plesiosaurus_ skeleton. Those animals are portrayed vividly here.

Manabe
Before Anning discovered that complete _Ichthyosaurus_, only a head had been excavated and it was thought to be part of a crocodilian. Also, at that time nobody thought such an animal as _Plesiosaurus_ had lived in the ocean.

However, when they looked at the skeleton that Anning had discovered, it was clear that the limbs were fins, so there was no doubt that the animal spent its life swimming in the sea. Thus the artist created this image. Although _Ichthyosaurus_ and _Plesiosaurus_ aren't dinosaurs, at that time no such distinction even existed. Description of these marine reptiles (and also of a pterodactyl) preceded the first descriptions of dinosaurs. I think that since people then had already seen this sort of illustration, it must have been easier for them to accept the existence of dinosaurs and other prehistoric reptiles when substantial remains were discovered later.

Terakado
People in the 19th century were also greatly interested in what the ancient animals looked like, and in that atmosphere these evocative, stimulating images were created. When we think about the history of dinosaur art and of paleoart, which includes depictions of dinosaurs, it is very interesting to note that paleoart started at the same time paleontology studies began.

Manabe
In those days, the Earth was not thought to be very old, and people could not believe that there was a world where animals so different from those in modern times existed. However, after seeing various fossil discoveries, people finally accepted that these previously unimagined animals had in fact existed. In 1815, the English surveyor William Smith published the first large-scale geological map, which covered much of the island of Great Britain.. Smith used fossils in conjunction with lithologies (rock types) as a basis for the map and thought that geological layers containing the same fossils were somehow related. That is matter of course knowledge now, but Smith was the first to notice it. Until then, fossils were simply collectors' items. At around the same time on the south coast of England, where

DURIA ANTIQUIOR.

1. Ichthyosaurus Vulgaris
2. Ichthyosaurus Tenuirostris
3. Plesiosaurus Dolichodeirus

4. Pterodactylus Macronyx
5. Dapedium Politum
6. Pentacrinites Briareus

Fig. 2 **Waterside scene in ancient Dorset**
This lithograph showing a waterside scene in prehistoric southern England was created by George Scharf in London in 1830.
Completed under the supervision of Henry de la Beche, a British geologist, it is considered the oldest reconstructed prehistorical image in the world.
An *Ichthyosaur* has seized a *Plesiosaur* by the neck.
Two *Pterosaurs* are flying in the distance, and among the creatures swimming below are crocodiles and a turtle.
©Science Photo Library/Aflo

ammonite fossils were often found, a girl named Mary Anning was making a living selling them, at times to wealthy visitors to the area. So there was a market like that for fossils. While people were familiar with fossils and some collected rare ones, Smith started to view fossils in connection with the geological layers in which they were found, and this became a subject of research. Subsequently paleontology was born. Then after the conception of the theory of evolution, a significant change occurred: people started to accept that in the past there had been animals different from those known in the present day, and that through many evolutionary changes, modern humans had come to exist.

Terakado
This lithograph was created in 1888 (Fig. 3). A variety of dinosaurs are depicted in this Jurassic Period landscape. We can see that the archetype of current dinosaur art was already in place, with elements such as general composition, the representation of the surrounding environment and the positioning of the animals. Looking at this kind of image, we can see that ever since they were discovered, dinosaurs have been the source of a sense of wonder for human beings, giving us surprise and excitement as we encounter things we never imagined.

Manabe
I agree that dinosaurs have that kind of power. With such pictures people were faced with evidence of the existence of creatures which they had only seen in their imagination, and at that point dinosaurs came to be seen as a reality. I think people's curiosity about dinosaurs and their desire to see them or to feel the reality of the dinosaur age have been constant since the 19th century, even though it is of course impossible to visit that time.

Terakado
There are some interesting dinosaur related

Fig. 3 **Jurassic landscape**
This 19th century lithograph, a reconstruction of a Jurassic Period landscape, was created in Stuttgart, Germany in 1888. A variety of dinosaurs are featured. In the foreground we see *Megalosaurus* on the right and *Iguanodon* on the left. Closer to the shore, on the right we see *Dryptosaurus*, a carnivorous dinosaur, and on the left *Hylaeosaurus*, a herbivorous dinosaur. In the water in the middle distance are Plesiosaurs.
©Science Photo Library/Aflo

DINNER IN THE IGUANODON MODEL, AT THE CRYSTAL PALACE, SYDENHAM.

Fig. 4 **Dinner party at the *Iguanodon***
This dinner party, with all guests seated in a model of an *Iguanodon*, was held on December 31, 1853. This illustration was created for an article published in *The Illustrated London News* on January 7, 1854. The *Iguanodon* model is now held by the Crystal Palace Park in Sydenham, London.
©Science Photo Library/Aflo

stories from around at that time. Here is an image of a dinner party held in London on December 31, 1853 inside the mould of a model of an *Iguanodon* (Fig. 4). In 1851, during the Great Exhibition, Benjamin Waterhouse Hawkins, a sculptor, created several life-size models of dinosaurs under the supervision of Richard Owen. After the exposition ended, the Crystal Palace, the venue of the exposition, was moved from Hyde Park to Sydenham, and a large park was created around it. Hawkins was asked to create more models of extinct animals there. This project, the first extinct animal theme park in history, received enthusiastic advance reviews. The guest list for this awesome New Year's Eve banquet included journalists, scientists such as Owen, and people connected to the Crystal Palace.

Manabe

That story is well known, but there are some elements that cast doubt on the event as depicted in the illustration. The space which was said to be where the party supposedly took place remains intact to this day, but it is very small. A professor emeritus of Bristol University guided me there. He said he could narrow down the possible location of the banquet, but the place is very small, so many people think it would not have been possible to have a banquet there like the one shown in the picture.

Terakado

I've never heard that before. What attracts my attention in this picture are the signs with people's names in the background. On the left is the name of Buckland, who reported the

discovery of *Megalosaurus*; on the right is the name of Mantell, who reported *Iguanodon*, and in the middle, beside the name of Owen, is that of Cuvier, a great pioneer of paleontology. To me this picture shows how well academia had accepted the concept of dinosaurs at that time.

Manabe

This illustration is very interesting, isn't it? (Fig. 5) Although it is established now that four-winged dinosaurs such as *Microraptor* did exist, they were completely a figment of the imagination when this illustration was created.

Terakado

This illustration was created in 1915 by William Beebe, an American naturalist and

biologist. He came up with it simply by imagining that a dinosaur with four wings might have existed. At that time the actual *Microraptor* fossils had not been discovered.

Manabe

That's right, it was purely his imagination. In 1877, the biologist Thomas Henry Huxley, famously called Darwin's bulldog, visited the US to lecture on the theory of evolution, acting as a sort of missionary for the theory. He said something like, "There is no evidence that dinosaurs had feathers. However, if such dinosaurs existed, it is not easy to decide whether we should call them bird-like reptiles or reptile-like birds." In a way he was predicting the discovery of dinosaurs with feathers. That could be the background of the

Fig. 5 **Four-limbed feathered "*Tetrapteryx*"**
American naturalist William Beebe, thinking that birds had evolved from four-limbed feathered dinosaurs, proposed the existence of *Tetrapteryx*. This bookplate illustration was published in 1915.

creation of an illustration like this. Finally feathered dinosaurs were found to be a reality in 1996.

Terakado

Well, those are some images created in earlier times. Now let's look at the development of modern dinosaur art, works in which dinosaur figures are recreated on the basis of skeletons. First we should talk about Charles R. Knight, who was born in 1874 in New York. He created a lot of images of dinosaurs and extinct animals for the American Museum of Natural History in his hometown. Then he worked for other museums including the Natural History Museum of Los Angeles and the Field Museum of Natural History in Chicago. Rather than using his own imagination, he created artworks based on the scientific knowledge of the time, getting a lot of advice from experts at the museums. Many of his works were used in magazine articles and books. This (Fig. 6) is one of his famous works: *Brontosaurus* in the water, with *Diplodocus* in the background.

Manabe

From the end of the 19th century to the beginning of the 20th century, many museums were founded in various locations; this increased the number of places where people could find out in detail what sort of animals lived in the past. Knight was active at that time. He was the key artist working to create reconstructive images of extinct animals in various forms, including pictures and models, and he had a major impact on the future of paleoart.

Terakado

In this fight scene (Fig. 7), *Dryptosaurus* is shown as a very dynamic dinosaur. This had a significant influence on the illustration work of Robert T. Bakker, whom we will talk about later. This photograph (Photo 1) is also very famous: here Knight is creating a model of *Stegosaurus*.

Manabe

Knight studied about dinosaurs under Edward Drinker Cope, who was at the Academy of Natural Sciences in Philadelphia. Cope is famous for competing with Othniel Charles Marsh to name new species of dinosaurs. That rivalry is now known as the Bone War. I don't know how much Cope's opinion is reflected in this *Stegosaurus* but I can tell it was very hard to make a model of it. For example, were the spikes on the tail pointing upward, up at an angle, or horizontally? Actually this was a source of argument until the 1990s. In a drawing you can be vague to some extent but you have to be decisive in a 3D model. It turns out that Knight's spikes were pointing in more or less the correct way.

Terakado

Then for museum exhibitions, it became necessary to have not only fossils but also restored images and 3D models.

Manabe

Yes, the museums needed content which could attract a lot of visitors; they needed to increase the viewing value, since in some cases the visitors paid admission.

Terakado

In that sense, we should talk about the mural, *The Age of Reptiles* in the Peabody Museum of Natural History at Yale University. This mural, which is 4.9 m high and 33.5 m long, depicts the history of the Earth from the Devonian Period to the Cretaceous Period.

Manabe

Rudolf F. Zallinger, then a student at Yale University's School of Fine Arts, started to create the mural at the museum's request for a visual exhibition of the history of reptiles. It took four and a half years, starting in 1943, to complete the *The Age of Reptiles*. After that Zallinger completed another smaller mural, *The*

Age of Mammals. This is essentially a picture scroll showing a combination of the history of the earth and the evolution of animals, taking an extremely modern approach. For his restorations of extinct animals Zallinger made sketches from restored skeletons exhibited in the museum, studied modern reptiles when there were no sample skeletons for anatomical comparison, and applied the advice of experts, to create figures so vivid they look like they are alive. He pioneered an expressive style of depicting the history of animals in panoramic form. These artworks had a great impact on people, and led to new ways of looking at fossils, in response to people's desire to see new images and discoveries.

Terakado
I was involved in the inauguration of a new science magazine in 1981 and I have produced many dinosaur illustration projects. I learned a lot from *The Age of Reptiles*. I thought simple restorations of dinosaur figures would not be enough: the readers of the magazine would not be able to imagine the reality of dinosaurs, or enjoy the topic much, without illustrations accurately depicting the environment during the time of the dinosaurs. I remember when

The Age of Reptiles was exhibited here at the Tokyo National Museum of Nature and Science in 2011. When I saw it I was very impressed by how the landscape and the vegetation in the scenes accurately reflected the historical evidence.

Manabe
There were plant fossil experts and reptile experts at the museum. That's why Zallinger was able to create such an accurate and impressive mural. I think until then research tended to be compartmentalized, with reptile experts studying only reptiles and plant experts studying only plants. The charm of this mural lies in how Zallinger achieved a realistic impression of the world of dinosaurs by integrating the findings of those studies. A vast period of time is condensed in this mural. Looking at this art, you get the sense that evolution really did take place, and that the world really has changed.

Terakado
In that sense, I think *The Age of Reptiles* can be said to be the origin of dinosaur art and paleoart as we know it today.

Manabe
In the late 1980s and early 1990s, when I was a graduate student, recreating scientific images of dinosaurs was very difficult. Now it is much better — in some cases we even know the color of dinosaur feathers and scales. But in those days, nobody knew how dinosaurs' muscles worked or what color their bodies were. Therefore at that time there was a tendency for mainstream scientists to talk mostly about skeletons and there was a considerable distance between dinosaur art and science. In one period in the 19th century paleoart emphasized science, but in some paleoart in the 20th century imagination was rather dominant. However, in the late 1980s and early 1990s, science and artists' imagination began to connect again.

Terakado
The trigger for that was the work of John H. Ostrom and his disciple, Robert T. Bakker, particularly when Bakker's reconstructed image (Fig. 8) of *Deinonychus* was included in Ostrom's 1969 research paper on *Deinonychus*. This is a new kind of dinosaur image, based on scientific investigation. In that paper, Ostrom reported in detail a new dinosaur which he had

discovered in Montana in 1964. The word 'unusual' occurs many times in the paper. It seems that Ostrom thought *Deinonychus* was a dinosaur with incredible, previously unknown characteristics.

Manabe
That's right. *Deinonychus* had a huge claw on the second toe. It could have been used to kill: *Deinonychus* might have leaped at its big prey and kicked repeatedly. Ostrom realized that *Deinonychus* probably needed a lot of stamina, but ordinary reptiles do not have that much stamina. Three *Deinonychus* skeletons were found clustered around the skeleton of a *Tenontosaurus*, a huge herbivore dinosaur. This suggested that *Deinonychus* might have hunted in a herd, which conflicted with the idea that *Deinonychus* was an ordinary reptile. Those observations led Ostrom to theorize the existence of warm-blooded dinosaurs. Also, at around the same time, he noticed that if the feathers were removed from *Archaeopteryx*, the skeleton would look exactly like a carnivorous dinosaur. Since the wrist of *Archaeopteryx* and *Deinonychus* resembles the equivalent structure in a bird wing, Ostrom saw an evolutionary connection between dinosaurs and birds, and he started to think that dinosaurs might have been warm-blooded (endothermic), not cold-blooded (ectothermic).

Terakado
At that time Bakker was Ostrom's student, wasn't he?

Manabe
Yes, he was. Bakker was very good at drawing and he was able to present Ostrom's ideas visually. Bakker quickly started to promote the theory of warm-blooded dinosaurs, but from Ostrom's point of view he went a bit too far, so eventually their relationship became awkward.

Terakado
Anyway, Bakker's illustrations had a significant

Fig. 6 ***Brontosaurus***
These gigantic creatures were reconstructed by American artist Charles Knight.

Fig. 7 ***Dryptosaurus* clash**
Action scene with *Dryptosaurus*, created by Charles Knight. The dinosaurs are depicted as very active and aggressive. It is said that this image later had a significant influence on Robert Bakker.

Photo 1
Charles Knight at work on a model of *Stegosaurus*.

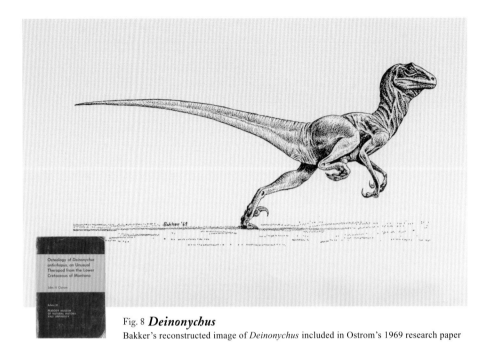

Fig. 8 ***Deinonychus***
Bakker's reconstructed image of *Deinonychus* included in Ostrom's 1969 research paper

impact.

Manabe
Yes, he has amazing expressive power. He created vivid images of dinosaurs one after another and by talking about them he spread new conceptions of dinosaurs.

Terakado
Ostrom conducted research on *Archaeopteryx*.

Manabe
Yes, he visited a museum in Holland to study pterosaurs, and when he was looking at a fossil labeled as a pterosaur, he noticed it had feathers and realized this could be an *Archaeopteryx*. There is an interesting story about that. Ostrom thought if he said the fossil was *Archaeopteryx*, the curators at the Dutch museum would not agree to lend such a valuable fossil to the US. So he started to say that he wanted to borrow this pterosaur to study it in detail but he let it slip that he thought this was an *Archaeopteryx*. The curator immediately grabbed the fossil and left the room. Ostrom thought he had made a mistake, but the curator returned with the fossil properly set in a box and handed it to him, saying, "You have noticed the importance of this fossil. Thank you so much. Please feel free to study it." Since *Archaeopteryx* could spread and fold their wings, their wrists must have been able to move both vertically and horizontally. The wrists of carnivorous dinosaurs generally moved only vertically. However, *Deinonychus* had wrists which moved horizontally as well. That tells us that although *Deinonychus* probably did not have flight-capable wings, it shows us a path by which dinosaurs evolved into birds.

Terakado
When did you study with Ostrom?

Manabe
From 1986 to 1990.

Terakado
At that time I was editing a lot of articles on dinosaurs, and I noticed considerable changes in the images of dinosaurs. A notable change at that time was in the posture of carnivorous dinosaurs such as *Tyrannosaurus*. They were often depicted as standing erect, but we started seeing images where their backbones were parallel to the ground and the tail extended backward as well. I remember that as a result, we could no longer use the illustrations we had produced previously.

I also remember that at that time museums started changing the way they displayed dinosaurs. For example, there are huge skeletons placed at the entrance hall of the American Museum of Natural History in New York: *Barosaurus*, a giant plant-eating dinosaur, is standing tall with its hind legs in a threatening pose, to protect its young from *Allosaurus*, a predator. So at that time, these dramatic postures, so unlikely in reality, were produced.

Manabe
Yes, the design of displays in museums has been changing. Museums used to simply exhibit individual fossil bones, but later they started to assemble the skeletons. In the beginning they just created statue-like postures for display, but later they started using casts and metal supports for the skeletons, which made the exhibitions really vibrant and dynamic. I think that the change in display style has changed the public image of dinosaurs.

Terakado
Steven Spielberg's movie, *Jurassic Park*, released in 1993, had a significant impact on public acceptance of new images of dinosaurs. One of the prominent characters in the movie was *Velociraptor*, a dinosaur similar to *Deinonychus*.

Manabe
Of course that was a fiction movie, so when I saw it I was not that enthusiastic. I thought that even though the dinosaurs in the film moved very realistically, nobody knew what they would really look like. Nevertheless it was a very good film. The details were carefully done, mainly thanks to the original novel by Michael Crichton. For example, the scene where the children ran into the kitchen pursued by velociraptors. The kids thought that the dinosaurs couldn't turn the door knob, so they shut the kitchen door with great relief, but the raptors' wrists can move horizontally, so they could open the door.

Also, when the dinosaur looked in the kitchen door window, it fogged the glass with its breath. That means that velociraptors have a high body temperature. I enjoyed the movie, and I came away thinking that the film makers really learned about dinosaurs.

I met Mr. Crichton when he visited our museum in Tokyo. I told him about my hypothesis based on the fossils found in Japan: that there was originally a small type of Tyrannosauridae in Asia which eventually became larger and moved to the North American continent. He was immediately interested in my hypothesis and asked me to send him my research paper. Originally a highly knowledgeable scientist, he was very thorough in his collection of materials and background information.

Terakado
There is a long history of movies featuring dinosaurs. The first dinosaur movie ever made was Winsor McCay's *Gertie the Dinosaur*, released in 1914. Then *The Lost World* was released in 1925. It was based on Sir Arthur Conan Doyle's 1912 science fiction novel of the same name. I guess writers and movie people even then were interested in dinosaurs.

In *Gertie the Dinosaur*, dinosaurs were moved by cartoon animation. In *The Lost World*, director of special effects Willis O'Brien, who

developed the stop motion technique, moved dinosaur models in small increments through individually photographed frames.

Ray Harryhausen, his assistant at the time, later used that technique to create dinosaur scenes in a number of science fiction movies. One movie was *The Beast from 20,000 Fathoms*, released in 1953, which was one of the catalysts for the creation of *Godzilla*, released the following year in Japan. By the time *Jurassic Park* was made, creators could move dinosaurs freely using computer graphics, a vast improvement over earlier Hollywood efforts to animate dinosaurs for their movies. In the background of all that, there must have been a strong desire among the public to see moving dinosaurs.

Manabe

Yes, people do seem to be strongly attracted to dinosaurs. I think there's a great power to imagining the ancient world, a place we can never see.

Terakado

The technique of creating dinosaur art using brushes and air brushes has given way to digital imaging. Those digital techniques brought new possibilities to the work of recreating dinosaurs. They also made it possible to create 3D models based on skeletons and apply textures to the surface of the models. I think that with these digital techniques, a new type of artist with very different skills has entered the world of dinosaur art.

Terakado

The discovery of feathered dinosaurs in 1996 changed the image of dinosaurs completely.

Manabe

Yes, the very close relation between dinosaurs and birds was reconfirmed at that time. When a feathered dinosaur was found, not all dinosaur researchers accepted the fact immediately. However, some researchers who had been focusing only on skeletons knew that dinosaurs and birds were closely related, so they took the position that the discovery of feathers merely gave additional evidence of that relationship. The feathered dinosaurs changed the public image of dinosaurs drastically. Even those who thought dinosaurs were scary and creepy started to have a more favorable image.

Terakado

Well, as we've been saying, dinosaur art has developed a lot up to now. In my work as an editor I have seen many works of dinosaur art. I get the impression that the number of works portraying dinosaurs in their environment in detail, not just the dinosaurs themselves, has been increasing steadily since the beginning of the 21st century. When we see such scenes of dinosaurs in their environment, we can get a better sense that dinosaurs actually existed on our planet long ago, and this may give us a deeper understanding of them. Now there are also many high-quality works of art portraying dinosaurs. I hope the readers will enjoy the examples of these works in this book. By the way, while I was listening to you talk I felt that a new relationship between dinosaur art and science is under way.

Manabe

I think so too. As I mentioned before, at the time when *Jurassic Park* was released, dinosaur researchers kept their distance. However, the public often asked them which parts of the movie were scientifically accurate. Public interest became stronger and the researchers had to answer that kind of question. For example, a researcher using a computer simulation might dream up an hypothesis that *Tyrannosaurus* could run 50 kilometers an hour and be able to test that hypothesis. Researchers do not usually pursue that kind of question if they work in a pure research environment. So in some way those questions from the public can stimulate new research.

Makoto Manabe (left) and Kazuo Terakado (right) engaged in a lively exchange about the history of dinosaur art.

Terakado

It was the same with research on the color of dinosaurs.

Manabe

It used to be taken as a given that it was impossible to know the color of dinosaurs but now we have started to find answers to that question. Also, everyone assumed it was impossible to know how dinosaur voices sounded because their vocal cords were soft and were never fossilized. However, now researchers have simulated the voices of a *Parasaurolophus* and its child. Not only that, since a Cretaceous bird fossil found on an island in Antarctica contained a fossilized syrinx, researchers have evidence that birds coexisting with dinosaurs in the Cretaceous Period communicated vocally. Although less is known about the case of the dinosaurs, it's seeming more likely that dinosaurs communicated with each other by voice. We can say that much in light of current research.

Terakado

So strong public interest can stimulate the advancement of paleontology.

Manabe

Surely. When the reader of this dinosaur art book has a question with some scientific aspect, a new viewpoint or inspiration could emerge that might prompt new research on dinosaurs.

Afterword
Kazuo Terakado

Over the past 40 years, in my work as an editor for science magazines and as a science journalist, I have been covering the development of the study of dinosaurs. At the same time I have witnessed a dramatic evolution in the world of dinosaur art, or paleoart, a great widening of scope.

In the dinosaur art of today, there is a strong trend toward detailed depictions, not just of dinosaurs but also of the environment and ecosystem in which they lived. I specifically chose this genre of illustrations to give the readers the sense that they were traveling in the dinosaur age. I also chose illustrations in which the readers could enjoy scientific content and at the same time appreciate great art.

I am sure that in these illustrations the cutting edge images of dinosaurs will surprise most readers, as they are far away from the standardized dinosaur images we are accustomed to. I'm sure this will be a stimulating experience. I hope you enjoy it without thinking too much about complicated aspects.

This book has been an exciting project for me as an editor. I have had the opportunity to create a collection of my favorite works by contemporary paleoartists from around the planet. I would like to thank the nine artists for their cooperation in the realization of this project.

Luis Rey was the first artist I contacted. His prompt response and warmhearted cooperation became the driving force of this book. Although his dinosaur art is well-known worldwide, Luis is also a surrealist and symbolic artist. In his blog, I saw a painting, *Home's Garden*, which he created in 1988. In that painting, reminiscent of the work of René Magritte, we see a skeletal specimen of *Tyrannosaurus* in a garden, intentionally set in an old fashioned erect posture. The sunset sky in the background and the lighting in the garden evoke for me a scene from one of my childhood dreams. This picture represents something that I came to feel strongly while editing this book: each artist has their own unique

Luis Rey's *Home's Garden*

background, with influences not only from science but also from art, history and culture. Dinosaur art, good quality art that expresses cutting edge science, can only be created from such a rich background.

From the moment I saw Zhao Chuang's *Velociraptor* (page 32 to page 33) in *Nature*, I was hoping to get a chance to work with him. This project made it happen. Currently in China, a series of discoveries are being made which overthrow the thinking behind existing dinosaur images. Zhao's illustrations reflect the latest scientific information brought by those discoveries, and at the same time his rich imagination injects great drama into the world of dinosaurs.

James Kuether recently published *The Amazing World of Dinosaurs* using many of his own illustrations. In that book he wrote explanations, not only about dinosaurs but also about the environment and ecology of the dinosaur age so that his readers could experience a journey to the Mesozoic era. His *Juvenile Tyrannosaurus* (page 66 to page 67) perfectly met my conditions for selection of images for this book. The readers will be drawn strongly to this quiet Cretaceous woods where purple flowers are blooming and birds are singing. Can we hear the rushing water as the young *Tyrannosaurus* is running there?

Davide Bonadonna is an Italian artist, so maybe that's why he uses the traditional tempera method in his illustrations. The first illustration I saw by him was *Spinosaurus* (page 82 to page 83), which was exhibited in the 2016 Dinosaur Exhibition at the National Museum of Science and Nature in Tokyo. I immediately contacted him and he promptly agreed to contribute to this book. At that time I discovered an amazing coincidence: Davide started his career as an illustrator for a science magazine which used be published in Italy. That magazine was the Italian version of the original Japanese science magazine of which I was the editor. I visited the magazine office in Milan many times, so we might well have seen each other in the editing room.

One of the artists who most influenced Ukraine's Sergey Krasovskiy was the Russian artist Konstantin Flerov, who was active in the Soviet time. Flerov's work can be seen in the Museum of Paleontology in Moscow. That museum had a long history, but it moved to a new building on the present site in 1987. At that time I was a member of a project to create an English pictorial record of this new museum, in book form. I often visited the museum to view Flerov's attractive artworks. So in that sense Sergey and I shared experiences in the same place at the same time.

Illustrations by Rodolfo Nogueira of Brazil reflect his extremely dedicated pursuit of finely detailed scientific accuracy. Among the nine artists featured in this book, only he lives in the Southern Hemisphere, so I thought it appropriate to choose *Staurikosaurus pricei* page 133 as the last illustration in his chapter, since it features the Southern Cross. Later, when Rodolfo sent me the caption for this illustration, I found out that the scientific name of that dinosaur is "lizard of the Crux." What a fantastic name!

Masao Hattori is the most active dinosaur artist in Japan today. His works will surely transform Japanese dinosaur art in the future. Like other dinosaur artists in the world, he has been making great efforts to create new dinosaur images. *Happy Family Scene* (page 150 to page 151) is his latest work in that direction. Although the editing of this book was already under way, I seized upon this illustration for inclusion.

I have been attracted to the work of Emily Willoughby for a long time, and not just because of her scientific accuracy. Her illustrations show her own way of seeing dinosaurs. Through careful observation of living birds, she tries to give life to the reconstruction of the dinosaurs that are distant ancestors of today's birds. Just like other animals, dinosaurs had unique life styles and they may well have shown unexpectedly emotional facial expressions, even poetic ones, at certain moments. *The Smell of Rain* (page 170) is one of my favorite works by Ms. Willoughby. Interestingly, some of her works are strongly reminiscent of the traditional theme of natural beauty in Japanese aesthetics (page 176 to page 177).

In closing, I would like to express my gratitude to Raúl Martín, who lent great support to the creation of this book at a time when he was extremely busy. His image of a scene featuring the meteorite that ended the age of dinosaurs was the perfect closing for this book of amazing insights into the dinosaur world. Raúl's participation in this project raises the bar.

The book closes with a conversation with Dr. Makoto Manabe of the National Museum of Science and Nature in Tokyo. The meeting room in the grand museum building was the perfect setting for our engaging talk about dinosaur art from the 19th century to the present. Coincidentally the museum's exhibition at that moment was *Treasures of the Natural World: Best of London's Natural History Museum*, which featured an Iguanodon tooth discovered by Gideon Mantell—whose name came up in the course of our conversation. Other items from that show that we mentioned in our conversation included a geological map created by William Smith, a portrait of Mary Anning, and the Ichthyosaur remains that she discovered. The synchronicity of the exhibition and our talk was most energizing. I would like to thank Dr. Manabe for his contribution to this book, including his foreword.

Credits of art works

Works by the artists can be viewed at
the following web sites.

Luis V. Rey
http://www.luisrey.ndtilda.co.uk/

Zhao Chuang
http://www.yiniao.org/en/

James Kuether
http://www.jameskuether.com/

Davide Bonadonna
http://www.davidebonadonna.it/

Sergey Krasovskiy
http://atrox1.deviantart.com/

Rodolfo Nogueira
http://rodolfonogueira.daportfolio.com/

Masato Hattori
http://masahatto2.p2.bindsite.jp/

Emily Willoughby
http://emilywilloughby.com/

Raúl Martín
http://www.raul-martin.net/

About the editor

Kazuo Terakado is a Japanese science journalist and TV commentator. He is also a senior researcher at Japan Space Forum. His reportage spans broad areas such as space technology, astronomy, planetary science, molecular biology, genomics, advanced medicine, global environmental issues, and paleontology. His interests range beyond science to cultural matters such as archaeology, Renaissance art, literature and science fiction.

In 1981 he joined Kyoikusha Co., Ltd. and served as the managing editor of *Newton* magazine from the inaugural issue. *Newton* immediately became the most popular science magazine in Japan. For more than 20 years Terakado was responsible for the editing of *Newton*, and the publication of numerous science books as well.

Terakado's major work in the field of paleontology is the *Virtual Biosphere*, a simulation of prehistoric biospheres on the Internet. This challenging project provides viewers with a nature-like cyberspace where they can experience science in an enjoyable manner, unlike formal, organized research outcomes such as scientific reports. The concrete purpose of this project is to allow young viewers to enter observation-like scenarios and find out how ancient creatures might have lived in the prehistoric world.

Among Terakado's publications are *The Final Frontier; Field Notes for The Night of Galaxy Train; Amazing Space: Collections of NASA Photographs; Complete Guide to the Solar System; China: Space Superpower Ambitions*; and *Rain as Seen from Space*.